FRANK CAPRA

Frank Capra

THE MAN AND HIS FILMS

EDITED BY
RICHARD GLATZER AND JOHN RAEBURN

Ann Arbor Paperbacks
THE UNIVERSITY OF MICHIGAN PRESS

First edition as an Ann Arbor Paperback 1975
Copyright © by The University of Michigan 1975
All rights reserved
ISBN 0–472–06195–X
Library of Congress Catalog Card No. 74–78987
Published in the United States of America by
The University of Michigan Press and simultaneously
in Don Mills, Canada, by Longman Canada Limited
Manufactured in the United States of America

We would like to thank the Horace J. Rackham Graduate School of the University of Michigan for a grant which enabled us to complete the manuscript of this book.

The movie stills reproduced here were made available through the courtesy of The Museum of Modern Art/Film Stills Archive.

CONTENTS

Introduction, John Raeburn vii

THE MAN

Thinker in Hollywood, Geoffrey T. Hellman 3

Directors without Power, Frank Capra 14

Frank Capra: "One Man—One Film," The American Film Institute 16

A Conversation with Frank Capra, Richard Glatzer 24

Capra at Work, Lewis Jacobs 40

THE FILMS

Capra's Idealism, Malcolm Lowry 47

Capra's Early Films, Richard Griffith 49

American Madness and American Values, John Raeburn 57

Frank Capra and Screwball Comedy, Andrew Bergman 68

Capra's Comic Sense, Robert Willson 83

Capra and the Picaresque, William Troy 99

The Business of Promoting a Thesis:
 Four Reviews, Otis Ferguson 101

A Director of Genius: Four Reviews, Graham Greene 110

Mr. Capra Goes to Town, Robert Stebbins 117

The Imagination of Stability: The
 Depression Films of Frank Capra, Robert Sklar 121

Meet John Doe: An End to Social
Mythmaking, Richard Glatzer 139
Why We Fight, Richard Barsam 149
Prelude to War, James Agee 155
It's a Wonderful Life, James Agee 157
It's a Wonderful Life and
Post-War Realism, Richard Griffith 160
Under Capracorn, Stephen Handzo 164
American Madness, William S. Pechter 177

Contributors 186
Filmography 187
Selected Bibliography 189
Illustrations, *following page 96*

INTRODUCTION

JOHN RAEBURN

In the "golden age" of American film—between the development of sound and the rise of television—Frank Capra was one of the two or three most famous directors in the world. Six times in the seven years between 1932 and 1939 his movies were nominated for the Academy Award as the best picture of the year; almost all of his films were extraordinarily successful at the box office; and beginning in 1936 with *Mr. Deeds Goes to Town* his signature was always featured in the credits *above* the title of each film, a tribute to the cash value of his name. During World War II he produced and directed a series of superlative information films for the Army which Winston Churchill praised as the most powerful "statement of our cause" he had ever encountered. Shortly after the war yet another Capra film, *It's a Wonderful Life,* was nominated for an Academy Award as the best picture of the year.

In spite of all this early public and professional recognition, however, Capra has not enjoyed the critical esteem that other directors such as Hawks, Welles, and Ford have, particularly since the late 1950s when American film was in a sense rediscovered. There are at least three reasons for this relative neglect. First, his overwhelming commercial success tended to militate against his being taken seriously. Lewis Jacobs, in *The Rise of the American Film,* articulated a widely shared assumption about Capra's work when he wrote, "his aims and interests fortunately coincide with commercial standards; so well, indeed, that his

success has obscured his weaknesses and made a virtue of sentimentality." His films, Jacobs concluded, were like O. Henry's stories, primarily of sociological interest because they were "enjoyed as pastimes by millions." Second, although he was active as a director into the 1960s, those films Capra directed after *State of the Union* in 1948 were by everyone's judgment, including his own, greatly inferior to his earlier work. His worst movies, in other words, appeared at the same time that American directors and films were being revaluated, and his reputation suffered because of this unfortunate timing. Third, and perhaps most important, the rediscovery of American movies was in large measure initiated by a group of young French filmmakers and critics who wrote for *Cahiers du Cinéma* and subscribed to the enormously influential *politique des auteurs*. These *cinéastes* created a hierarchy of American directors, a hierarchy which was then largely adopted by their American followers. The *auteur* theory, for all the argument it generated both in France and America, has more than anything else shaped our contemporary notions of American film history. Capra was not included in the front rank of directors, largely, I believe, because the experience of his best films was not fully accessible to these French critics. He was the most insistently American of all directors—that is, he was most obsessively concerned with scrutinizing American myths and American states of consciousness—and because of this particularity, his work was not as exportable as that of, say, Ford or Hitchcock or Hawks. Much of the world of a Mr. Deeds or a Mr. Smith or a John Doe was simply culturally unavailable to non-Americans.

At present there are unmistakable signs that this period of underestimating Capra's work is over. Younger critics and scholars, free from the rigid classifications adopted by the followers of the *auteur* theory during their battles of the 1960s, are reexamining his movies and finding them interesting and important. They see in his work the sure touch of a cinematic master whose films may serve as texts on such matters as camera placement, framing, pace, and editing. They have also discovered that his work is an important source for understanding the artistic and cultural history of our not-so-distant past. Historians who study American culture of the second quarter of the twentieth century may now avoid Capra's movies only at their own peril.

Nearly as important in indicating the revival in Capra's reputation is the enthusiasm for his movies among students in colleges and universities across the country. The film generation, as Stanley Kauffman has aptly dubbed the young, regards Capra as one of the very finest American directors. His films regularly appear on the programs of film societies, and Capra festivals have been held on dozens of campuses over the

past few years. At one such festival at the University of Michigan, ten Capra films were screened in eight nights, and nearly every showing was sold out long before the evening's program was to begin. When Capra himself appeared on the penultimate night of the festival, after the screening of *It's a Wonderful Life,* he was given a tumultuous standing ovation that one would have thought only Hermann Hesse could have commanded from students these days.

II

The response of contemporary students to Capra's movies is interesting for what it tells us about the students themselves, and, more to the point here, for what it can indicate to us about the nature of the films. How may we explain the extraordinary enthusiasm among the young for a filmmaker whose America is ostensibly so distant psychologically as well as temporally from their own? Why is it that films such as *Mr. Deeds Goes to Town, You Can't Take It with You,* and *Mr. Smith Goes to Washington,* all of them made a generation ago, have such an impact on young people whose coming of age coincided with the political and social upheavals of the 1960s? Capra's films share a common assumption that America is the last, best hope of mankind, the country where the fate of the common man is of the utmost consequence. The world they create is an unabashedly middle-class one, and they celebrate the characteristic institutions of that class: marriage, the family, the neighborhood, the small business. The consciousness of students has presumably been formed in part by artistic works which are skeptical of the American Dream, and in particular by such antibourgeois films as *The Graduate, Easy Rider,* and *Joe;* how is it, then, that they applaud so vigorously Capra's paeans to middle-class values?

In the first place his films are so extraordinarily professional. All of them are acted, photographed, and directed with such a sure hand that it would take an act of will to resist them. In *Mr. Smith Goes to Washington,* for example, James Stewart filibusters in the Senate against an appropriation bill which, if passed, will line the pockets of the political bosses and kill Stewart's dream of creating a fresh-air camp for the boys of America. The set of the Senate floor and galleries is so accurate—even down to the hole kicked in the side of Jefferson Davis's desk by an angry Union soldier—that it is difficult to remember that this is not the Senate chamber itself. Stewart's performance is a real *tour de force,* his beleaguered idealism finding its objective correlative in the tension between his physiological need to slump down and lean against his desk and his

will to stand upright and assert the righteousness of his cause. By masterful editing, Capra makes dynamic what is potentially a static dramatic situation. He keeps the action moving, cutting from Stewart's speech to Vice-President Harry Carey's alternately judicious and amused reactions to it, from Jean Arthur's promptings in the gallery to the outraged grumblings of Stewart's colleagues in the cloakroom. The style, the pace, and the technical élan of this scene are not untypical of Capra's best work—*American Madness, Lady for a Day, It Happened One Night, Mr. Deeds Goes to Town, Lost Horizon, You Can't Take It with You, Mr. Smith Goes to Washington, Meet John Doe,* and *It's a Wonderful Life.* Students these days have a remarkably competent grasp of the grammar of the film, and they respect the formal virtuosity that a talented director such as Capra demonstrates.

But it is not Capra's talent as much as his genius that moves students to respond in such a galvanic manner to his movies. Technical excellence is the *sine qua non* of films which survive long enough to be featured in film societies' retrospectives; students regularly see the best work of such directors as Eisenstein, Renoir, Ford, and Welles, and while they are not blasé about matters of craft, they have come to assume this kind of excellence as their due. Capra's films are attractive to young audiences because they consistently point to and exalt certain characteristics of American life which have fallen into desuetude. It is not the "message" exactly—nothing so reductive as that—but rather the pervasive attitude in all the films that American life has certain modes and traditions which have been allowed to atrophy and which ought to be revived and cultivated.

Capra's films have occasionally been accused of being animated versions of Norman Rockwell's illustrations, and, indeed, there is some truth in the charge. Capra, like Rockwell, idealizes the middle class in his art, and he shares with the illustrator a propensity for aggrandizing ideal American types—the "solid citizen" of the small town, the superficially tough but inwardly sentimental career girl, the fervent idealist, the slightly eccentric but lovable "character." On the whole, however, the comparison does an injustice to Capra. Rockwell's pictures are frequently treacly—his children have too many freckles, his townsmen radiate too much geniality and benignity, his situations are too self-consciously cute—while Capra's movies are more often than not graphic in their observations about the manipulative and calculating ways in which human beings treat one another. Neither Rockwell nor Capra has much of a sense of evil, but Capra at least has one of villainy which, if it does not exactly explore the depths of the human condition, still suggests a version of American life which is not totally jolly. For all their devotion

to middle-class life, Capra's films are saved from emotional thinness and vapid sentimentality by, on the one hand, a limited but omnipresent vein of social criticism, and, on the other, by the director's skill in animating and making credible an ideal conception of American national character.

Capra's social criticism is not profound, nor was it meant to be. Descriptive rather than prescriptive, it is concerned with what Capra defines as anomalies in a fundamentally healthy system rather than with inherent flaws in the system itself. For all its lack of political and social complexity, however, his social criticism is still remarkably pertinent, and its presence in the films is one of the reasons students find his movies so attractive. The villains of the films include a New York lawyer who for his own personal gain would sabotage a plan for the relief of the economically distressed; a financial wizard who in his ambition for wealth and power will destroy a healthy community; a political boss whose contempt for his fellow citizens is absolute, and who has no scruples about manipulating the mass media to get his way; a United States senator who was once a crusader for social justice, but has become a mouthpiece for the economic and political elite; and an unscrupulous and immensely wealthy plutocrat who hopes to wield his power in such a way as to create a quasi-fascist movement which will crush individual rights. There is a strong libertarian streak in Capra's films, a distrust of power wherever it occurs and in whomever it is invested. While there is a certain innocence in this attitude, there is also a kind of healthy skepticism about the motives and good will of the ruling elite that is all too uncommon in the popular arts. The point in Capra's films is that the "little people"—namely the middle class—if they are vigilant and support one another, can thwart the insidious designs of the rich and powerful and preserve the basic integrity of their political and social institutions. (Capra has recently said, quite accurately, that Ralph Nader is a contemporary analogue of his cinematic heroes.)

It is Capra's critique of American materialism, however, which students find most attractive in his films. His heroes are uninterested in wealth (and power, its corollary, at least in America), and if they happen to be the beneficiaries of it, their response is one of nearly total discomfiture. Longfellow Deeds gives away much of the fortune he has inherited from a wealthy uncle; his scheme to finance the purchase of small, self-sufficient farms for the impoverished would have met the approval of Thomas Jefferson, one of the heroes in Capra's pantheon. The Vanderhof family in *You Can't Take It with You* not only resists the blandishments of easy money, but also proselytizes among the moneyed heathen for converts to its brand of exuberant antimaterialism. For Jefferson Smith, the boys camp on Willow Creek is infinitely more

important than the financial windfall that Boss Jim Taylor and Senator Paine (and Smith himself, if he wanted to be included) would reap if Willow Creek became a pork-barrel dam project. And the lesson that George Bailey learns in *It's a Wonderful Life* is that money is not the measure of wealth: family, friendship, and community are.

There is, of course, nothing unusual about antimaterialism, but what is unusual is to find it coupled with such a vigorous defense of middle-class life. Most often we find it in the hortatory literature of the counter culture and in the works of such artists as Jean-Luc Godard, Michelangelo Antonioni, and, in a different medium, Kurt Vonnegut. While no one would deny that homage is paid by students to these artists, neither would one deny that most students quite accurately recognize that they will soon be members of the middle class caricatured in *Weekend, Zabriske Point,* and *Cat's Cradle.* What Capra's films provide young people, and this I believe is at the heart of their attraction, is a way of looking at middle-class life which does not make it seem banal, sterile, and purposeless, and which invests it with vitality and style.

Besides materialism, the charges most often made against the middle class are that it is conformist, bland, and insular. In Capra's films it is none of these things. Instead, its representatives, Longfellow Deeds, Jefferson Smith, et al., are characterized by a vigorous (but not rugged) individualism, a zest for experience, and a keen sense of political and social justice. Most important, they stoutly resist every effort made by nominally more powerful members of the society and by the centripetal forces of the mass society itself to reduce them to an indistinguishable unit in a homogeneous mass, and they again and again assert the uniqueness and the importance of their own experience.

As strange as the hybrid may seem, Capra in his better films fashioned his heroes by crossing Jefferson's independent yeoman with a grown-up version of Mark Twain's Tom Sawyer. The yeoman no longer works his self-sufficient farm—he has moved to the adjacent small town or city—but he retains all his intrepid individualism and all his distrust of vested power. He is not interested in getting rich; he only wants money enough so that he will not be beholden to any man and can live in comfort and dignity. Because he is not consumed by the desire for wealth and power he has sufficient time and energy to savor life and to discover what is truly important to him. And because the independent yeoman is by definition a good citizen, he works to make his community a decent and democratic place in which to live. Just as the independent yeoman is our most venerable political myth, so is Tom Sawyer (along with Huck Finn) our most important literary one. Capra's heroes all share Tom Sawyer's quixotic temperament, youthful innocence, and

irrepressible enthusiasm. If they lack his bookishness, they still retain his boyish sense of adventure and especially his playfully unrespectful attitude toward established authority. But unlike Huck Finn, neither Tom Sawyer nor Capra's heroes have any intention of dropping out of society and lighting out for a more uncivilized sphere—they are social beings who need the community as much as it needs them. Capra's heroes, in short, are ideal types, created in the image of powerful national myths. If they are solidly middle-class, they nevertheless retain the power to convince us that the American national character still has within it the capacity for creating a life of spontaneity, independence, and dignity. Little wonder, then, that young people find Capra's films so compelling.

III

This volume has a three-fold purpose: to provide a brief biographical perspective on Capra's work; to gather together the best that in the past has been written about his films; and to present a number of fresh interpretations of his movies. The individual pieces collected here represent a variety of approaches and viewpoints and can speak for themselves. There is a great deal remaining to be done, however, not only with Capra's movies, but also with those of virtually every important American director.

American film criticism (as distinguished from reviewing) is in its infancy. The movies themselves are now about seventy-five years old, but except for the work of a few pioneers like Lewis Jacobs, the serious study of American films and filmmakers is of quite recent vintage. There are available a number of remarkable studies of American film, but what is most striking is that the quantity of truly useful work does not seem commensurate to all the energy going into film studies these days. The problem is that film scholars are not quite certain what they ought to be doing or how they ought to go about it. They lack a general consensus about method.

I do not wish to propose that we develop a monolithic theory and all conform to it; that would surely be even more inhibiting than our present situation. My proposal is much more modest, and is based in part upon an analogy with the history of literary criticism. When the New Criticism began to take hold in literary studies during the 1940s, it had a dramatic and extremely beneficial effect on the state of knowledge about literature. Because it emphasized the close and intensive analysis of a text, it demanded from the scholar an intimate and imaginative engagement with the actual created work itself. He had to master the form of

the text before he could begin to draft any statement about its meaning, and because his attention was so riveted on the art itself, at least initially, he often discovered previously undetected patterns and details which altered significantly his understanding of the work. This revolution in literary criticism rendered obsolete the sloppy sociological, historical, and biographical generalizations and impressionistic maunderings which often passed for criticism in earlier years. Even those who did not accept all the axioms of the New Criticism learned to read in a more exact and penetrating way, and their writing about, say, the cultural significance of a work of art improved immeasurably.

With appropriate modifications for a different artistic medium, there is no reason why the same general principles that the New Criticism brought to literary study cannot be applied to film study. What we need most immediately is a body of careful and intensive examinations of individual films, examinations which first rigorously analyze the subtle interrelationships between form and content, and only then go on to generalize about the cultural, social, and historical meanings of the film. With these individual studies as supports, we can proceed to discover and evaluate precisely what it is that makes a director's work coherent, or how a particular artist moved the art of the film forward, or why one genre movie works and another fails. With this kind of careful study as a basis, the possibilities for rewarding future work are immense.

Fortunately, there is a superb model for this kind of criticism: John G. Cawelti's long essay entitled, "The Artistic Power of *Bonnie and Clyde*," collected in the volume *Focus on Bonnie and Clyde*, edited by Cawelti. No brief paraphrase could possibly convey the richness and subtlety of this essay. It combines formal, historical, and cultural criticism, and does so in such a lucid way as to make every other interpretation of the film seem pedestrian by contrast. It ought to be required reading for every student and certainly every critic of the movies.

What has this to do with Frank Capra? Simply this: because his films lend themselves so readily to thematic and historical analysis, most of them have not had this kind of close, almost frame-by-frame analysis. Like countless other films, they are, in a sense, still unknown to us, waiting for someone with a sharp eye, an acute ear, and a sure grasp of social and cultural context to illuminate them.

THE MAN

THINKER IN HOLLYWOOD

GEOFFREY T. HELLMAN

Frank Capra, whose recent picture, *Mr. Smith Goes to Washington,* was widely acclaimed as first-rate entertainment as well as a rousing bit of Americanism, is considered the surest director in Hollywood. For the past several years the unfailing success of Capra-directed pictures constituted the chief asset of Columbia Pictures Corporation, the company producing them, and put Capra well up in the six-figure income brackets. Nevertheless, Capra is, professionally at least, a firm detractor of the rich and powerful and a consistent champion of people in the lower income groups. In his last five or six pictures he has almost invariably depicted the poor and humble as upright, lovable characters and their masters as unprincipled and surprisingly inefficient fellows who either turn over a new leaf in the last reel or else get what is obviously coming to them.

On the rare occasions when a well-to-do Capra character betrays a kindly nature, he is likely to be a person of questionable social position who is pitting his powers, on behalf of some admirable pauper, against those of a society man of even greater means than himself. Thus, in *Lady for a Day,* a 1933 Capra success, the director permitted a number of solvent gamblers and racketeers to help Apple Annie, a lady apple-peddler, pull the wool over the eyes of a family of Spanish nobles into

From *The New Yorker* 16 (February 24, 1940): 23—28. Reprinted by permission; © 1940, 1968 The New Yorker Magazine, Inc.

which her daughter, who believed herself to be an heiress, was about to marry. Assisted by the Mayor of New York and the Governor of the state, the racketeers surround Annie with the appurtenances of wealth and position during the visit of the well-born Spaniards, who depart in the idiotic conviction that their son has made a suitable match. In *It Happened One Night,* an unemployed newspaperman, forced by circumstance to spend two nights in the same room with a girl who is to inherit $20,000,000, wins the rich girl away from her playboy husband by a course of conduct so gentlemanly as to be provocative. Capra doesn't permit himself the luxury of chivalry when portraying his class enemies, and he sees to it that his impoverished hero is on a higher moral plane than his moneyed heroine. "Peter," runs a Columbia release describing one of this couple's *nuits blanches,* "realizing Ellie is married, ignores her sly advances." Capra's contempt for $20,000,000 was also forcibly expressed in *Mr. Deeds Goes to Town,* whose homespun hero finds that the inheritance of this sum brings him nothing but woe. Capra showed up the vanity of wealth again in *Lost Horizon,* in which one of the major characters, wanted by the law for a gigantic stock swindle, forgets all about money in the superior joys of fixing up a modern plumbing system for Shangri-La.

Capra himself forgot all about money while shooting *Lost Horizon* and took twenty-six reels, which were whittled down to twelve before the picture was released in the spring of 1937. According to a suit later filed by Capra, Columbia Pictures, headed by Harry Cohn, a man with absolutely no contempt for money, withheld some of Capra's salary that year, possibly because it felt that the director had spent too much time and too much money on *Lost Horizon.* (Capra had used up two years and $2,000,000.) Furthermore, Capra charged that the company had showed it still appreciated the value of his name by selling to English exhibitors as a genuine Capra a Columbia picture called *If You Could Only Cook,* which Capra had not directed. The cachet of Capra's name is such that exhibitors will buy Capras on faith. What had disturbed Capra as much as anything else was that English friends had told him they didn't think *If You Could Only Cook* was quite up to his standard. The suit was settled out of court to Capra's satisfaction, and he says that he bears no ill will toward Columbia today.

Negotiations between the Cohn and Capra lawyers occupied a good part of 1937, and during this period Capra took a vacation. He went to Europe for several months. In Russia, the point of view he had displayed in *Mr. Deeds* caused him to be well received by Soviet officials, who felt that a man who appreciated the unhappiness which a $20,000,000

inheritance brings in its wake must be some sort of spiritual fellow-traveller.

Two pictures made by Capra since his unpleasant experience with the world of business show that his ideals were not impaired. In *Mr. Smith,* the guileless and hayseedy hero bravely circumvents the machinations of a malefactor of great wealth and outwits his political minions. It is probable, however, that Capra most clearly reveals himself as a social thinker in the film which immediately preceded this, the cinema version of the Kaufman-Hart play *You Can't Take It with You.* Realizing that Messrs. Kaufman and Hart had somehow overlooked the true implications of their major characters, Capra, a director who has a hand in the script as well as the actual filming, changed Grandpa Vanderhof from a whimsical old madcap to a serious denouncer of those who prefer gold to friends, and the minor and inoffensive Mr. Kirby, who had been a rich boy's father, to a sinister munitions man who causes at least one suicide.

Although Capra's primary purpose is to entertain, he is genuinely concerned with the moral impact of his films. "It sounds sappy," he said recently, "but the underlying idea of my movies is actually the Sermon on the Mount—a plus value of some kind along with entertainment. I think if you read the Sermon on the Mount to anyone a little removed from an ape they would warm up to it." Capra realizes that the Sermon can be overdone, however, and whenever sweetness and light in his sequences seem to approach the saturation point, he contrives to have a fat man get wedged in a telephone booth or the hero stumble over a succession of ashcans in order to give the public a laugh with which to wash the pill down.

Capra is an old Mack Sennett gag man and comic touches come easy to him. The fact that a certain amount of horseplay is necessary to induce audiences to sit through films that are essentially improving has not made him in the least cynical about the public. "I have a definite feeling that the people are right," he says. "People's instincts are good, never bad. They're right as the soil, right as the clouds, right as rain." Capra is so sure that people's reactions are right that when he makes a picture he usually shoots several endings, which he tries out at sneak previews around Los Angeles before the picture is released, and he always uses the ending which goes over best with the audience. The various audiences are given questionnaire cards on which they can record how well they like the particular ending they see. He follows the public's verdict even when it runs counter to his own opinion. In *Mr. Smith,* for example, the ending which Capra liked most showed the destruction of the political machine opposing Mr. Smith. The audience on which this

was tried out failed to react as favorably as the one which saw a noncommittal conclusion leaving the fate of the political boss in doubt. Capra settled on the latter version.

Capra's feeling that the meek will inherit the earth from the rich, or possibly wrench it away from them, is not confined to his pictures, and it often crops up in his conversation. When he airs his social and economic theories, and he does this during most of his spare time, his face lights up, his handsome black eyes sparkle, and he looks like an unusually animated freshman at a college bull session. He likes to tell his friends that money is the curse of Hollywood and that trade and profit are ruining the world. His friends nod at these remarks and tell each other that Frank is the most thoughtful man in the industry, which he probably is. The war has caused Capra to think more than ever about the part which the lowly might well play in bringing the powerful to their senses and in putting things to rights. "I've always had a dream for a picture," he told his dinner companions at a restaurant a few weeks ago. "I once had Mussolini in mind, or the Prince of Wales. He goes down to a bordello, and there a little trollop like Mary Magdalen tells him, while in her arms, to throw away your guns, throw every goddam cannon in the ocean, open up your borders." Capra looked around the table dreamily. "Mussolini's too far gone now," he said, "and I'm afraid Hitler wouldn't do."

Capra's disappointment in Mussolini is especially sincere since he is an Italian himself, born at Palermo, in Sicily, forty-two years ago. When he was three his parents took him to California, where his father became a fruit picker. The family, in which there were seven children, was extremely poor, and when Frank was six he and his brother Tony began to help out the Capra finances by selling papers in Los Angeles after school. To the distress of his parents, Frank developed a great urge to pursue his education beyond high school. He decided to become a chemical engineer and in 1915 entered the California Institute of Technology. He financed such expenses as his entrance fees by playing the banjo in Los Angeles cabarets while he was still at school, and then worked his way through college by waiting on tables, running the student laundry, editing the undergraduate paper, and, from three until seven every morning, wiping engines in the municipal power plant at Pasadena for twenty-five cents an hour. He not only paid his way but was soon giving his mother a handsome allowance. Mrs. Capra accepted this gratefully, though she told Frank that except for his extracurricular financial activities he was, in her opinion, wasting his time. Capra today disagrees with this sharply. In an autobiographical sketch, written in the third person, which he produced for Columbia's files in 1929, he says of Cal

Tech's influence on him, "He changed his whole viewpoint on life, from the viewpoint of an alley rat to the viewpoint of a cultured person." He paid a further tribute to his education by writing, of a later and difficult period of his life, "His former teachings and life's lessons stood him in good stead and he did not become discouraged." Capra's dynamic qualities amazed his classmates, and one of them wrote in the class prophecy, a year after the United States entered the last war, "Frank Capra, having offered his services to the U.S. Army as a general and having been refused, in a huff has offered his services to Mack Sennett as a Keystone Cop and has been accepted." Capra never actually made an attempt to become a Keystone Cop, but he did write gags for Sennett, which he thinks was close enough.

After graduating from Cal Tech in the spring of 1918, Capra enlisted in the Army. He taught mathematics to artillerymen at Fort Scott, San Francisco. His father died in 1919, and after the war Frank went home to live with his mother. It was a bad time for chemical engineers and he was unable to find work. His two brothers and his four sisters, all of whom had jobs or were married to high-school graduates who had jobs, sneered at the unemployed college dude in their midst. Capra got in a low state of mind, and this was aggravated, around 1920, by terrible pains he felt in his abdomen. His mother, who could not afford to call in a doctor, covered his stomach with cold compresses. Capra stayed in bed two months and it was a year before he felt well enough to walk around. He continued to feel pains for years after, and in 1934, when he had made a few hundred thousand dollars and felt he could afford a doctor, he had himself examined and was operated on for chronic appendicitis. Capra regards this operation as a good joke on himself. "It turned out I didn't need it at all," he explains, "since I had no appendix. My appendix had burst twenty years before and all I had were the shreds of a burst appendix." Capra's physician attributes his survival to the fact that Sicilians, conditioned by generations of knifings, have very hardy interiors.

Capra's indisposition failed to shut his family up for very long. Soon after he got out of bed their taunts at his inability to find work made him leave home. For several years he lived in flophouses in San Francisco or else wandered about the West doing odd jobs and playing poker with similar footloose characters. Around 1922 he became a salesman of Elbert Hubbard books. Armed with fourteen-volume de-luxe editions of the sage of East Aurora's *Little Journeys,* he disposed of them at $120 apiece to culture-hungry people in the West. Each set gave him a $30 profit and he averaged around $20 a week. The edition had been published after Hubbard's death as a memorial, and to sell them in a

dignified way Capra posed as a worker in Hubbard's East Aurora work-shop who was permitted to peddle the sets as a special privilege. "I told 'em I'd been taken in by Hubbard at the age of seven and had worked there ever since," he says. When he is selling something, Capra has a reverent air, and his story was challenged only once—by an archbishop who bought a set anyway.

Capra was deflected from his bookish calling in 1924. Resting up between business trips at a San Francisco flophouse one evening, he read a newspaper item which stated that someone was starting a movie studio there. Although, as a man who sold $120 sets of books, he was rather contemptuous of the cinema, he decided to look into this. He called on the San Francisco pioneer, an old Shakespearean actor named Walter Montague, who had taken over an abandoned gymnasium for a studio. "I'm from Hollywood," said Capra. This caused Montague to explain his project, which was to picturize poems, beginning with a ballad of waterfront life by Kipling, "Fultah Fisher's Boarding House." Capra showed such a lively and apparently professional interest in Montague's plans that the old man, congratulating himself on the rare luck that had sent a man with Hollywood experience his way, commissioned him to take entire charge of the film for $75 all told. Capra persuaded a Los Angeles cameraman he knew to come to San Francisco, and he himself attended several movies in order to familiarize himself with his new profession. Today Capra won't direct a picture unless the cast includes some big boxoffice names—he held up production on *Mr. Deeds* for six months, at a cost of approximately $100,000, in order to get Gary Cooper—but in making *Fultah Fisher's Boarding House,* he went out of his way to get a cast of people who had never faced a camera before. "I didn't want real actors, who might show me up," he says. "I got a cast of amateurs—bellhops and so on." While Mr. Montague deferentially hovered about, Capra and the cameraman made the picture, a one-reeler, in two days. It cost $1,700 to make and was bought by Pathé for $3,500. It played the New York Strand, a first-run house, for two weeks along with a Harold Lloyd comedy. Capra has a print of it in his house in Brent-wood, a suburb of Los Angeles, and occasionally runs it off for friends. "It's a very melodramatic thing," he says. "Not bad at all."

Pathé signed Montague up for some more picturized poems, but the old man's success had turned his head and he decided that instead of using the work of established writers like Kipling, he would compose his own poems. This caused Capra to quit, a step which seemed justified by the failure of subsequent Montague productions, but he resolved to continue in his new profession. After a few months as property man with a small film company in San Francisco, he went to Hollywood as a gag

man for Hal Roach's *Our Gang* comedies. Six months later he joined Mack Sennett in a similar capacity and soon was writing gags for Harry Langdon, the comedian. In 1926, when Langdon left Sennett to do feature pictures for First National, he took Capra with him as his writer and director. Capra directed Langdon in *The Strong Man, Tramp, Tramp, Tramp,* and *Long Pants,* endowing him with the character of a man of superhuman emotions and no brains at all. Langdon's stock went up enormously, but he failed to appreciate the important part Capra had played in his success. After *Long Pants* he fired Capra and tried to direct himself. His pictures were unsuccessful and today he is a gag man for Hal Roach. After breaking with Langdon, Capra directed a picture in New York called *Love o' Mike,* which was notable not only for losing nearly a hundred per cent of the money invested in it but for driving Claudette Colbert, its heroine, back to the stage. Miss Colbert was toying with the idea of going wholeheartedly into the movies, but after *Love o' Mike* it was two years before she could be persuaded to try another picture.

After this failure, Capra went back to Sennett as a gag man at $75 a week. He soon received a call from Columbia Pictures, which in 1927 was a rather unsuccessful minor studio. According to a number of Hollywood authorities, Capra's connection with Columbia came about as a result of his name's beginning with the third letter of the alphabet. Harry Cohn, Columbia's president, was looking, they say, for an inexpensive director and, in thumbing through a list of available men, came across Capra's name fairly near the top. He got in touch with Capra. Capra went to see Sam Briskin, Columbia's general manager, who told him the company was considering him as a director. "Your last picture wasn't so good," said Briskin, with the bluntness of an employer about to offer a prospective worker a modest salary. Capra is a small man, friendly in manner and soft-spoken, but he does not care to be criticized in a non-specific way. "What was my last picture?" he asked. Briskin scratched his head and Capra walked out of the office. It took several weeks' polite negotiation by Briskin to get him back again and to sign him up. Capra's first assignment was *That Certain Thing,* a comedy about box lunches. Planned as a small program picture, this turned out so well that it was released as a special. Capra was twelve weeks making it and he was paid $1,000 for it. He did four or five more pictures for Columbia at $1,500 each.

In 1928, President Cohn became dissatisfied with the way *Submarine,* a picture about submarines, was shaping up. He turned it over to Capra, who changed it from a straight melodrama to comedy and injected the down-to-earth quality which has now come to be called the Capra touch. The first day he went to work on the *Submarine* set, Capra

gazed scornfully at the trim sailor suits Jack Holt and Ralph Graves, the picture's chief players, were wearing. "I expect you boys to break into song any minute," he said. Capra forced Holt and Graves to put on unpressed suits, to remove all their makeup, and to chew gum. He was a pioneer in getting male actors to chew gum and play without makeup. His forte is realism, and while the absence of makeup on actors makes things harder for his cameramen, since every skin reflects light differently, Capra generally insists on it. He has no patience with trick shots, preferring that audiences should be unconscious of the photography and concentrate simply on the action of the characters.

Submarine, produced with sound effects and a few snatches of dialogue, was Capra's first picture to have sound. Its success brought Capra a $25,000-a-year contract with Columbia, and it was followed in 1929 by Capra's first real talkie, *The Younger Generation.* In that same year Capra directed and wrote the script for *Flight,* another Holt-Graves Service affair. He began to think of himself as a writer as well as a director and submitted to Cohn another script for a picture to be called *Ladies of the Evening.* Cohn was delighted with it. He sent copies to his staff writers and asked them for their opinions at a conference held just before production was to start. One man after another proclaimed the script admirable in every way, while Capra, sitting next to Cohn, beamed. Finally Jo Swerling, a New York newspaperman who was in Hollywood on a six weeks' contract with Columbia and had never met Capra, read fifty specific notes he had prepared on the script, tending to indicate that it was preposterous and an insult to show business. "My throat was constricted, I was so angry with the hallelujah chorus," says Swerling, whose throat still tightens up when he recalls the incident. "I noticed a dark little guy I thought was Cohn's secretary staring at me murderously as I read my report." Cohn introduced Swerling to Capra after the meeting, and Capra insisted that his detractor be retained as his collaborator.

Ladies of the Evening, rewritten by Swerling, was filmed as *Ladies of Leisure.* It made a star of Barbara Stanwyck, who had been practically unknown on the screen. A couple of years later another Capra production, *Platinum Blonde,* made the late Jean Harlow a star, and Capra's reputation as a maker of stars was furthered when he made *Lady for a Day,* which established May Robson as a top movie actress. *It Happened One Night* didn't precisely make Clark Gable a star, but it did change him from a heavy lead, in which capacity he was slipping at the box office, into a highly popular light comedian. Capra gets his actors to perform naturally, without mannerisms, and to speak their lines in low-conversational tones. During a scene of *It Happened One Night,* Claudette Colbert talked too loudly to suit him. "Please do it over again so I can't hear

what you're saying to Mr. Gable," he said. "What?" shouted Miss Colbert. "You're used to playing to the last row of a theatre gallery and you're playing it too loud," whispered Capra. Miss Colbert refused at first, but Capra won her over by promising to use whatever version of the scene she chose from the rushes, which were to be run off the next day. She picked the sequence which was done according to Capra's instructions.

In 1933 the Capra-Swerling combination was succeeded by a collaboration between Capra and Robert Riskin. The two soon became the most generally admired writer-director team in Hollywood. Between 1933 and 1938 they turned out *Lady for a Day, It Happened One Night, Broadway Bill, Mr. Deeds, You Can't Take It with You,* and *Lost Horizon.* The spectacle of Capra and Riskin receiving statues, medals, etc., at the annual dinner of the Academy of Motion Picture Arts and Sciences has been a familiar one in Los Angeles for some years. To keep their relationship from becoming stereotyped, the two men frequently resorted to calling each other names which reflected on their racial origins and to playing practical jokes on each other. On one occasion Capra called at Riskin's apartment, where he had often been before. He rang the bell several times and got no response. Finding the door unlocked, he walked in. The apartment was pitch black. Capra concluded that all this was a buildup for one of Riskin's practical jokes and he decided to launch a counterattack. He cupped his hands about his mouth and emitted a fearful Sicilian yell. When no one replied, Capra began to feel his way around the apartment, continuing to yell in order to flush Riskin. Suddenly he heard people rushing to the door, the lights were turned on, and he saw the building superintendent and several porters and neighbors staring at him in horror. It turned out that Riskin had moved to another apartment in the same building and had neglected to tell him. Capra was delighted with the joke he had played on himself. "When he finally got to my place," Riskin reports, "he was so convulsed with laughter at himself that it was hours before he became coherent again."

Riskin left Columbia in 1938, and Capra's writer for *Mr. Smith* was Sidney Buchman. At the completion of this film last fall, Capra's contract with Columbia was fulfilled. He declined to renew it and he has now set himself up as an independent producer-director, with Riskin as his partner, under the firm name of Frank Capra Productions, Inc. Capra will get sixty-five per cent of the profits and Riskin thirty-five per cent. Warner Brothers will distribute their first production, *The Life and Death of John Doe,* a picture about an information clerk who is almost driven to suicide by the oppressiveness of the modern social structure and one which, in standard Capra fashion, dwells on the iniquity of the rich.

Capra has been making around $200,000 a year working for Columbia. If his future pictures do as well as his last few, he will probably make considerably more than that, in addition to having the pleasure of selecting his own themes and taking as long as he wants on a picture.

Capra thinks that writers and directors should produce their own pictures as he and Riskin will do and that many old-line producers, who technically outrank directors in the making of a picture, are not creative and constitute just so much unnecessary overhead. He has frequently displayed a rather informal attitude toward producers, of whom most Hollywood workers stand in awe. At the Academy dinner in 1938, when various medals and honorific objets d'art were awarded to those involved in Warner Brothers' *Zola,* the master of ceremonies, following a plethora of stuffed-shirt speeches by the heroes of the evening, besought the boys to loosen up and speak as though they were talking to their wives. Jack Warner, quick to take a hint, got up and said, "Well, from now on all awards will be won by Warner." "It sounds as though Mr. Warner was talking to his wife all right," said Capra, who had just arranged to borrow a certain actress from Warner for *You Can't Take It with You.* The loan was cancelled the next morning.

Last winter Capra used his position as president of the Academy to turn the heat on Joe Schenck, chairman of the board of Twentieth Century-Fox and president of the Association of Motion Picture Producers. Capra, who, like Schenck, prefers to head organizations of which he is a member, is president of the Screen Directors Guild, which was then dickering for a contract with the producers. The directors' group had for several weeks made vain efforts to gain the ear of Mr. Schenck, President C. going so far as to pursue President S. to the Santa Anita race track in the hope of getting recognition for his union. Schenck finally retreated to Palm Springs a few weeks before the annual Academy dinner. Capra, whose *You Can't Take It with You* was scheduled to receive both direction and production awards at the dinner, wired Schenck that unless he took some action on the contract, which had been submitted to him, Capra would not only boycott the Academy dinner himself but would see to it that no actors, directors, or writers attended. The Academy dinner is Hollywood's major annual prestige occasion, and Schenck capitulated. As a result the present agreement between directors and producers was signed, giving the directors a closed shop, setting the minimum weekly salary for an assistant director at $135, restricting the degree to which a producer may edit his director's films, and so on.

Although Capra can behave like a fighting cock when he suspects that an organization of which he is president is being slighted, he is quiet

and unassuming in private life. In 1923 he married Helen Howell, a vaudeville and screen actress who was born in Chicago and educated in Los Angeles. He was divorced in 1928 and four years later married Lucille Reyburn Warner, a Los Angeles girl who was divorced from her first husband. The Capras have two children, Frank, Jr., who is five, and Lucille, who is two. Another son died in infancy. In addition to his Brentwood house, Capra has a summer cottage at Malibu Beach and a forty-acre citrus ranch near San Diego. The Brentwood place includes several acres which Capra has covered with fruit trees as a sort of memorial to his father. "My father was a magician as a horticulturist," he says. "He had oranges and lemons and grapefruit all growing on the same tree, and red and white roses on one bush." Capra, who, dressed in overalls and with grimy hands may often be found spraying arsenic on his orchard, has contrived to raise grapefruit and lemons on the same tree and thinks oranges may join them any day.

Capra likes to excel at everything he does. His current enthusiasm is ping-pong; he has taken lessons and is one of the most expert players in Brentwood. He is also an accomplished musician, given to singing Italian songs in an excellent tenor and to strumming on the guitar. He fancies himself as a composer and often treats dinner guests to improvisations on the piano which sound to them suspiciously like something by Chopin. He likes to fish and hunt, and to climb mountains. Although Capra much prefers to be the first man up any given mountain, his sense of competition, when it comes to making movies, is tempered by a vast regard he feels for the industry as a whole. He does not hesitate to give public credit to other directors whose work he admires, and a few months ago, when he came East for the Manhattan opening of *Mr. Smith,* he referred flatteringly to Alfred Hitchcock in an interview with a reporter from the *Post.* He is quick to justify the movies to people whom he suspects of being captious about them, and recently said of a reviewer in whom he detected an iconoclastic attitude toward this medium, "A man who so dismisses motion pictures is criticizing the greatest art form ever discovered." Capra believes in the mass approach and he thinks a picture that has a limited appeal is bound to be a poor one. The most exciting moments of his life have been spent in movie theatres watching people look at films directed by himself. "I never cease to thrill at an audience seeing a picture," he said the other day, his eyes sparkling and his lips parted. "For two hours you've got 'em. Hitler can't keep 'em that long. You eventually reach even more people than Roosevelt does on the radio. Imagine what Shakespeare would have given for an audience like that!"

DIRECTORS WITHOUT POWER

FRANK CAPRA

To the Screen Editor:

I read your column in Sunday's *Times* (March 19) regarding us poor, benighted directors. You paint a marvelous picture of the power and importance of the director in the making of pictures, but unfortunately and regrettably that is not exactly the case. You should hear some of the arguments and conferences we have had in the Directors Guild regarding these same matters and your opinion of the director's power would be shattered completely.

First of all, there are only half a dozen directors in Hollywood who are allowed to shoot as they please and who have any supervision over their editing.

We all agree with you when you say that motion pictures are the director's medium. That is exactly what it is, or should be. We have tried for three years to establish a Directors Guild, and the only demands we have made on the producers as a Guild were to have two weeks' preparation time for "A" pictures, one week preparation time for "B" pictures and to have supervision of just the first rough cut of the picture.

You would think that in any medium that was the director's

From the *New York Times* (April 2, 1939), x, 4. © 1939 by The New York Times Company. Reprinted by permission.

14

medium the director would naturally be conceded these two very minor points. We have only asked that the director be allowed to read the script he is going to do and to assemble the film in its first rough form for presentation to the head of the studio. It has taken three years of constant battling to achieve any part of this.

We are now in the process of closing a deal between director and producer which allows us the minimum of preparation time but still does not give us the right to assemble our pictures in rough form, but merely to assemble our sequences as the picture goes along. This is to be done in our own time, meaning, of course, nights and Sundays, and no say whatever in the final process of editing.

I would say that 80 per cent of the directors today shoot scenes exactly as they are told to shoot them without any changes whatsoever, and that 90 per cent of them have no voice in the story or in the editing. Truly a sad situation for a medium that is supposed to be a director's medium.

All of us realize this situation and some of us are trying to do something about it by insisting upon producer-director set-ups, but we don't get any too much encouragement along this line. Our only hope is that the success of these producer-director set-ups will give others the guts to insist upon doing likewise. I believe the blame is as much the director's as it is due to the mass-production system, because directors are prone to sit back and enjoy their fat salaries and forget the responsibilities they have toward the medium they are in.

So please excuse this letter, which doesn't seem to make any too much sense, but the director at present has no power, and pictures today are not truly a director's medium. About six producers today pass upon 90 per cent of the scripts, and cut and edit 90 per cent of the pictures.

Frank Capra

Hollywood, Calif.
March 23, 1939

FRANK CAPRA: "ONE MAN—ONE FILM"

THE AMERICAN FILM INSTITUTE

Multiple Cameras

Joseph R. Silke: Can you describe your use of multiple cameras?

Frank Capra: I used multiple cameras almost from the beginning. When sound pictures came, we had to use multiple cameras because of those great big booths the cameras were in. Really had to make a little play out of every scene, a small act out of every scene, which took three or four cameras. The photography was very bad, everything was very bad about it, but we had to get it all on one sound track. We had to use one sound track for three or four angles.

 We hadn't learned to intercut sound track as easily as we can now. So we had to get three or four angles on one sound track, perforce we had to use three cameras on every important scene: one to take a medium shot, a close-up this way and a close-up that way, that was the usual set-up. It was almost dictated by the fact we used these great big booths and they were so big they couldn't be maneuvered. You set one, two, three and put the actors in front and let them work to the cameras. But when we got the cameras out of the booths, with freedom again, we

From *Frank Capra: "One Man—One Film,"* Discussion no. 3 (Washington: The American Film Institute, 1971), 5–6, 9, 16–17, 20–23. Copyright © The American Film Institute, Inc. 1971. Reprinted by permission.

went back to mobility. The three camera set-up stayed with me because I couldn't match, I had a difficulty matching close-ups to medium shots; getting the action and the sound to match, getting the actors in the same mood. I thought: "Isn't this crazy," that we have to take one shot, then take it over again in close-up and then take it over again in another close-up, then you put them together and the voices would jump, the moods change. Perhaps you did them an hour apart; perhaps a day apart. The actors had something to eat for lunch and they never can do the same scene twice. That was a difficulty.

I used multiple cameras so that I wouldn't have this jump in tempo, jump in voice when intercutting between close-ups and medium shots. Also I used multiple cameras because early I used an actress by the name of Barbara Stanwyck who had had no experience whatever in films, some in theater, a very young woman, very silent, very somber woman. Fires were bursting out of her, but they burned too fast. I found out that she left her best scene the first time she did it, even in rehearsal. It was just wonderful, but then she could never reproduce that scene again. The more you did it, the farther she got from it; she just left it, she was just drained. She gave it all in that one scene. This was a very amazing thing, I had never run across it. Most people get better in rehearsal; she got worse. She had been rehearsing mentally and she threw it all out at once. Therefore, I had to use multiple cameras on her because I'd never get the same scene again if I used different shots, different set-ups. That caused me to use multiple cameras.

Editing

Bruce Henstell: How closely did you work with your film editor? Was he given an editing script to work from or would you actually be in the cutting room with him?

Capra: I'd be in the cutting room with him. They couldn't get rid of me no matter what.

Henstell: Did much of your films develop in the cutting room?

Capra: Yes. I remember once, in the shooting of *The State of the Union,* there's a place there where an actor jumps out of a plane. It was a kind of big, fast-acting piece of melodrama going on. We put it together one way and we thought it was great. Hornbeck was the editor. Then we took it apart and tried it another way and we could never get it back the

way we had it at the beginning. After that experience we took the first editing that we did and made a dupe of it fast so we could always go back to it. We had forgotten how the heck we did it. This shows you how important editing is because that scene changed, it was never as good as it had been because mechanically it was not edited as well as it had been.

Silke: Could you restructure a whole scene in editing it?

Capra: Yes, I overshot purposefully so as to have some leeway. His dad (turning to Stevens) was the master of shooting for cutting. George Stevens made all his pictures in the cutting room; he had enough film.
 A fellow like Jack Ford was never interested in editing a film, so he would shoot it so that it could be edited in only one way. He had no leeway. I allowed enough leeway so that we could maneuver with the film. That's why I say that in the cutting room a great deal of creation goes on.

The Reactive Character

Silke: There are scenes that you play with absolutely no movement and with the performers' backs to the camera, where you don't let us see anything. Do you save those for a particular moment?

Capra: Well, when it might be embarrassing to the character.

Silke: You play the motel scene in *It Happened One Night* between the two in almost total darkness.

Capra: Yes. Love scenes are murder, love scenes are tough. That's where they giggle at the wrong places, when you try to play a love scene. So, generally, I have a reactive character. This is an interesting thing about comedy; you can have a character who represents the audience. He sees what's going on and is amazed by it, moved by it, stunned by it and he reacts. That way you trigger the laugh. You control the audience by asking for the laugh with a reactive character. Then they're not laughing at scenes where you don't want them to. For instance, I could take one of these nude films today, one of these sexy nude films where they roll around in the bed and bite each other and kick each other, and I could make it very funny just by having a reactive character watch. It would make a very funny piece of business. It would destroy completely what the film tries to do. The use of the reactive character in comedy is very important. If you think they're going to laugh, or there is a chance

they'll laugh, stick in a character actor there, he bats his eyes, and you get the laugh.

Silke: In the Senate scene of *Mr. Smith* you used the press that way. They guide the whole scene, watch the flow of the drama; is he winning, is he losing . . .

Capra: They are one with the audience; the Greek chorus.

The Capra Hero

Steve Mamber: Your interest in common man, figures such as Smith and Deeds, and your concern with small-town life; do you think that came out of finding stories that people would be interested in or was there something about America you were trying to say?

Capra: There was my own youth, things that were involved with that, there was the fact that I had always been a rebel, against conformity; for the individual, against mass conformity. That means mass conformity of any kind. I see mass conformity happening again today, and I just don't like it. I don't like to see these youths conform so to each other. I'd rather see some individuals. That was the common man idea, I didn't think he was common, I thought he was a hell of a guy. I thought he was the hope of the world.

Robert Mundy: Do you think that the Capra heroes you evolved in the thirties have become less tenable today? The nature of America has changed and the loss of innocence is no longer an issue.

Capra: I'm not so sure of that. There's a guy called Ralph Nader who would make a perfect Capra hero. An individual, alone. He is worrying and moving politicians, industrialists, great industries, and he's making them squirm, alone. He's a typical Capra hero and he's working today. No, I don't agree with that, I think that the individual is the way we have leaped forward, the way we have progressed.

Control of the Means

George Stevens: There are two parts to making pictures and you mastered both of them very early. One was the talent and ideas of what was

going to go into a film and the other was getting control of the film, getting control of the means. You were able to decide what pictures you were going to make.

Capra: I took that responsibility. Actually, most directors who wanted that responsibility could have it. They'd be sticking their neck out, of course. They had to back up everything they did. They couldn't say "the writing was bad" or "he told me to do this" or "the acting was bad." But if you're willing to take full responsibility, even right now, a director can go as far as he wants to, can have all the responsibility he wants to take. He has to say no, he has to argue, and he has to fight, but he can take it. And if he is willing to take the responsibility, and if the picture is bad, he has to take it. If it's good, he gets the credit. All this is part of having enough confidence in yourself, enough courage in yourself, to go out there and stick your neck out.

I worked for a very tough man called Harry Cohn. It was a constant battle, but he never won one single battle with me. I had to win every argument with him, because if you didn't, he lost confidence in you.

He'd challenge you on everything. If you didn't win the argument, he'd throw you out. This was a very crude way to run a studio but he got results by this crudeness on the simple theory that an artist with courage and guts should know more about what he's doing than the sensitive ones who are unsure. And he didn't want any unsure people around him. He wanted people who'd say: "It's going to be this way Harry or go to hell." That's fine.

Mundy: It seemed that the pressure from Cohn was more bureaucratic and financial than artistic. I wondered if there were any instances where Columbia made you change the picture from the way you wanted it.

Capra: Never. I had to win every argument to stay there and that meant no changes unless I agreed with them. Harry Cohn did not know enough about, had no trust in his own artistry of any kind, but he was a great showman, a great gambler. But he'd only gamble on the people he thought knew what they were doing. You had to make him feel that you knew what you were doing even though you didn't, which was most of the time.

Mundy: Most directors mention with pride the movie where they first had the right to final cut. But it seems that you had that very early in your career.

Capra: Yes. I thought that was the way pictures should be made. I suppose, being a Sicilian, I take a very dim view of authority of any kind. I don't like anybody telling me what to do.

Stevens: You hear so much about studios which imposed on the film-makers. My experience has been that people who really wanted responsibility could have it.

Capra: Unless you wanted to fall back on alibis and share the blame with somebody else if it didn't turn out right, then you had to share everything else. But if you took it all on yourself, it's poor but it's my own, you could take it. That's the way pictures should be made. One man—one film.

Stevens: What does that mean?

Capra: One man makes one film. One painter—one painting. It isn't a committee.

Stevens: There's a lot of collaboration involved.

Capra: Collaboration but not committee. Not committee responsibility. Collaboration—of course. You've got collaboration with thousands of people really. One man has to make the decisions, one man says yes or no. That man should be the director. And if it isn't, then you get unevenness.

Money

Stevens: Were you involved in the budgeting of your films?

Capra: Yes, *Ma'am.*

Stevens: Could you talk about that? The answer is obvious but why?

Capra: Why? Because I knew that a film is a dichotomy of business and art and there's no other way you can figure it. And you have got to make both work. You've got to pay attention to both.

If your film loses money, you're not going to make many more films. Your films have got to be successful. I know you don't think talking of commerce is very important. But don't lose sight of the fact

that if you don't make money with your films you're not going to make many films. You might be working in films but if you're going to be filmmakers, you must pay attention to the money side, the financial side. Writing a book, you know, you buy a typewriter and you buy some paper and that's it, that's the total expense and the rest of it is your time. Making a picture is hundreds of thousands of dollars, millions of dollars, tens of millions of dollars perhaps, and that's an enormous responsibility. Time is your great enemy, schedules, and budgeting and so forth and I paid a great deal of attention to that. If you do, you get the picture made on time and don't lose any of the ingredients of the picture, any of the artistry of the picture.

Stevens: In other words, the budgeting is a whole series of decisions about where money is going to be spent so that it goes in the direction you want the film to go.

Capra: Right. Filmmaking is decision making. That's all you do, make decisions, you make a thousand a day. You have got to make them fast and you have to make them—not by logic, logic isn't connected with filmmaking—they're gut decisions. That's your creativity. You make a decision and you make it fast. And don't worry about it after you make it because that's it. I've often gone back in after a picture started and the whole thing evaporates, just goes off into the air. How can you possibly make anything out of this crap? You have these ups and downs and you go and hide in a room and read it and conceptually it's pure nothing. How did you ever get started in this thing? You want to leave the country fast. And you can't do that, you have got to trust in that original, "why did I pick it in the first place?" You have to go back to the original decision making, that you thought it was pretty good at the time and stay with it. And it'll evaporate at times but you have to trust that first instinct. You have to discipline yourself to trust in those instincts.

Stevens: Even in those pictures that turned out to be enormously successful, you had those "loathes" . . .

Capra: I should say, you bet.

Stevens: How do you account for that?

Capra: Well, because you don't know what you've got until the very last minute. Until you've spent all the money and put the picture together,

you don't really know what you've got and you worry. You worry because there goes hundreds of thousands of dollars of expense, millions of dollars of expense, and it's all in a few cans of film. It looks very, very cheap for the amount of money you spent on it and you don't know what you've got until you play it before an audience. You really do not know. There's no way of knowing.

A CONVERSATION WITH FRANK CAPRA

RICHARD GLATZER

Glatzer: Many of your early Columbia films like *The Younger Generation, That Certain Thing,* and *Power of the Press* no longer exist. Why didn't you save prints of your early movies?

Capra: Well, nobody thought they were important enough to save. You know, the films we were making in those days were just nickel and dime affairs. They were like today's newspaper—you don't save today's newspaper. And when they were finished, nobody expected to ever see them again. As a matter of fact, many negatives were just thrown out and sold for the silver by smarter men than I. Certainly we didn't think any of these things were masterpieces or anything like that. We were very glad to make them and get paid and go on to something else.

Glatzer: Yet your attitude changed shortly after you made these films. Your cardinal precept of "one man—one film," which you adopted early in the 1930s, suggests that you thought of yourself as an artist interested in much more than simply getting paid. What made you buck the system and insist on having artistic control over your movies?

Capra: Well, I suppose I'll never be able to answer that question adequately, except that I rebel against control of any kind. I'm a bad

This interview was held in August and December, 1973.

organization man, I like to be my own man and I don't like somebody else to tell me what to do. It was just the natural rebel in me that I couldn't take orders. Also, I felt that I knew more about films than the people who tried to tell me how to make them.

Glatzer: More than Harry Cohn?

Capra: More than Harry Cohn, more than any of those executives. I knew what it took to make motion pictures. I knew there was a *way* to do things, like painters know there is a way to paint and sculptors know there is a way to sculpt, I knew there was a way to make films and they shouldn't tell me how to make my films.

Glatzer: Why didn't other directors feel as you did?

Capra: Well, other directors wanted freedom. Let me tell you, I had a backstop. Down in my heart I wanted to go back to Cal Tech and get a doctor's degree and teach science. If films didn't work out for me I knew I could make that go. So, I didn't depend on films entirely; if I could make films, fine, I'd make them, but if I couldn't then I would do something else. If I couldn't make films the way I wanted them, I didn't want to make them at all. For many other directors films were their total business, and their income depended entirely on them. When you want your own way in films you stick your neck way out. The chances are only about 1 in 10 that you'll succeed—this is normal in all show business because nobody can predict what is wanted—and on that kind of percentage it's difficult to stick your neck out and say, "Let me do it my way." The chances are you'll fall on your face. And if you do fall on your face, one failure is acceptable, two failures and maybe you get another chance, three failures in a row and you're out. That's a big risk to take. Very few people wanted that total responsibility because they were afraid for their careers. I was not afraid for my career.

Glatzer: I'd like to hear about your 1928 movie, *Power of the Press.* Why didn't you mention it in *The Name Above the Title?*

Capra: An oversight: I'd just forgotten about it. But it was a very good picture.

Glatzer: What sort of film is it?

Capra: A gangster movie about the power of the press to unearth gangsters when the police can't find them—a prying reporter digs up stuff

about a crime syndicate and brings them to justice. Doug Fairbanks, Jr., was the reporter.

Glatzer: I usually don't think of you as a suspense director. Any special scenes you remember?

Capra: Oh yes, there is a suspense scene in it, a comedy suspense scene about how Fairbanks escapes from prison. They've put a special guard on him sitting outside his cell—they realize this reporter is pretty smart and will try all kinds of things to get out. The guard likes to sleep, so he puts a ring of keys around his finger and he holds his hand up in the air. He knows that if he dozes off, his hand will drop and the keys will fall off his finger and hit the concrete floor and wake him up. That's his alarm system. And it works. He snoozes, the keys drop, he wakes up and sees that Fairbanks is still there. But Fairbanks gets an idea. He has his hat with him, and he uses a stick to poke his hat out through the bars. He manages to get his hat under the guard's hand, and as the guard dozes off the keys drop off his finger, fall into the hat, and don't make any noise. The guard doesn't wake up. So Fairbanks pulls in the keys, opens the door, and lets himself out.

Glatzer: *Power of the Press* was your last silent film. How did the transition to sound affect you. Did you prefer one mode to the other?

Capra: How can you compare them? It's like trying to compare sculpture with painting; is sculpture better than painting? The art of pantomime had advanced to a very high degree in the making of silent films. People like Murnau, Griffith, Ince, and DeMille and others had reached a high degree of excellence in a language that was universal.
 When the film developed a larynx it was an entirely new ball game: a new element had been added that was a realistic element. You didn't have to depend so much on photography because people became more real on the screen. As far as I'm concerned, it was an enormous step forward. I wasn't at home in silent films; I thought it was very strange to stop and put a title on the screen and then come back to the action. It was a very contrived and very mechanical way of doing things. When I got to working with sound, I thought, my, what a wonderful tool has been added. I don't think I could have gone very far in silent pictures—at least not as far as I did go with sound.

Glatzer: How important is editing to the final film? Some directors—John Ford, for example—didn't edit their films, but I believe you played a major role in the editing of yours. Why?

Capra: No two directors work alike. John Ford didn't have patience enough to do the nitty-gritty of editing. But he shot his films in such a way that they could only be edited one way. He didn't give the editors much film to play with, so they had to edit them practically as he had shot them.

Now I loved film editing—I get a sensuous feeling out of film when I feel it in my fingers. I know what can be done with film: I know what the juxtaposition of scenes can mean for the finished film, how when you have twenty scenes and you put them together there's probably only one or two ways in which that film can come alive and the rest of the ways you can put them together means dullness. I think that editing is the greatest fun about filmmaking.

Glatzer: Can we talk about the way you use the camera? In 1932, you wrote an article for the *Cinematographic Annual* asserting the importance of the cameraman in film. Yet you rarely draw attention to a moving camera. . . .

Capra: I move the camera a lot more than you think—all the time. But if you don't see it, that's a great compliment, because audiences are not supposed to see the camera move. You want them to be involved only with the characters on the screen. If you do distract them with camera movements or other gimmicks, then that's bad directing in my estimation.

Glatzer: Did you have a specific way of blocking out scenes? How far in advance did you visualize how you wanted a scene to be shot? Was it in the scriptwriting stage?

Capra: No, the scripts were all written in master scenes. We never broke them down into individual shots because that was just a waste of time. The set wasn't built yet, you didn't know what kind of cast you would have, so you were just massaging your ego with "Close up . . . long shot . . . cut to this, cut to that. . . ." You didn't need all that detailing. What you need is what the scene is about, who does what to whom, and who cares about whom. The mechanics of shooting have to be left up to the director and crew.

Now that doesn't apply to everybody, of course, because directors all work differently. Some directors want scripts that are blueprinted right down to the last detail; others have to be flexible and let the scenes create themselves. There are different ways of working. All I want is a master scene and I'll take care of the rest—how to shoot it, how to keep the machinery out of the way, and how to focus attention on the actors at all times.

Glatzer: How improvisational were you while shooting?

Capra: Well, if you work with master scenes, it gives you a chance to open or close them up. If you've got a scene and you get a group of actors who can't play that scene, there is no shoving it down their throats. It'll be a bad scene. So you rewrite the scene, half of it, two-thirds of it, all of it; until you come up with a scene the actors can play—providing, of course, that you're not mutilating a key scene. You can't fool with those key scenes too much. But there are many, many scenes—the expository ones, which are the duds, where you're not dealing with characterization but filling in the plot. It's how you handle these plot scenes that is really important; how you keep the ball up in the air. You don't just set actors up and let them talk; you give them "business" to do while they're yakking. And this is where some directors are much better than others.

Glatzer: You don't notice expository scenes in *American Madness*—everything moves so fast. I think you give the film short shrift in *The Name Above the Title*. You've seen it again recently—since writing the autobiography—haven't you? What do you think of it now?

Capra: Well, I thought the picture looked as if it were made yesterday. And I was so surprised by it. I gave it short shrift in the autobiography, but I did say that it was a key film of mine because it was the first time I used accelerated tempo. And it worked! The tempo is about forty per cent above normal at all times in *American Madness*. Things keep happening so fast that you're afraid to look away from the screen. There's an urgency about it because of the tempo—it just holds you. And of course that's part of what you want to do, hold the audience, hold their interest. You don't want them to reach for that popcorn.

Glatzer: Even the dialogue seems to be accelerated, with overlapping speakers, people cutting each other off, and so on. It's very cinematic. . . . You anticipate Robert Altman's treatment of dialogue in some respects—and by forty years.

Capra: I didn't know I was doing anything new. It was just the way I felt about dialogue. We were constantly improvising, there were no rules. Everybody had their own way. We were maturing and we were discovering things. I was amazed at how *American Madness* turned out, how the faster pace perfectly fitted that picture.

I play a number of very important scenes in crowds in that film. I

like to fill the screen with people. I love faces, I love to look at people, and I think others do too—all kinds of people, walking in and out. I never try to isolate a scene too much from real life.

Glatzer: Where did you get your notions of economics that Walter Huston articulates in *American Madness?* They're New Dealish, almost Keynesian.

Capra: Well, yes. But we made the film before Roosevelt was elected. I got the idea for the story from the life of Giannini, a pushcart guy who started the Bank of Italy—the Bank of America today. He started it to finance the vending of Italian fruit and vegetables in California, and he gradually built a little bank. He'd lend money on character.

I remember one time a man came to our house. He'd just arrived from Italy with only the clothes on his back, and a few cans of tomato paste that he'd brought with him in a sack. We passed some around and everybody tasted it. My father said, "Oh, that's wonderful tomato paste. What would you like to do with it?" And he said, "I'd like to make it."

My father took him down to the Bank of Italy, and said, "This man's got tomato paste, and he'd like to make it." So they passed the tomato paste around. And Giannini said, "Can you make this? Do you know how to make it? You've got the recipe?" So he made some at our house, and took it back to the bank and passed it around again. Giannini said he'd build him a plant! So the guy began to make tomato paste. I forget what the hell happened to him. He could be Del Monte.

That's the kind of an egg Giannini was. All the other banks thought he was absolutely nuts, lending money on character. He'd take collateral if you had it, but if you didn't and you had character, he'd lend you money anyhow. So I think he was the inspiration for Walter Huston's character in *American Madness.*

Glatzer: Could you tell me something about *Soviet?* You started work on it with MGM, never finished it, yet in 1938, in an interview, you said that it was the best thing you had ever worked on.

Capra: Well, it probably was. It was a tremendous melodrama and I had the dream cast of all time—Clark Gable, Wally Beery, Joan Crawford, and the wonderful Marie Dressler. It was about the building of a dam in Russia with an American engineer supervising it. Wally Beery was going to play the role of a commissar who was given the job of building this great dam. He didn't know anything about engineering, but was a man in charge who had made his way up from the bottom of the Bolshevik

regime. Marie Dressler was his wife, and a very patient, loving wife she was. Joan Crawford was to play a very, very politically minded gal who was the assistant commissar. Clark Gable was an American engineer, sent over to help them build this dam.

The conflicts were personal and ideological: the American wants to get things done and the commissar wants to get them done in his own way. Gable falls in love with Joan Crawford, and they have a running battle: she hates anything American and anything that is not Communistic, and he hates anything that *is* Communistic—all this plus the drama of building this dam. Nothing but great battles: they fought nature, they fought each other, they fought the elements, all to get this great dam built.

Glatzer: Did they get the dam built?

Capra: Yes, they did. I want to tell you about the end of the film. They were celebrating the completion of the dam. The Wally Beery character was particularly complex. One of his hands had been cut off, and on his remaining hand he wore a handcuff—with an empty handcuff dangling— as a symbol of his slavery under the Czarist system that had cut off his hand—he never took this handcuff off. During the celebration the camera pans down the enormous face of the dam and then moves into a close-up and there is this handcuff sticking out of the cement—Beery has been buried inside the dam.

Glatzer: How did that happen?

Capra: Well, I can't go into the story—it would take all day. But that was the end of the film.

Glatzer: Clark Gable marries Joan Crawford?

Capra: No, no, he doesn't marry anybody—he goes home.

Glatzer: How far did you get with the movie?

Capra: We didn't get anywhere, except that we had the script written. It was a pet project of Irving Thalberg and Thalberg died suddenly. He and Louis Mayer didn't get along, and anything Thalberg had in the works instantly went out when Thalberg died. That story went out, and I went out of MGM with it.

Glatzer: In some of your films you seem to have a feeling for footloose drifters, especially in *It Happened One Night* and *Meet John Doe.* Would you talk about those years after World War I when you just drifted around. . . ?

Capra: That was a long period, several years. I just bummed around and had an excellent time. I met up with a professional bum named Frank Dwyer, an Irishman who played a ukulele and sang. He taught me how to hop trains, things like that. He also taught me how to make a living selling photographs house to house. If you punched enough doorbells, you could make five or six dollars a day. With six sales a day, you could work two days a week and you'd have enough for the rest of the week. Frank Dwyer . . . what a wonderful character! He lived just as he wanted to, wherever he wanted to. He had this racket, the photographs, that he could make money with whenever he wanted. He had it made!

Glatzer: Did you get your sense of small towns during this period?

Capra: Got a real sense of small towns, got a real sense of America. I found out a lot about Americans. I loved them. This great country, I saw a good deal of it. I roamed all over the West. I saw the deserts, the mountains, I met the farmers, the people, the people who were working and not complaining. It was a great experience. I met a lot of Gary Coopers.

Glatzer: Can we talk a little more about the autobiographical dimension in your films? After you bummed around you started to work in the movies; weren't you involved in a small claims suit that was similar to scenes in some of your films later?

Capra: Well, there was a small claims suit. I was working in a film laboratory at the time and I did any odd jobs that came along—editing newsreel footage that came in, and so on. One guy brought in a scenic documentary, a Chamber of Commerce sort of thing, and asked me to write some titles for it. I wrote about thirty titles. Then I didn't get paid, which burned me up. We had settled on fifty dollars for the thirty titles, which was pretty cheap. Still, fifty dollars was a lot of money at that time and he wouldn't pay it. He said he didn't have the money yet. He had thirty-three backers, bankers and real estate people in San Francisco, but they wouldn't give him any more money. So I sued them.

For a sum that small, you can go to a small claims court without a

lawyer. So I went to court and they asked me to fill out this huge form. They said, "Who do you want to sue?" and I said, "I have a list of thirty-three people I want to sue." They included the biggest names in San Francisco, men like the president of the Crocker National Bank. I thought if I made enough stink they would pay. The court bailiff said, "Boy, you're going to have writer's cramp doing this thing because you're going to have to fill out thirty-three complaints in triplicate." I said, "I don't care, I've got a lot of time." I took the thirty-three complaints, in triplicate, filled them out in longhand, brought them back, and they were mailed out. It must have cost a fortune for postage.

I didn't expect anybody to show up for the hearing. I just wanted the fifty bucks and I was going to harass somebody. I was sure none of these big people would show up. Well, they did! They all showed up! Thirty-three legal big wigs, representing the San Francisco brass. "Hi Bill!" "Hi there!" "How are you doing?"—you know. They all got together and said, "What's this slop?" They wanted an indignation meeting with the guy who made the film. They thought the film stunk. It cost too much money and it stunk. I was in the middle, so they came down to court to harass me about the film. I said I didn't make the film, I had just written the titles and agreed to get paid fifty dollars. They said, "The titles stink too!" "I don't care whether they stink or not—I want to get paid for my work!" So one guy says, "For God's sakes, so he's not a Shakespeare. These titles aren't very good, but by God he turned them in and they're in the film. Let's pay the guy the fifty bucks."

But who was going to pay the fifty dollars? So one lawyer took off his hat and went around and got contributions from all of them. Then he emptied it on the judge's desk, and the judge counted it to see if it was enough. And the judge put in a dollar of his own. I've loved judges ever since.

Glatzer: So that's what inspired the judges in *Mr. Deeds* and *You Can't Take It with You.* What about doctors? So many fathers in your movies are doctors—Jean Arthur's in *Mr. Smith,* Gary Cooper's in *Mr. Deeds,* Barbara Stanwyck's in *Meet John Doe.* . . .

Capra: Well, there was a doctor I met in the Sierras who caught my imagination. He was a very well-known surgeon who went there to retire. But the people there needed him, so he organized a little hospital. He'd want to go fishing mornings, but there he was down at the hospital because he was needed. He'd only charge them fifty or sixty cents, but he gave two dollars worth of medicine. He was that kind of a guy. I got

to know him very well. I'd try to take him fishing, but they'd catch up with him, blow the horn on the highway, and off he'd go.

When he was dying I went down to see him at the· hospital. I couldn't get in because the hallways were so packed with people. When I finally made my way up to his room, I asked his daughter how he was. She said, "He's not very well, but he certainly is glad all these friends came down to see him." I was amazed; none of these people knew one another, but at some point he had touched each of their lives. I never saw such a tribute to a man. There was every kind of person there: conductors, truck drivers, bankers. Where did he meet all those people?

He died a very rich man because he had so many friends. He still seems to me to be a person to be looked up to and to be respected. He worked only for others. So, if you're going to have a father, you ought to have one like that.

Glatzer: So many of your films have offhand, somewhat improvisatory musical numbers in them—i'm thinking of Gary Cooper and Jean Arthur in Central Park in *Mr. Deeds* or the bus passengers singing "The Man on the Flying Trapeze" in *It Happened One Night* or the "You Can't Carry a Tune" bit between Williams and Harlow in *Platinum Blonde,* and so on. It's almost a trademark. . . .

Capra: Sometimes your story has got to stop and you let the audience just look at your people. You want the audience to like them. The characters have no great worries for the moment—they like each other's company and that's it. The less guarded they are, the more silly it is, the better.

These scenes are quite important to a film. When the audience rests and they look at the people, they begin to smile. They begin to love the characters, and *then* they'll be worried about what happens to them. If the audience doesn't like your people, they won't laugh at them and they won't cry with them.

Glatzer: How did you work with scriptwriters?

Capra: If you get two people who vibrate to the same tuning fork, then a kinship and a friendship develop and you start bouncing ideas off each other. You become performer and audience to each other. When that happens, it's a symbiotic relationship; things are better because the two of you are together. The whole is better than the sum of the parts. I've had occasion several times to have that arrangement with writers, where

you really were vibrating to the same tuning fork and were audiencing for each other. It's a very, very happy relationship.

There were other times when the relationship was not so happy and I could not get along with the writers; then I had to depend on myself. I just said, "I'll write it myself, to hell with it." Writing is something I liked to do, but if you try to write and direct and produce a show and do it all yourself, you have a great many headaches to take care of. Whereas if you get a writer who understands you and you understand him, he takes on the bulk of the work of writing the script. Now that's a very fine arrangement. So you ask how do we write scripts? Well, you get together with a writer you like and who likes you.

Glatzer: Could you talk a bit about your relationship with Robert Riskin?

Capra: Robert Riskin was a very talented man with a fine ear for dialogue. That ear for dialogue was what really intrigued me about Riskin. People always sounded real when he wrote their dialogue, and I worshipped that.

We were good friends. We saw each other a great deal—went out together. It was a very wonderful relationship, and a very profitable relationship for both of us, in the sense I spoke of before—the sum of our work was greater than the individual efforts we both put in.

Glatzer: You admit, in your autobiography that you and Riskin had difficulty creating an ending for *Meet John Doe*. Did Doe commit suicide in any of the alternate endings you considered?

Capra: Yes. In one version, the movie was to end in a short scene, played on the steps of City Hall. Walter Brennan is waiting for Cooper to show up, still waiting for him, not knowing he's upstairs on the roof. Barbara Stanwyck is running upstairs. We see Cooper on the roof about to jump. And we cut down to Brennan. Suddenly Brennan hears something, turns around, and my God he sees (we don't show it) he sees the body on the steps. He rushes onto the steps, cradles Cooper in his arms, and says, "Long John, Long John, you poor sucker, you poor sucker." That's the end.

Glatzer: Did you distribute that ending to any theaters?

Capra: No. You just don't kill Gary Cooper. It's a hell of a powerful ending, but you just can't kill Gary Cooper.

Glatzer: You obviously liked working with Gary Cooper and Jimmy Stewart: between them, they appeared in five of your movies. Could you talk about the differences between them?

Capra: Cooper is the more mature person, at least he gives you that impression. He also gives you the impression of being a more solid, earthy person. He's simple, but he's strong and honest, and there's integrity written all over him. When you're dealing in the world of ideas and you want your character to be on a higher intellectual plane than just a simple man, you turn to persons like Jimmy Stewart because he has a look of the intellectual about him. And he can be an idealist. So when you have a combination of an intellectual who is also an idealist, you have a pretty fine combination.

Glatzer: What about actresses? You used Jean Arthur and Barbara Stanwyck a good deal, and got an Academy-winning performance from Claudette Colbert. What were the differences among them?

Capra: First of all, I think all three of them are just great. Jean Arthur is a warm, able, lovable kind of a woman who has a very feminine drive. I think of her as a woman who is always looking for someone to marry, looking for that man who she could give her whole life to, but who can't seem to find him. A tough gal with a heart of gold.

Claudette Colbert is another type of woman, much more intellectual. She knows what's going on, and she's a bit of a rebel. She doesn't want to be told what to do. She was perfect for *It Happened One Night,* because she was a shrew and she had to be tamed by someone we like. She wasn't looking for any man, she wasn't looking for any romance. She was much more intellectual than the women Jean Arthur played.

Barbara Stanwyck started out with a pretty hard life. She was a chorus girl at a time when the gangsters ran the nightclubs, and that was pretty tough on the girls. Life was pretty seamy. So she can give you that burst of emotion better than the other two can. She is probably the most interesting of the three. She's also the hardest to define: she's sullen, she's somber, she acts like she's not listening but she hears every word. She's the easiest to direct. She played parts that were a little tougher, yet at the same time you could sense that this girl could suffer from her toughness, and really suffer from the penance she would have to pay.

Glatzer: I like the sense of complete characterization your bit players often provide, even in extremely minor parts. How did you accomplish this?

Capra: Well, I didn't treat them like bit players. I treated them all as stars. Whether they were in that picture for ten minutes, or ten seconds, that time they were on the screen had to be perfect. If the so-called bit people are believable and can involve the audience in a sense of reality, the audience forgets they're looking at a film. They think they're looking at something in real life. The bit people have a great chore because they're helping to make that background real. If the audience believes in the small people, they'll believe in the stars.

I'd take a great deal of time casting those parts, and a great deal of time playing them. I don't mean I shot many takes or had many rehearsals, because I did not. But I spent a lot of time talking with the actors.

Glatzer: Did you often act out the parts for them?

Capra: No, I didn't want them to ape me. That's another way of directing, and men like Lubitsch did that very well. I wanted to stay out of the picture entirely. I wanted audiences to think it was all happening for the first time. I gave each of the actors a personality, a sense of being, a sense of existence—no matter how small their part, even if it was a walk-on. I'd say, "You're a little bit worried because your father is in the hospital." Give bit actors an identity, and boy, they come to life! They look real.

Glatzer: Of your contemporaries, which directors did you admire most, and why?

Capra: That's a difficult question to answer because no two directors work alike—each one has his own style, and his style may not suit someone else. So it's difficult to compare them, and I can only tell you about some of them whose pictures I've liked.

John Ford I liked very much; I think he probably knew more about picture-making than all the rest of us put together, and I think he made some of our best films. I know his stock is going down at the moment, but I think his films will live. John Ford was an artist: he was an Irishman, he was pigheaded, he was all kinds of things—but he loved films with a passion, and the films he made show this passion. I think when a hundred years roll by, Mr. Ford will be right up there with his films.

Another man whose films I liked very much was Leo McCarey. I liked his comedies—when he started to do dramas, he was just lost. But

his comedy films were about as funny as anyone has ever made. Delightful, delightful comedies they were.

Howard Hawks is another guy I admire very much, because he's a real craftsman. He knows his tools, and he knows their limitations. He uses his tools expertly, like a surgeon. He makes films that only he could make. You're never bored by a Hawks film.

William Wellman's films are never boring either, because Wellman himself is not a boring man. He's a man who talks like he wants you to think he knows nothing, but he knows a great deal about a lot of things.

These men all have one thing in common: a passionate love of film. And they each have a style. You see their films, and their personal stamp is on them. It doesn't make any difference where the story came from, or what actors are in it, the style is there. Only when people achieve that distinction of putting their own mark on something—their style—can you really call them filmmakers.

Glatzer: What about Orson Welles? Do you admire him as a director?

Capra: No, not particularly. I wouldn't put him with the people I've mentioned at all. First of all, he hasn't made enough films to stamp anything. As a director, he's made very little beyond *Citizen Kane* and *The Magnificent Ambersons.* I know that *Citizen Kane* is supposed to be the nearest thing to the second coming of Christ, but I don't think so.

Glatzer: Making the *Why We Fight* series must have been very different from making a dramatic film. . . .

Capra: But not so different. You see, the fact that I had never made a documentary before was a great help; I didn't have a documentary mind, I had a dramatic mind. Here was the world stage, here were actors, here were plots, here were stories, and I told them dramatically. You had the world's greatest heroes and the world's greatest villains competing. You had a chance to dramatize it with film. I think what was different about those documentaries was that history was dramatized, and I think that was their main attraction.

Glatzer: Did your wartime experiences have any effect on *It's a Wonderful Life?*

Capra: Yes, the war did affect me. I didn't want to see another cannon go off, I didn't want to see another bomb blow up. War lost its glamour

for me. Just to see those trembling people in London during the Blitz, poor sick old ladies crying, crying in terror. . . . Children. There's got to be something better than bombing old ladies and children. I lost . . . there's nothing glamorous about war. I didn't want to be a war hero, nothing. That's why I made a movie about an ordinary guy.

Glatzer: Is that why you moved away from politics? I feel that *It's a Wonderful Life* is your least political major film.

Capra: Yes, it is. But then I made *State of the Union.*

Glatzer: But did your coming back from the war influence you to make this movie about an anonymous man in a small town?

Capra: I wouldn't be a bit surprised. I couldn't be interested in anything else. I certainly wasn't interested in things like *The Best Years of Our Lives* or anything like that. I didn't want to see anything more of war—the brutality of it so upset me and so filled me with a feeling of the incompetence of the human race. If the best way they can think of settling an argument is dropping bombs. . . . There's nothing accomplished by that. Nobody's licked, because you can't lick the people. They'll just hold on and sit it out.

 I never lost faith in people, I just lost faith in leadership. I couldn't cheer when I would see the films of the destruction of Germany—I couldn't cheer at that. I wanted us to get Hitler, but what was happening to us in London was happening to people in Germany, and I thought, "God, how stupid." The inadequacy of thought, of feeling, and of leadership. . . . What the hell good were the leaders? Right then and there I felt that war—which had been pretty glamorous to me before—seemed pretty unglamorous, and rotten.

Glatzer: It seems strange that *It's a Wonderful Life,* the movie you had the largest number of scriptwriters for, is the film that seems to me to be your most personal work. Didn't Clifford Odets write some scenes for it?

Capra: Yes, Odets had written a script before I saw Phillip Van Doren's story. The story itself is very slight: it came from a Christmas card. It's slight in the sense it's short, but not slight in content. I bought it from RKO. They had already had three scripts written—Connelly and Odets and Trumbo had each done one. I read all three scripts, and kept a couple of scenes from Odets's version.

Glatzer: Which ones?

Capra: Well, the relationship between the boy and the drugstore man. And that was all from the three scripts; we wrote entirely new scripts. I had some awfully good writers working with me, but somehow they couldn't see what I could see in the thing. I finally just sat down and wrote the script the way I wanted it to be. So that's why it is a very personal statement.

Glatzer: One of my favorite scenes in that movie is when Jimmy Stewart and Donna Reed are talking long-distance on the telephone to Sam, and Stewart realizes for the first time how much he is in love with her.

Capra: I think that's one of the best scenes I've ever put on the screen. I love that scene. It's an offhand and offbeat way of playing a love scene. Scenes like that are just great when you can find them, because love scenes are so difficult to stage. It's very difficult to get a real emotion out of them, you can't play them straight. So you have to find some way to play a love scene that is a little bit offbeat so people don't laugh at it. Love scenes are funny, the audience is right on the edge of tittering. All you have to do is to put in a reactive character—somebody looking on at the love scene—and you get a laugh immediately.

Glatzer: The post-war criticism of *It's a Wonderful Life* underrated it considerably, I think. The realism of *The Best Years of Our Lives* seemed to be more what critics wanted in 1946. When people see the two films today, they seem to prefer *It's a Wonderful Life.*

Capra: I think that people understand films better now than they did then. They were labelled "corny" then because people didn't know what to call them. The critics particularly wanted the more obscure things, the more negative things. This positive attitude toward life, this optimism, this great reverence for the individual that is dramatized in all of my films was a little bit too sticky for them at the time. Yet, are the people today any cornier than they were in those days? No, people today seem to be much more aware of something that is real, good, and true than even people of my day. So to me that's a big plus. There is no generation gap between my films and the present generation at all.

CAPRA AT WORK

LEWIS JACOBS

Frank Capra is one of the rare directors in Hollywood whose name appears above those of his stars. Sober, judicious, he has definite and logical ideas about his work. "There must be a reason behind a picture—and that reason must be the kernel of the story. To me that is axiomatic." He is particularly distrustful of the Hollywood formula and "factory method" of turning out pictures and likes to break all the rules.

To prove the success of his credo, Capra lists the productions which convinced him that breaking the rules was responsible not only for his making better pictures but for their paying greater dividends. "*Lady for a Day* was one of the first productions in my new order of things. They told me that the story was impossible, that actresses past middle age could not hold the interest of an audience. The box-office proved they were wrong." When he made *It Happened One Night,* "they told us we were crazy." But when the picture was released, the Academy of Motion Picture Arts and Science awarded it a flock of gold statuettes. He was told that race-horse pictures never made money. He made *Broadway Bill.* It, too, was a smash at the box-office. Both *Mr. Deeds Goes to Town* and *Mr. Smith Goes to Washington* met with the same objections as *It Happened One Night,* and again they were disproved.

From *Theatre Arts* 25 (January, 1941): 43–48. Reprinted by permission of the author.

Now once more Capra stakes his reputation in order to "make what I like and then hope and pray that other people will like it too." His latest undertaking, *Meet John Doe,* is an independent venture, financed by himself and his scenarist. Capra has mortgaged his house and farm. Robert Riskin, who has worked with him for many years, "has put all his stocks and bonds into the kitty in order to make the kind of movie we believe in."

When you face Mr. Capra on the set of Warner Brothers Studio where he is shooting *Meet John Doe,* you see a short, stocky man with a square face and olive complexion topped by thinning black hair. The most striking thing about him while he is directing is his complete immersion in the film problem. He is seldom to be found in the chair marked "Director." Instead, he is continually roving about, seeking ways and means to heighten the scene. Every set-up absorbs his attention.

His effort is endless to make every detail significant and to maintain a continuous pace, even in short and relatively minor scenes, such as that in a police station toward the end of *Meet John Doe.* While the crew sets up, Capra is busy placing the actors. The police captain is in the foreground, sitting with his back to the camera, playing solitaire. Opposite him is Jimmy Gleason, a drunk in a battered derby, drinking milk. Against the wall Capra groups Barbara Stanwyck, crying, in the arms of her mother, Spring Byington. It is raining outside and a reflection of the drops is made to fall across their faces. Capra signals an assistant that the effect is too hard—"Soften it."

A moment later he is seated in Jimmy Gleason's chair meditating on a piece of business. He experiments with the policeman's hat to have it throw a significant shadow on the wall beside Miss Stanwyck. Then he whispers to her to get her into the mood for tears. He goes to the camera, and while he watches through the lens, the players rehearse their action. What he sees dissatisfies him; he is off the camera and, with viewfinder in hand, roams the set for a better angle. Finally he has the camera re-set on a track for a dolly shot, and again the actors go through the scene. This time he studies it through the moving camera. "This is it!" he says, pleased.

While the crew prepares for the take, Capra is off again, surveying, suggesting, making last-minute changes, equally concerned with technicians and players. Throughout he speaks calmly, in low tones, and gives his instructions directly rather than relaying them through an assistant, the usual procedure.

Finally the scene is set. "Ready, boys?" asks Capra. His assistant blows the "all quiet" whistle. Capra whispers, "Turn 'em over." Then, alert, on tiptoe, he cues the cameraman to begin his dolly forward. The

policeman, who has already started his solitaire, interrupts his game to turn on the radio. Capra signals his dialogue director, who speaks the announcement supposed to come from the radio. At its close, it is Capra who again cues the policeman as to the exact moment to turn off the broadcast.

Almost simultaneously—so timed is the action—the camera pans to the drunk. Capra cues him and Gleason lifts a half-filled bottle of milk and says, "Well, you can chalk up another for the Pontius Pilates." Before that speech is finished, Capra has cued Barbara Stanwyck so that when the camera and microphone pan and dolly in to her, her sobs can be heard before we see that she is crying. She speaks through her tears, and the camera continues to hold her after her speech is finished, while the microphone picks up only the sound of the rain as it beats against a window.

Suddenly Capra calls, "Cut! Try it again. Much faster." The scene is repeated. Again Capra is dissatisfied. "Still too slow," he says.

The camera moves back to first position, Capra confers with Miss Stanwyck. The "all quiet" whistle blows. The shot is retaken—swiftly, smoothly. At its end, Capra says, "That's about how it should run, boys. O.K."

The script girl indicates the third take as the one to be printed; the crew prepare the next set-up. Capra kisses Barbara for her good performance; she can't stop crying, having gone overboard on her tears.

All this has been done with a minimum of noise and motion. Although there seems to be a tremendous store of energy in Capra's lithe movements, it is never unleashed in the form of harangues, temperament or jitters. He transmits his instructions with so much reserve and regard for others that crew and cast act similarly. By his own example, he seems to draw the best out of everyone. He is a director who displays absolutely no exhibitionism.

"The pictures I direct," Capra says, "are practically finished before I go on the set. I work right along with Robert Riskin, the writer. It takes three times as long to complete a workable script as it takes to shoot the picture. Even then I don't consider it iron-clad. I'm apt to change any sequence or incident, if it doesn't feel right to me when it gets before the cameras."

What concerns Capra most in a movie is the story. "I have some general rules that I abide by religiously in selecting a story. My first rule is that it must have charm. This is pretty hard to define, but if a tale leaves you with a glow of satisfaction, it has the quality I seek. Second, it must have interesting characters that do the things human beings do—or would

like to do if they had the courage and opportunity. My third and last requisite is that the members of the cast must in real life be the nearest thing possible to the characters they are to portray, so that their performance will require the least acting. Give me these three things and a lot of story formulas that I can violate, and I am completely happy."

THE FILMS

CAPRA'S IDEALISM

MALCOLM LOWRY

[*Dollarton, 1952*]

My dearest sister Priscilla:

We went to see *The Strong Man;* being privileged to be related to the star, to say the least, we were invited as honored guests to see a private showing albeit it is now wowing the audiences again in the theatre proper. I think you should know too that of all the cinematic consummate masterpieces in demand *The Strong Man* is about the most popular, if not the most popular, and consequently one of the hardest to obtain. That it was got in time for us to see it was due to the courtesy of the Museum of Modern Art for the same privileged reason as above. And before I say anything else, Priscilla—though I have seen the film before—I want to say immediately that your performance is one of the most profoundly realized and inspired—one of the greatest and most permanent things in short that I or anyone else have seen in a movie. The audience was certainly of the same opinion.

From *Selected Letters of Malcolm Lowry,* edited by Harvey Breit and Margerie Bonner Lowry (Philadelphia and New York: Lippincott, 1965), 309—10. Copyright © 1965 by Margerie Bonner Lowry. Reprinted, with changes, by permission of J. B. Lippincott Co. Copyright 1965 by Malcolm Lowry. Reprinted by permission of the Harold Matson Co., Inc.

That Chaplin seems to have borrowed liberally and literally from the general idea in *City Lights* was something that occured to the audience too, to the grave detriment of one's memories of the direction of Virginia Cherrill therein, but perhaps this is a minor point: or one that could have been more liberally minor had not your performance in *The Strong Man* been so absolutely major.

The film itself—though we saw it under the worst kind of circumstances in one way, 4 or 5 people in a room, recorded thundering music that was far too soft and rarely varied and only once really imaginative, when they shut if off altogether when you were playing the terrific scene with Langdon on the garden seat—struck me as being colossal too: its revelation of the human soul was profound. Not to say the present situation, even if partly unconscious on Capra's part, though it must be said that he has not failed to continue to mine that apparently inexhaustible gold mine of the American consciousness of decency and wisdom against the forces of hypocrisy. Perhaps it wasn't meant to be profound, but even if not, your own performance would have made it a pioneer work in cinema. In short, as a film, it must strike anyone who has loved such things as important.

Your affectionate brother,
Malcolm

CAPRA'S EARLY FILMS

RICHARD GRIFFITH

"He liked the flavour of an imperfect world, and the preposterousness of peccant humanity."—Thomas Love Peacock, *Nightmare Abbey*.

Frank R. Capra was born in Palermo, Sicily, May 18, 1897, the youngest of seven children of Salvatore and Sarah (Nicolas) Capra. When he was six years old, the Capra family emigrated to the United States and settled in Los Angeles. As a boy, Frank sold newspapers to help with the family expenses. Not yet sixteen when he completed high school, he was ineligible for college and took a job for a year before matriculating at the California Institute of Technology, where he supported himself as a waiter, manager of the student laundry, and engine-wiper at the Pasadena power plant. He also secured a travelling scholarship and won a letter of recommendation from the National Research Council for an incendiary bomb on which he did chemical research.

Capra graduated from the California Institute in 1918 and enlisted in the army. Having served as a captain in the reserve, he was assigned as an artillery officer to teach mathematics at Fort Scott in San Francisco. Discharge found him seemingly unable to come to terms with himself. He abandoned chemical engineering as a career; he was ill for more than a year; he played extra in Harry Carey Westerns, pruned fruit trees, worked

From *Frank Capra*, New Index Series no. 3 (London: The British Film Institute, 1951), 6–14. Reprinted by permission of Mrs. Ann Griffith.

on farms in California and Oregon, and otherwise followed a variety of catch-as-catch-can occupations suggestive of Stroheim's early years in the United States. It was in one of the interims of selling wildcat oil and gold stocks that he first took a serious interest in the movies.

Stopping over in San Francisco, he read a newspaper advertisement announcing that Walter Montague, a quondam Shakespearean actor, was starting a movie company to be devoted to the one-reel visualization of famous poems. Capra overawed the old man by saying "I'm from Hollywood," and was hired to direct the first of the projected cinepoems at a total salary of $75.

Capra's First Film

1923. *Fultah Fisher's Boarding House*

Kipling's forgotten poem was the initial subject chosen by Montague. Capra rejected actors in favour of types, fearing that professionals would realize that he was innocent of film experience. The picture seems to have consisted of stanzas from the poem followed by their visual re-enactment. Capra completed it in two days at a cost of $1,700. Pathé bought the film for $3,500 and it opened successfully at the Strand Theatre in New York along with a Harold Lloyd comedy. Montague, intoxicated at doubling his money on the first try, decided to jettison famous poems and write his own ballads. Although Pathé had contracted to distribute further films, Capra could see no future in the new method of composition and left the company. Pathé rejected the next two Montague productions and bankruptcy supervened.

After a few months with another small film company in San Francisco, Capra returned to Los Angeles and sought work along Poverty Row. Harry Cohn, then about to launch a firm known as Columbia Screen Snapshots, hired him at $20 a week. With notable, and unwonted philanthropy, Cohn told Mack Sennett that Capra was worth much more than he was being paid, and Sennett shortly engaged him as a gag man. For more than a year he was an inmate of the notorious writers' tower on the Sennett lot, chiefly occupied with writing gags for Harry Langdon. Langdon, a veteran comedian, was then starring in Sennett two-reelers. "His personality," says Alva Johnston in *The Saturday Evening Post*, "changed from minute to minute to fit the gags. He was a hero or a villain, an intellectual giant or an idiot, according to the way the laughs had been constructed Capra finally worked out a definite character-ization for the comedian. He endowed Langdon with all good qualities

except sense. Langdon became a sainted moron in a world of miscreants. His only ally was Providence, which kept intervening with masterful gags to rescue him from desperate situations. . . . This high-souled and feeble-minded character became an immediate success. Big companies began to bid for Langdon. Leaving Sennett to make feature-length pictures for First National, Langdon took Capra with him."

Capra and Langdon

1926. *Tramp Tramp Tramp*
1926. *The Strong Man*
1927. *Long Pants*

Langdon's features for First National, based on the character described above and gagged by Capra, were at first enormously successful. In both popularity and critical acclaim he was for a few years the peer of Chaplin, Lloyd, and Keaton. There is no doubt that Langdon as an actor stands comparison with other similar figures of the silent screen. Numerous stories centre around the separation of Capra and Langdon. The most widely accepted is that the intelligentsia convinced Langdon that he should exploit the pathos inherent in his screen character rather than the broad comedy which had won him a following. Capra disagreed on the ground that Langdon's pathos was a by-product of the comic predicaments which overwhelmed him. Langdon fired him. Whatever the truth of the story, two facts stand out: *The Strong Man,* greatly successful with the public and rich in the overtones which made Langdon admired of the intellectuals, was both written and directed by Capra; and no subsequent Langdon film was a box-office success.

Long Pants, though, on a re-viewing to-day, has many good moments of comedy, and Langdon as a small-town adolescent dazzled and duped by a beautiful schemer has a simpleton charm. The film is more skillfully and economically handled than Harold Lloyd's comedies of the same period, it essays a dream sequence in colour, and Langdon's first meeting with the adventuress, his mounting infatuation as he cycles foolishly round and round the open car in which she is invitingly sitting, is a brilliant scene. In its ease of comic invention (sometimes running to over-emphasis), quick ability to establish atmosphere—from the lightly sentimental family scenes to the brassy nightclub in the city (to which Langdon follows the schemer)—the fundamentals of Capra's talent can clearly be seen.

A Failure

1927. *For The Love of Mike*

After his separation from Langdon, First National gave Capra the oppor-
tunity to direct this routine comedy on a familiar theme of the twenties:
the waif brought up by three wrangling godfathers, German, Jewish, and
Irish. Innumerable similar films of the period were successful, but *For
the Love of Mike* was regarded as a failure of such dimensions that
Claudette Colbert, later to be identified with Capra's greatest success,
decided to return to the stage. The picture's reception taught Capra
something: "the fault I know now was with the story. It was Hollywood
formula No. 1 and was catalogued under Rules for Romance. I am deeply
grateful for that picture now. It started me thinking." Henceforward he
resolved to follow a path which, years before, Griffith had recommended
to Stroheim: "Take the job but don't do it the way they tell you. Do
what you want to do."

After the failure of this film, however, there were no jobs to "take."
Capra considered giving up the movies; he was offered a job with the
chemical expedition to South America of a large rubber company. The
young doctor who had pulled him through a year-long illness in his salad
days told him to keep plugging: "After all, you've gone far in the
movies." Capra then applied for, and got, a directing job with Harry
Cohn who had recommended him to Sennett years before.

Eight Quickies

1928. *So This is Love*
1928. *The Matinee Idol*
1928. *That Certain Thing*
1928. *The Way of the Strong*
1928. *Say It with Sables*
1928. *The Power of the Press*
1929. *The Younger Generation*
1929. *The Donovan Affair*

Several years before Capra joined them, Harry Cohn and his brother had
founded CBC Pictures (known in Hollywood argot as "corned beef and
cabbage"), later rechristened Columbia Pictures. Columbia was one of
many studios which constituted "Poverty Row," and which were de-
voted to the production of "quickies." These small companies repre-

sented the last stand of the independent producers who could no longer obtain access to first-run screens, and who had therefore to produce films so quickly and cheaply that their modest costs could be recouped profitably through rental to exhibitors in small towns and villages. The quickie producers were at this period slowly being forced to the wall because they could no longer afford to produce pictures of sufficient quality to attract even the humblest theatre. The Cohns set themselves to solve this problem in the teeth of the rapid consolidation of production, distribution, and exhibition which was going forward at the major studios. Their films were made with lightning speed—few were more than two weeks in production— but they studded their casts with stars temporarily "at liberty," or with former stars who could no longer get work with the big companies but whose box-office draw, and salary, was still high. Columbia kept down costs by "bunching" the scenes in which these stars appeared, so that their shooting could be completed within a few days with resultant salary savings. Thus this small company managed to turn out films which were reasonable facsimiles of the programme pictures of the larger studios, and which in time made their way to the first-run screens and the big money.

Capra was an important part of this policy gamble, if not its mainstay. "Action" was the watchword of films produced so breathlessly, and the economy and forcefulness of his cinematography today bear the marks of his early training. How rigorous that training was may be gathered from the fact that he directed nine films for Columbia in slightly more than a year.

Nearly all of them were topically flavoured comedy dramas, expert exercises in the laughter and tears formula: *The Power of the Press* had a newspaper background, *The Younger Generation* was an adaptation of Fannie Hurst's romantic best-seller (from slum to mansion and back again, contrasting the life and loves of rich and poor), *The Way of the Strong*, the story of a crook who cannot bear the sight of his own face, falls in love with a blind girl but finally loses her.

Submarine, Flight, Dirigible

1928. *Submarine*
1929. *Flight*
1931. *Dirigible*

Submarine appears to have been begun by Irvin Willat, then a much better known director than Capra, but Harry Cohn was dissatisfied with

the initial treatment of his most important picture to date and turned to the man he had come to think of as his trouble-shooter. The box-office success of the film made a popular starring team of Jack Holt and Ralph Graves, and a successful cycle of the films of the armed services with which they were identified. Though made as economically as possible, these pictures were not "quickies." They represented a new departure for Columbia in the scale and scope of their rendering of sea and air disasters. Simple and straightforward as the films were, Capra's style began to emerge in them. Among other innovations, he removed the make-up from Holt and Graves and made them tough guys far removed from the typical movie heroes of the period. The trade now recognized Capra as a box-office director in the "programme picture" field, and after *Submarine*, Harry Cohn gave him a contract at $25,000 a year. He had made his first picture at Columbia for $1,000.

New Colleagues

1930. *Ladies of Leisure*

Capra wrote the script for a projected film to be called "Ladies of the Evening," from Milton Gropper's play. "Cohn," says Geoffrey Hellman in *The New Yorker*, "was delighted with it. He sent copies to his staff writers and asked them for their opinions at a conference held just before production was to start. One man after another proclaimed the script admirable in every way, while Capra, sitting next to Cohn, beamed. Finally Jo Swerling, a New York newspaperman who was in Hollywood on a six weeks' contract with Columbia and had never met Capra, read fifty specific notes he had prepared on the script, tending to indicate that it was preposterous and an insult to show business. "I noticed a little dark guy I thought was Cohn's secretary," says Swerling "staring at me murderously as I read my report." Cohn introduced Swerling to Capra after the meeting and Capra insisted that his detractor be retained as his collaborator. "Ladies of the Evening," rewritten by Swerling, was filmed as *Ladies of Leisure.*

Besides achieving Capra's (and Columbia's) greatest popular success to date, the picture attracted the attention of the critics. It was a harbinger of the new sophistication, the more realistic approach to American life, which arrived with the talkies and the depression. *Ladies of Leisure* also made Barbara Stanwyck a star. United Artists had brought Miss Stanwyck from Broadway to Hollywood for *The Locked Door* (1929), after which there was no further demand for her services.

In accordance with his policy of signing stars for one picture after they had been dropped by the major studios, Cohn cast Miss Stanwyck in *Ladies of Leisure,* and it was Capra who discovered and brought out the naturalness and sincerity which for many years distinguished her acting.

1930. *Rain or Shine*

This, Capra's only musical to date (he says he is still interested in that form) was a harum-scarum extravaganza freely adapted to the screen. Critics and connoisseurs of Joe Cook deplored its departures from the original, but it was notably more successful than the many musical comedies of the period which had been brought literally to the screen.

1931. *The Miracle Woman*

This thinly veiled, and somewhat sweetened, recapitulation of the career and methods of the notorious woman evangelist, Aimée Semple Macpherson, struck the New York critics as an effective combination of drama and hokum, the latter quality being perhaps what was subsequently described as "Capra-corn." *The Miracle Woman* foreshadowed the topical film cycle which in the next few years was to turn the spotlight of critical realism on current events, at the same time conforming perfunctorily to popular preferences and prejudices. Thus the methods of the evangelist racket are mercilessly exposed, but the heroine is saved from obloquy by an unconvincing reformation brought about by the power of love. Again Capra relied upon Miss Stanwyck to make the reformation believable, and again her honest performance turned the trick, at least to popular satisfaction.

1931. *Platinum Blonde*

Since Jean Harlow's debut in *Hell's Angels* had just popularized the platinum blonde coiffure, it was natural for Cohn and Capra to exploit the new sensation. Miss Harlow was ludicrous as a scion of aristocracy, but she was only a nominal attraction. The film's interest derives from its story situations, which seem to predict some of Capra's greatest successes. The role of Gallagher, played here by Loretta Young, is surely the prototype of the several Capra heroines, customarily acted by Jean Arthur or Barbara Stanwyck, whose whimsical tough-mindedness cures the hero of delusions about himself or others. The film was warmly praised for the effective performance of the late Robert Williams, for the acute realism of its scenes of newspaper life, and for its bright dialogue

by Robert Riskin. This was the first time that Riskin, a former playwright who had joined Columbia in 1930, and Capra worked together.

1931. *Forbidden*

Forbidden resembles many of the "confession" films popular in the early thirties, in particular *Back Street* and *Possessed,* being almost a carbon of the latter. Acknowledging this, contemporary criticism emphasized how believable Capra had made (his own) trite story, in contrast with the wholly meretricious versions of Joan Crawford, Irene Dunne, and Norma Shearer then current.

AMERICAN MADNESS AND AMERICAN VALUES

JOHN RAEBURN

Frank Capra could not have chosen a more inopportune time than 1932 to make a film with a banker as hero—in the previous year more than 2000 banks had failed and bankers were in disrepute everywhere—but in spite of its unseasonableness, *American Madness,* his film about an idealistic banker, is one of the finest American movies to emerge from the early years of the Depression. Very little in Capra's early career as a director suggested he was capable of creating a film as sharp in its social observation and as ambitious in its analysis of American values as this melodrama about robbery, murder, a bank panic, and the conflict between social responsibility and greed. In the mid-1920s he had directed three silent comedies starring Harry Langdon, and then a series of low-budget "quickies" for Columbia Pictures, most of them competent enough but not particularly distinguishable from scores of other movies made at the time. *American Madness* was the first film in which Capra demonstrated his maturity as an artist, and it heralded the beginning of a remarkable fifteen years in which he would direct a number of the finest and most satisfying films ever produced in Hollywood.

There is a good deal of "business" in the plot of *American Madness* but basically the film centers on what would become Capra's perennial subject in his best films: the conflict between a resolute individual, full of goodwill toward his fellow men, and the forces of disunity and corruption who would create and exploit social dislocations for their

own benefit. Tom Dickson, the film's hero (Walter Huston), is a bank president who believes that loans should be made on the basis of character rather than collateral, and that in hard times it is especially important that banks circulate and not hoard their money. Dickson's conservative board of directors opposes his unorthodox philosophy of banking and tries to force him to agree to a merger with a larger bank, a deal which would net all of them, including Dickson, a tidy profit, and would put the affairs of the bank in more "responsible" hands. Dickson refuses even to consider the merger; to agree to it would mean abandoning his friends, the bank's customers.

At the very moment that his board is pressing him, however, an event is taking shape elsewhere in the bank which will force the issue. The bank's head cashier, deep in debt to a local underworld figure, agrees to rig the time lock on the vault so that the mobster and his gang can plunder it. While cleaning out the vault the gangsters are surprised by the night watchman, and they shoot and kill him in making their escape. Suspicion falls on Matt Brown (Pat O'Brien), an ex-convict whom Dickson has hired and helped to rehabilitate. At the same time, a panic develops among the bank's depositors as the news of the robbery spreads, and a run on the bank begins. Dickson at first tries valiantly to save the bank—getting no help at all from his board of directors, who see the run as the wedge they need to force Dickson to follow their wishes for a merger—but he then gives up and apathetically agrees to follow the board's wishes when he mistakenly thinks his wife has had an affair with the oleaginous head cashier. A clever detective uncovers the cashier as the inside man in the robbery; and shortly thereafter, Dickson's friends— small businessmen whom he had saved when they were in trouble by lending them money on their character—begin to stream into the bank and force their way through the crowd in order to make deposits, all the time loudly proclaiming their faith in Dickson and his bank. The panic begins to subside and then collapses completely when the board of directors, repentant because they realize how shortsighted they were, pledge their own personal resources to shore up the bank's cash supply. Vindicated by this show of loyalty on the part of his depositor friends, Dickson is revitalized, straightens out the misunderstanding with his wife, and the film ends with the bank still securely in his capable hands.

Capra's mastery of his medium is obvious in *American Madness,* as it would be in most of his later films. Form and content are inextricably linked, and meaning derives from the fusion of the two. The tempo of the film, for example, is perfectly synchronized with the action. In the opening scene the camera lingers over the employees preparing for the new business day, and concludes with a long and leisurely tracking shot

which follows the tellers as they roll their money carts from the vault to their stations. Nothing extraordinary is yet happening, as the camera itself tells us. Later in the film, when Capra uses a similar lengthy take again, it is to follow Tom Dickson as he moves from one teller's window to the next after the run has begun, trying to rally his employees as a general moves from position to position in a battle giving encouragement to his troops. This time the camera moves neither slowly nor fluently: it is jerky and staccato, conveying the urgency of the moment. As the intensity of the panic increases, Capra reduces the duration of each shot and uses more and more cross-cutting and jump-cuts to emphasize the "madness" of what is happening on the screen.

Like any superior artist Capra shows rather than tells his audience what it needs to know. The relationship between Cyril Cluett (Gavin Gordon), the chief cashier, and Dude Finley (Robert Ellis), the gangster to whom he is in debt, is obviously an important one which has to be established early in the film; and Capra reveals it with a visual subtlety and an economy beyond the powers of a less gifted director. In a long shot we see the dapper Finley enter the bank, followed at a step by two larger men in slouch hats. They stop in the middle of the bank floor; suddenly the camera assumes Finley's point of view and zooms in on the hands of a teller counting out a large stack of bills, then just as quickly it retreats to a middle shot of the three men, who in the space of a few seconds have been pegged as definitely shady. Next we see Cluett come out of his office and recognize them at a distance; he is taken aback and clearly would like to avoid a meeting, but they see him before he can move. At this point the camera shifts to a fixed medium position behind Cluett, and we see him walking the twenty-five or thirty feet away from the camera toward Finley and his henchmen. They remain where they are and do not move forward at all to greet him. By these purely visual means, Capra establishes not only Finley's disreputability, but also Cluett's indebtedness to him. It is only when the four men are walking together back to Cluett's office that we overhear one of the bank employees say to another, "Isn't that Dude Finley? He's one of the toughest gangsters in town."

As Graham Greene later noted, Capra understood perfectly the added possibilities the introduction of sound gave to film. " . . . He hears all the time just as clearly as he sees and just as selectively," Green wrote, and this creative use of sound is as apparent in *American Madness* as it is, for instance, in the more famous example of Paul Muni's whispered, "I steal," at the conclusion of Le Roy's *I Am a Fugitive*. Thanks to Robert Riskin, who wrote the screenplay for *American Madness* as well as for a number of later Capra films, the dialogue is vivid and colloquial, laced

with those Americanisms which H. L. Mencken only a few years before had savored in *The American Language*. Capra added to the naturalistic quality of the dialogue by having speakers overlap one another, as they often do in ordinary life; this was an innovation that helped to move the talkies away from the example of the legitimate stage, which early in the history of the sound film was an accepted but imperfect model for it.

It was not only with language, however, that *American Madness* extended the resources of the sound film. Capra also used sound as an important element for creating mood and for underscoring what was being seen on the screen. The opening scene, as we have seen, takes place in the vault room of the bank, and Capra uses the echoes of footsteps, rolling money carts, voices, and doors being opened and closed to create an eerie feeling of loneliness and isolation, subtly undercutting the leisurely ordinariness of the beginning of the business day. The importance of this aural foreshadowing only becomes apparent when late that same night Dude Finley and his gang are robbing the vault. We follow the night watchman by his flashlight beam and the sound of his footsteps until he discovers in the silent and shadowy darkness that the vault door is open. The camera then moves inside the vault, looking out at the feeble beam of light being directed into it. Suddenly and without warning there are two loud explosions and two blinding flashes of light, and the watchman staggers; we then dimly see three figures dart out of the vault, but we hear clearly the departing echoes of their shouts and footsteps as the watchman fires an erratic shot and falls heavily to the floor. The shock and terror of this scene are amplified greatly by Capra's selective use of both sound and light, each of them reinforcing the other.

That *American Madness* was not a film with sound added, but was truly a sound film is most apparent in the mob scenes during the run on the bank. Except for Griffith, Capra was without peer among American filmmakers as a director of crowds. They both shared the ability for individuating the members of a crowd while at the same time conveying a vivid sense of its collective nature. The crowd, in other words, was for both an active principal, not a backdrop against which the action is played. But if we compare the mob scenes in *American Madness* with those in *Intolerance,* we see that Capra's use of the mob is even more effective than Griffith's, because he had sound to work with and Griffith did not. This is not so much a question of verisimilitude as of intensity of dramatic effect. At the beginning of the bank run, when the crowd is just beginning to form, we distinctly hear the rapid click of footsteps as the depositors hurry in to make out their withdrawal slips. Except for the noise of their coming and going there is an ominous silence. Soon, however, the crowd swells in size and we can no longer hear individuals;

instead, what we hear is an indecipherable murmur that steadily grows in volume as more and more people stream into the bank; now and then it is punctuated by an almost disembodied angry epithet or desperate cry. The camera and the microphone work together organically in these scenes. At one point, when the frustration of the mob is beginning to peak, the camera withdraws from ground level to a crane shot of the entire floor of the bank. We are watching the crowd milling about aimlessly and hearing the steady hum of its dissatisfaction, when, out of the corner of our eye, we see more violent movement at the edge of the screen at the same instant that we hear muffled shouts from afar. The camera moves in on that sector of the floor and the shouts become louder as we now see that two men are shoving and swinging at one another. We never discover why they are fighting, but it is hardly important. What is important is that this mob is getting uglier and more violent—it is out of control—and what we have heard as well as what we have seen have been equally instrumental in conveying that to us.

The hysterical panic of those who are trying to withdraw their savings from the faltering bank is the most obvious reminder that American Madness is a film about the Depression, but it is not the only one. At every moment we are aware of the cankerous effect of the Depression both on institutions and on individuals: the tellers joke with a nervous bravado about bank failures and breadlines; for financial reasons, Matt Brown must delay his marriage to his sweetheart; Tom Dickson neglects his wife while trying to convince other bankers of the necessity of an unorthodox approach to banking policy; and the bank directors doggedly insist on the need for fiscal conservatism in such "precarious times." The fearful and panicked mob is simply the objectification of the profound anxiety felt by everyone in this society.

But if American Madness reflected the disorientation and tense apprehension felt by members of its contemporary audience, it also held out hope for a better future. It did not suggest that "prosperity was just around the corner," as Herbert Hoover had intimated a year or two earlier, much to his later chagrin, but it did propose that "the only thing we have to fear is fear itself," which almost a year later was to become the rallying cry of the New Deal. In fact, American Madness anticipated the New Deal in a number of ways, notably in excoriating the bankers (excepting Dickson, of course) who had "failed through their own stubbornness and their own incompetence" (the words are Roosevelt's in his Inaugural Address), and in proposing a quasi-Keynesian economics which gave highest priority to increased spending brought about by loans made on character rather than collateral, the banking equivalent of an unbalanced federal budget. The way to recovery lay in casting aside the

discredited shibboleths of the past, retaining what was still functional in the economic system, and relying more on the essential industriousness and goodness of the American national character. If we all pull together, the film seemed to say, we can lick this Depression.

American Madness, then, was a self-consciously topical film, rooted in the social tragedy of its times in a way few other Hollywood movies were. Capra's willingness to confront directly questions of social and cultural value—his artistic ambition, in other words—was one of the reasons his work was, and is, so satisfying. Yet for all its timeliness, the society we see in the movie is not American society of the 1930s, or even the 1920s; it is American society of the mid-nineteenth century, and even at that it is probably mythical. The story takes place in New York City, yet like a small-town banker Dickson knows many of his customers personally. He also is aware of the personal problems of his employees, from the janitor to the tellers, and maintains a benevolently paternal attitude toward all of them. His disparagement of the basic financial structure of the United States would hardly have come from a real twentieth century banker. The right kinds of security for a loan, he says, are not "stocks and bonds that zig-zag up and down, not collateral on paper, but character." J. P. Morgan placed his emphasis on character, too, but he also demanded collateral, and he certainly never derided Wall Street. A banker of 1932, whatever his shock at the breakdown of the financial structure, would hardly characterize that structure as outmoded and irrelevant. Those men whose character Dickson believes in, moreover, are not the kind of customers a New York bank would more than moderately care about. We hear their names clearly at several points in the film—Henry Moore, Manny Goldberg, Tony Cazzaro, Joseph Macdonald, Alvin Jones—small businessmen all, not a titan of industry or finance among them. "Jones is no risk," Dickson tells the directors, "nor are the thousands of other Joneses throughout the country. It's they who have built up this nation to be the richest in the world, and it's up to the banks to give them a break." As even Jay Gatsby's father knew, magnates like James J. Hill were the men who "helped build up the country," not small entrepreneurs like Jones. The health of the economy in 1932 depended on the balance sheets of enormous corporations like General Motors, RCA, and AT&T, and small businesses prospered or failed in relation to the vicissitudes in the earnings of these giants. The most anachronistic feature of the film, however, was Capra's assumption that the bank itself was inseparable from the living presence of Tom Dickson, its president. Emerson wrote that "an institution is the lengthened shadow of one man," a proposition Capra eagerly gave his assent to, but whatever the truth of Emerson's maxim in 1840, it was not true for

economic institutions a century later. By that time, corporations, including New York banks, were complex bureaucracies that guaranteed that no single man would wield the kind of authority and power that Capra gives to Dickson in *American Madness*.*

There was of course a considerable degree of nostalgia in Capra's treatment of Tom Dickson and his bank, certainly not an unusual attitude in a period of extreme social distress. But Capra's nostalgia had a cutting edge that uncovered the reason for the passing of the old system, and it gave to his film a significance that a purely sentimental look at the past would have lacked. If it had not been a comedy, *American Madness* would have been an elegy for individualism; but since it was a comedy it pretended as if individualism were still the dominant ethic, while at the same time it undercut its own primary assumption by demonstrating that Tom Dickson was the last of a dying breed. He is opposed by virtually everyone who has any power—the board of directors and the other New York bankers to whom he vainly appeals for help—and although he does win this one victory, there is no guarantee that he will not be defeated the next time. Dickson is out of step with his times. He refuses to consider the possibility of merger, he rejects the idea of bigness and organization. His personal stake in the management of the bank is more important to him than a large profit. Even the names Capra gives to the banks—Dickson's is the Union National Bank, reminiscent of the mid-nineteenth century with its emphasis on the "union," a federation of sovereign entities, while the bank with which the directors hope to effect a merger is the New York Trust, unmistakably located in the very heart of American corporate and financial power, and bearing as its last name the word that for Americans had come to represent the colossal centralization of economic power—even these names underline the central social conflict which the film portrays. Capra was not of course the first to point out that the concentration of capital in ever-expanding corporate enterprises was making the individualistic ethic obsolete, but he was among the few artists—certainly in Hollywood, the very few—who were able to give this perception suitable dramatic form.

Capra's skillful exposition of the clash between the corporate and individualistic ethics would alone have made *American Madness* one of the most interesting films of the 1930s, but there is more to it even than that. Like Mark Twain, an artist whom he often resembles, Capra portrays American culture at its breaking point, but always within the

*An exception to this—and an important one in this case—were the Hollywood studios, where one man often was the absolute boss, e.g., Harry Cohn of Columbia Pictures.

context of a comic vision. The critical situation brought about by the economic catastrophe of the Depression, like the crisis of slavery, threatens to tear the society apart and turn its members into a vicious and bloodthirsty mob. To symbolize the profundity of this crisis, Capra employs the imagery of traditional religion, yoking it to the "religion" of American belief in small, individual enterprises. The Union National Bank itself (and the film was shot on a set, not on location), with its high ceilings, vast floor, and austere marble interior reminds one of nothing else than a grand cathedral; the bank offices are located on a balcony overlooking the floor, and it is from the steps leading to this balcony, or pulpit, that Tom Dickson unsuccessfully tries to reason with the unruly mob. Dickson's office looks more like a cardinal's chambers than a bank president's office—it has a fireplace and is richly furnished—and a number of scenes in it are played before a stained glass window which features, instead of the iconography of the church, a Leger-like representation of the symbols of industry. Even the door of the bank vault itself, where so to speak the materials for holy communion are kept, is embossed with crosses and is often seen in a medium-long shot framed by a romanesque arch. All of this imagery suggests that a fundamental set of beliefs is in danger of collapse, and that the faith of an entire people is in jeopardy. By the end of the movie that faith is of course reaffirmed, but we have no evidence that this victory is anything other than a temporary one.

It is in the scenes of the mob panic that Capra portrays most vividly his alarm about the state of American culture in the early years of the Depression. The fear of mobocracy was one that had long disturbed analysts of the American scene, from Alexis de Toqueville to Mark Twain to Henry James. In the very year that *American Madness* appeared, President Hoover dispatched General Douglas MacArthur and four troops of cavalry, a column of infantry, and six tanks to drive out of the Anacostia Flats of Washington some 15,000 army veterans petitioning Congress for a bonus. They were a "mob," said MacArthur, motivated by "the essence of revolution." A few years later Nathanael West would use the purposeless frenzy of a mob at a Hollywood premiere as a symbol of American culture at the end of its tether. The mob in *American Madness* is anarchic like West's rather than (putatively) revolutionary like MacArthur's, but its threat to the American belief in a reasonable and moderate order imposed by a thoughtful citizenry is as great.

In one of the most extraordinary montage sequences in the history of American movies, Capra portrays the dissipation of rationality under stress, and the concomitant growth of a mob psychology as panic begins to take over. This sequence opens with a shot of a switchboard operator behind a confused grid of telephone lines—the potential for mass panic

increases rapidly with the development of electronic media, as the radio broadcast of *The War of the Worlds* would dramatically illustrate a few years later—and then in a sequence of perhaps fifty shots, each lasting only a few seconds, we follow the story of the bank robbery as via the telephone it permeates almost instantaneously every level of society. The facts of the theft are immensely exaggerated in the process, and the actual loss of $100,000 becomes $5,000,000 by the time the story is told a few dozen times; the rumor that it was an inside job, moreover, turns into the conviction that Dickson himself has engineered the robbery. By the end of the sequence those who have heard the rumors have lost all semblance of rationality: they stampede the bank in a frantic and sometimes violent effort to withdraw their funds. Capra integrates the form of this montage with its meaning; form indeed becomes meaning. Not only does the rapidity with which we see the series of individual vignettes contribute to the sense of increasing panic, but the angle of vision itself in these shots creates a feeling of agitation. Capra was a superb technician, but his camera was unobtrusive and he rarely used it in a way which would call attention to the composition of the shot; in this montage, however, many of the individual shots are obliquely framed and the shooting angle is frequently an unexpected and therefore jarring one. Surely this sense of disorientation and disorder explicit in the content of this sequence and implicit in its form is the meaning of the title of the film. Something was happening in American society that was unhinging it.

Individual man, under the pressure of the Depression, was becoming mass man, and mass man was irrational, cruel, and uninterested in the value of community. Capra recently said—referring to *Mr. Deeds Goes to Town,* but the statement is even more appropriate for *American Madness*—that he "was fighting for . . . the preservation of the liberty of the individual against the mass." Tom Dickson is the exemplar of that besieged individual man, and he successfully resists absorption into the herd, and in fact disperses the herd, at least temporarily. But the potential for the mob to form again is still there—is *always* there—and if the conditions are right, it will surely reappear. The comity of American society (at least in Capra's model of it) is based upon the goodwill and the reasonableness of its members; and its encouragement of individually determined standards of conduct is at once its greatest strength and its greatest weakness. If it allows the fullest freedom for the individual, it also, as Toqueville noted, provides the conditions by which the majority may tyrannize a minority, by which, in short, a mob may usurp power and override reason.

This perception informs much of the action of *American Madness,*

but is given specific representation in the figure of Oscar (Sterling Holloway), one of the tellers. Oscar is *l'homme moyen sensuel,* not corrupted like Cyril Cluett, not inspired by a lofty ideal like Tom Dickson; he is also the dramatic depiction of the potential ugliness which a social dislocation can uncover in the average man. He delights in disaster because of the tempting possibilities for self-aggrandizement it gives him. Shortly after the board of directors arrives to confront Dickson, we see Oscar spreading the rumor to the other tellers that Dickson is "out on his ear"; "everyone's talking about it," he says, although in fact no one except Oscar is. This little scene foreshadows his behavior after the robbery and murder: once again, Oscar is spreading an ugly rumor, this time that ex-convict Matt Brown was the inside man in the crime because it was he who was supposed to set the clock which locked the vault. Now, under the sway of Oscar's insistence, the tellers begin to believe him. Like those depositors who precipitate the run on the bank, Oscar is willing to believe the worst of anyone and to promulgate rumors which destroy the goodwill on which the society is founded. Oscar was also the first to discover the body of the night watchman, and he delights in telling and retelling the experience. We see him with the other tellers in the vault room as the police are going over the scene of the crime. Someone asks him if there was much blood, and Oscar gleefully replies, "Was there much blood? Come on over fellows, I'll show you!" A policeman has to shoo them away. As the rest of the story unfolds, Oscar tells the story of his discovery to anyone who will listen, always concluding it with the peroration, "You could have knocked me over with a pin." The tragedy provides him with an occasion to assert his own importance—something denied him in less excited times—and in this he exactly resembles the man in the white fur stovepipe hat who reenacts for the admiring citizens of Bricksville the shooting of Boggs in *Adventures of Huckleberry Finn.* That episode, like *American Madness,* concludes with a scene of mob hysteria, and although Twain does not tell us whether the man in the white fur stovepipe hat was a part of that mob, we recognize that his response to the death of Boggs partakes of the same cruelty and irrationality which animates the mob trying to lynch Colonel Sherburn. Just so, Oscar shares a psychology with the mob that stampedes the bank, even though he himself is not a member of it. All that is required for the worst qualities of Oscar, the man in the white fur stovepipe hat, and the respective mobs to emerge, is a crisis, and then they easily shed their covering of decency and individuality and become mass men.

American Madness was much more than a "fantasy of goodwill," as Richard Griffith later characterized Capra's movies. The sense of crisis

brought on by the Depression, with all of its implications for the private lives of Americans, permeates the film; and that crisis was far from over in 1932. Capra realized that it took very little in such times to unbalance the delicate equilibrium of American society, and the film never suggests that the period of testing was over. The goodwill was there but so was the implication that the battle would have to be fought again and again. The happy ending of *American Madness,* with Tom Dickson triumphant, only nominally resolved the insistent tension between the individualistic values Capra affirms by his portrait of the benevolent, resolute bank president and the herd instinct of Oscar and the mob which storms the bank; and it is the verve and subtlety with which this tension is made palpable that gives to the film its significance as both a social document and an important work of the imagination.

FRANK CAPRA AND SCREWBALL COMEDY

ANDREW BERGMAN

Film comedy in the early thirties had blown things apart. Destructive and corrosive, the Marxes and Fields and Lubitsch had been of a piece with the cold-eyed, suspicious and edgy spirit of 1930-1933. In the mid-thirties, something new emerged: a comedy at once warm and healing, yet off-beat and airy. Film historians would label this phenomenon "screwball" comedy.[1] The titles are familiar: *It Happened One Night, Mr. Deeds Goes to Town, My Man Godfrey, You Can't Take It with You, Easy Living, Nothing Sacred,* and *The Awful Truth* have endured the years with grace and verve. And for good reason. They were (and remain) very funny, perfectly paced, and alive with good humor and terrific people. They left one with what Frank Capra, the most notable of the "screwball" directors, called "a glow of satisfaction."[2]

The glow was genuine: screwball comedies were received with love and are to this day. (One has only to attend a screening of *Mr. Deeds* or *It Happened One Night* to see the hold these films still have over their audience, especially those who remember them from the thirties.) They were special films, for a number of reasons.

First, they brought out the best in a number of incredibly attrac-

tive and talented actors and actresses. In Capra's *It Happened One Night,* Clark Gable came into his own as an ironic masculine presence, played off against Claudette Colbert's uncertainty and dewiness. Jean Arthur (*Deeds, You Can't Take It with You, Easy Living,* and *Mr. Smith Goes to Washington*) had the most wonderful speaking voice anyone had ever heard: she was the one movie star men could actually visualize marrying. Carole Lombard quivered with easily cured neuroses in *My Man Godfrey* and *Nothing Sacred* and was a beautiful comedienne. Capra turned Gary Cooper, in *Deeds* and *Meet John Doe,* into the off-beat embodiment of small-town simplicity, honesty and common sense.

But the overwhelming attractiveness of the screwball comedies involved more than the wonderful personnel. It had to do with the effort they made at reconciling the irreconcilable. They created an America of perfect unity: all classes as one, the rural-urban divide breached, love and decency and neighborliness ascendant. It was an American self-portrait that proved a bonanza in the mid-thirties.

Lewis Jacobs has stated the conventional view: "If 'screwball' comedies successfully turned the world on its ear, that was perhaps the way it already looked to a depression generation which felt cheated of its birthright."[3] The "screwball" quality is taken as a kind of veneer, a desperate cover for Depression-bred alienation. Arthur Knight soberly notes that these comedies had "as their points of departure the terrible realities of the period—unemployment, hunger and fear."[4] Neither perspective really seems to work. The screwball comedies were very much a response to the Depression, but not in the tradition of alienation implied by Jacobs and certainly not as the socially aware documents Knight attempts to make of them. Simply stated, the comic technique of these comedies became a means of unifying what had been splintered and divided. Their "whackiness" cemented social classes and broken marriages; personal relations were smoothed and social discontent quieted. If early thirties comedy was explosive, screwball comedy was implosive: it worked to pull things together.

Frank Capra's America

Frank Capra's early years could be textbook assignments on the humble beginnings of great men. The Capras arrived in California from Sicily in 1903, and young Frank started hawking newspapers to help keep the poor family solvent. Graduating from high school at a precocious fifteen, he entered the California Institute of Technology and worked his way through school, waiting on tables and running a student laundry. He

graduated in 1918, entered the service, and emerged from his hitch into a career crisis. Dropping chemical engineering, Capra drifted, did farm work, was an extra in some westerns, and sold dubious mining stock to gullible farmers and farmers' wives. Going from door to door, he became a "tinhorn gambler and petty financial pirate."[5]

Capra's movie-making vocation began as part of his quest for some easy money. Arriving in San Francisco, he told a local producer, "I'm from Hollywood," and was hired to direct "cine-poems" for seventy-five dollars per week.[6] From that point in the mid-twenties, Capra was set in pictures, blossoming into a major director in the early thirties, and becoming a star director with *Lady for a Day* in 1933. In 1934, Capra got Columbia Pictures to purchase, for five thousand dollars, the rights to a Samuel Hopkins Adams story entitled "Night Bus." MGM lent the services of a second-rank star named Clark Gable, and Capra borrowed Claudette Colbert from Paramount. Neither star was enthused by the prospect of working at Columbia, at that time a decidedly second-class studio. The budget was minimal. Nevertheless, *It Happened One Night* became *the* picture of 1934, stirring a genuinely spontaneous wave of affection throughout the country, playing return engagements and making the fortunes of Columbia, Colbert, Gable, and Frank Capra.[7] Screwball comedy dominated the rest of the decade.

Capra's erratic background was reflected in his best films. The seemingly wide-eyed immigrant boy who travelled the traditional path to success in college (carrying trays in the commons, pen and slide rule concealed beneath the white jacket) was obviously one with faith in the classic American route to opportunity and fulfillment. But the Capra who hustled farmers and sold coupons to their wives, the Capra who turned from chemical engineering to the glib sales pitch and "I'm from Hollywood," was more cold-eyed than wide-eyed. Those two Capras—immigrant dreamer and con man—gave a peculiarly attractive and beguiling quality to his best work. He had a perfect pitch for Americana, for depicting what he passed over as American types, and a sheer genius for manipulating those types. Capra's comedy was a wide-eyed and affectionate hustle—the masterwork of an idealist and door-to-door salesman.

Capra's Films, 1934–1941

It Happened One Night (Columbia, 1934)
Mr. Deeds Goes to Town (Columbia, 1936)
Lost Horizon (Columbia, 1937)
You Can't Take It with You (Columbia, 1938)

Mr. Smith Goes to Washington (Columbia, 1939)
Meet John Doe (Warner, 1941)

Before creating the screwball comedy, Capra seemed comfortable with the shyster mania that prevailed between 1931 and 1933. *Platinum Blonde* (Columbia, 1931) showed his initial sympathy with, and attraction to, newspapermen and their racy urban milieu. His hero was an urban Mr. Deeds, an individualist ace reporter with disdain for a world of "phonies." By 1936, the "phonies" would include those very newspapermen. In 1932, Capra directed a movie about bank failures entitled *American Madness,* with Walter Huston the beleaguered and incorruptible banker, kept afloat during the panic by the faith of his depositors.[8] That kind of faith was typical of Capra.

His next vehicle, *Lady for a Day,* was taken from a Damon Runyon story ("Madam La Guimp"), and the choice of material indicated Capra's continued affection for the shyster city. Runyon's world was peopled by the breezy and the sleazy of a Broadway long since gone. Capra revelled in the efforts of various blondes, race touts, and gamblers to pass off "Apple Annie" as a lady of wealth to secure her daughter's marriage to royalty. Eventually, the police and Mayor and Governor of New York pitch in to bring off the deception. It was all urban, this unity—a cheerful combine of all the types Capra would turn against in *Deeds.*[9] A different city—cynical and destructive—appeared in his work from 1934 on.

In the late thirties, Capra evolved the shyster into a vaguely fascistic threat. The urban sharper became the Wall Street giant, communications mogul, munitions kingpin, and reactionary political force embodied in the corpulent and bespectacled figure of Edward Arnold. Capra's emphasis upon the melting of class tensions changed as the decade ended. Class amiability, the end of *It Happened One Night* and *You Can't Take It with You* (and non-Capra works like *My Man Godfrey* and *Easy Living*), became a means. If the mid-thirties witnessed a stress on the resolution of social tensions, Capra, by 1939, fancied that resolution to be an accomplished fact. And so the common decency of all Americans, rich and poor, got turned, in *Mr. Smith* and *Meet John Doe,* against threats to our most sacred national institutions. Capra was exchanging the symbols and dynamics of the thirties for those of the forties.

With *It Happened One Night,* the first of the screwball comedies, Capra began to turn against the city. His central character, Peter Warne (Gable), was a newspaper reporter and had all the qualities the early thirties had bestowed upon that role: brash, resilient, more interested in sensation than in personal financial gain. He was a man of the city. Yet

Capra added dimensions to his character that pointed toward liberation from the iron-clad cynicism of the New York reporter: a vague idealism and dreaminess that aimed at escape, an offbeat cockiness that could effect that escape. Capra's two greatest films—*It Happened One Night* and *Deeds*—both involved the liberation of newspaper reporters. In *Deeds,* the reporter would stand for a whole range of debased urban values, but Gable's role is more complex. He was part hack reporter, part Longfellow Deeds, the small-town idealist.

He hates the newspaper world and vaguely yearns to get out. "I saw an island in the Pacific once," he tells millionairess Ellen Andrews (Colbert). "Never been able to forget it." But he is still the wise-cracking news hawk, feuding with his editor and hot for scoops. And adjusting that great thirties hat (brim down), Gable looked the perfect reporter. When he comes across the heiress Ellen Andrews, she is attempting to escape from her father (Walter Connolly) by bus. She remains at his side, at first out of fear that he will reveal her whereabouts and then, inevitably, out of love. From the process by which mutual cynicism melted before romance evolved screwball comedy.

The "screwball" act was individualistic, idiosyncratic, and, above all, disarmingly open. Capra said that his films insisted upon characters who "are human and do the things human beings do—or would do if they had the courage and the opportunity."[10] His central characters had both. When their night bus is halted by a torrential rain, Warne unhesitatingly takes a single room for himself and the skittish millionairess—and then proceeds to hang a blanket between their beds, calling it the "wall of Jericho." The blanket separates, but the offbeat act of putting it up brings them closer together. They wisecrack over it, get comfortable with each other. The fact that Ellen is short of funds and dependent on Warne's lower middle-class street wit just to survive foreshadows the ultimate melting of class barriers between them.

In a famous hitch-hiking episode, Gable nailed down his stardom when he claimed to have perfected all the nuances of the thumb. He completely fails. Colbert demonstrates her own resourcefulness by stepping to the road, raising her skirt, and bringing the first car to a screeching halt. Both having demonstrated their "screwballness," their class differences disappear. Audiences loved them and loved Capra—for their daring, and his.

When her father's private detectives come pounding on their motel door, the couple inventively phases into a comic, mock married squabble: he the exasperated slob of a husband, she the shrill and hysterical plumber's daughter. The detectives exit in confusion, mumbling about "wrong room"—and Peter and Ellen draw even closer. It set the pattern

for all screwball comedy: each act of inventive fancy resulted in greater unity. And in *It Happened One Night,* as in most screwball comedy, that invention broke down walls rooted invariably in class. Peter and Ellen—he a working stiff, she with millions—come to each other with strong initial antagonisms. At the film's beginning, he is full of loathing for her world of wealth and society parties, full of contempt for her flight to marry a playboy named King Westley. Peter calls her a "spoiled rich kid. . . . Haven't you ever heard of humility? You, King Westley, your father are all a lot of hooey to me." She is put off by his brashness, appalled and secretly thrilled by his world.

But Capra, Colbert, and Gable were hardly about to lead us to class warfare. The director discovers rich stores of "screwballness" and good humor not only in the young couple but in Ellen's wealthy father as well. Having made his fortune by tough initiative, not sloth, he greatly prefers Peter's individualistic strength to the idle, polo-playing wealth of Westley. He therefore helps effect his daughter's marriage to Peter. Walking down the aisle on the day of her scheduled wedding to Westley, he turns to Ellen and whispers "You're a sucker to go through with this" and informs her that a car waits. Clad in white, the bride dashes away from the elaborate ceremony, as the assembled guests stand in horror, to the arms of Clark Gable.

The good sense of the wealthy father should perhaps be no surprise; one acute analysis of Hollywood's attitudes toward the rich noted that the "rich household itself is fumed against, but the kingpin of the household is not."[11] The leftist *New Theatre* was appalled at the "wish-fulfillment" involved in the portrait of "a grumpy plutocrat who, of course, had a heart of gold. *It Happened One Night* took place in a social and economic vacuum."[12] It was not so much a vacuum as a fantasy. For Capra, Americans were all the same—social class served as a character, rather than an economic, definition. Beneath the silk hats were common men who had ridden their initiative all the way. "Class" conflicts, in mid-thirties comedy, were really personality conflicts, and hence easily resolved by a good chat. So at the unifying conclusion of Capra's *You Can't Take It with You,* super-plutocrat Edward Arnold whips out his harmonica and plays along with the "whacky" Vanderhof family, immediately embracing their values.

With the wealthy father simply John Doe writ large, carrying a contract-filled briefcase rather than a lunch bucket, Capra helped reinforce an important myth in America. And the myth was rarely as important as in the mid-thirties, when the pieces of the old success formula were being carefully glued back together. Robert and Helen Lynd quote a 1936, Muncie, Indiana, editorial on the subject:

Nearly All Are in "Working Class"

In the United States ... every man has worked who had the ambition and the opportunity to do so. There has been no class of idle rich. The average industrialist has put in as many hours as the salaried man or wage earner, and he often points with pride to the number of jobs he has been able to afford for others through the effort of his own thrift, intelligence and industry.

... The great danger is that an attempt at redistribution of wealth, through increasingly high taxes, will end in poverty and misery for all, as has been the case in Russia. But there is another danger which is just as great—a danger that the United States will become a nation of class-conscious haters. Such a condition will spell the end of American prosperity and progress.[13]

The Alexander Andrews type was by no means limited to Capra. As Barbara Deming observed:

... film after film is obedient to a compulsion to clear of any serious censure the big money man, the big breadwinner. ... Censure of the idle rich but not of the rich who work for their money is of course in the Puritan tradition. And it is in that tradition for a millionaire to be identified with ... the common man. For is he not just that—the common man who has fulfilled himself?[14]

Other successful screwball comedies picked up on this trend. *My Man Godfrey* (Universal, 1936. Director, Gregory LaCava) set "hobo" William Powell (really a Boston blueblood) as a butler in the bizarre household of the fabulously wealthy Bullock family. Carole Lombard floats about in a starry stupor, her mother exists in total befuddlement, but the head of the house, Eugene Pallette, is rock solid, a wealthy common man attempting to cope with his "zany" women. Powell finds no trouble in convincing him of a scheme to get the jobless back to work and builds a night club called The Dump on the site of a former shantytown. The hobos get token employment—with vague plans for relief and housing projects come winter.

The *New Theatre* complained of "the familiar condescending paternalism of the upper classes toward their charges—the masses." F. Scott Fitzgerald had seen it even more clearly. "Let me tell you about the very rich," he wrote in 1926. "They are different from you and me. Even when they enter deep into our world or sink below us, they still think they are better than we are."[15] The blueblood turned "hobo" certainly thought so and Pallette, the wealthy common man, winds up with nothing but *noblesse oblige* toward bums.

Having opened in a hobo camp with Powell, like Henry V, mingling

with the masses, *My Man Godfrey* ended with rich and poor together. At The Dump, the rich walk through the doors. The poor hold them open. Thus "the terrible realities of the period" Arthur Knight saw as points of departure. Screwball directors handled depression milieus as if with tongs: their vision depended on it. *My Man Godfrey* placed its faith with the good-natured rich.

So did *Easy Living* (Paramount, 1937). Director Mitchell Leisen presented a soft-hearted Wall Streeter (Edward Arnold) and a plain Jane working girl (Jean Arthur) and left no doubt that some kind of union lay ahead. That Arnold would be delighted to have son Ray Milland marry Jean was preordained. Domestic tranquillity was assured. Maybe Edward Arnold would let your daughter marry his son. Maybe Eugene Pallette would lend you money.

Mr. Deeds Goes to Town

In 1936, Frank Capra was surely encouraged to extend his "screwball" perspective. *It Happened One Night* had become one of the great triumphs of American film, both financially and in winning all major Academy Awards for 1934: best film, screenplay, director, actor, and actress, the only film ever to achieve such a sweep.[16] *The Nation* noted the "wholly spontaneous response with which the picture was received."[17]

Confident of his audience, Capra turned to the small-town hero and away from the city. Longfellow Deeds (Gary Cooper) is set against the slick morality, fortune-hunting and cynicism of the shyster city, neutralizes its debasing influences, and emerges ascendant. If he had felt at home with newspapermen and Broadway sharpers between 1931 and 1933, Capra now turned against them and made them stand for the decline of the nation's traditional verities—rooted in village virtues.

Through *Mr. Deeds Goes to Town* parade all the sleek, compromised figures of the early thirties, all those men with the little mustaches: headline-crazy newsmen, society swells, corrupt lawyers, and a jeering public. In a series of encounters with Deeds, their cynicism gets blunted and turned against them.

The plot line bestowed upon Deeds an inheritance of twenty million dollars. He responds, "Twenty million! That's a lot, isn't it?" and turns to play his tuba. A screwball. Brought unwillingly to New York from his little home in Mandrake Falls, Deeds gets housed in a mansion complete with butlers, bodyguards, and a rasping, jaded press agent played by Lionel Stander, the incarnation of Broadway cynicism. Besieged by the city's jackals, Deeds refuses to be taken in and begins showing up New York's corrupted value system.

He withholds his power of attorney from the shysters who seek it. He dismisses fortune-hunters: a lawyer with a competing claim, a society belle named Madame Pomponi (the comic strip name indicating the quality of Capra's urban demonology) and the "opera board." This board requests $100,000 to cover its losses: Deeds, the practical Yankee, rebels. If the opera is losing money, "there must be something wrong." It must give "the wrong kind of show." Profit is the practical, small-town yardstick here, and his screwball individuality in rejecting the request works a unity. Press agent Stander delights in the rebuff to the snobs and starts warming toward his yokel boss.

Deeds wins over the newspaper crowd by melting the tough exterior of reporter Babe Bennett. Assigned to keep Deeds on the front page, she insinuates herself into his guileless affections and relays his exploits (slugging arrogant New York literati, drunkenly feeding doughnuts to a horse), to laughing, heartless New York. But when Babe hears his raptures in front of Grant's Tomb ("I see an Ohio farm boy becoming a great general . . . becoming President"—the first touches of the patriotic sentimentality which would engulf *Mr. Smith Goes to Washington* and which Capra did so brilliantly), she comes to his side, loving the innocence she fears she has lost. And the fact of her small-town origins only solidifies her unity with Mr. Deeds. Soon her editor is likewise protecting him from the urban predators.

Capra shrewdly added some topicality to *Deeds,* and made his hero virtually untouchable, except by those who advocated corruption and starvation. A hungry farmer breaks into Deeds' mansion, waves a pistol about, and breaks down in despairing sobs. Deeds, to the horror of all the shysters, decides to sink his entire twenty million into small farms to be distributed to the needy poor. What was called Capra's *"Saturday Evening Post* socialism"[18] was simply benevolence from above. What made it seem like more was Deeds' small-town, tuba-playing character, his "screwballness." His idiosyncracies were simply small-town virtues disdained by Shyster City. Deeds the village democrat forbids his butler from getting down on his knees; Deeds the village prankster slides down the bannister of his mansion; the fair-minded Deeds realizes he must share his wealth. Importantly, the wealth is a fluke to begin with. Not earned by initiative or wisely invested or saved—just given. There was nothing to do but give it away: the objects of the philanthropy—small farmers and land rather than libraries—made it seem more daring than it really was. Such was Capra's skill that he used this last "screwball" act to unify virtually everybody.

When corrupt lawyers, in a desperate attempt to prevent the hero from distributing his fortune, claim him insane and have him institu-

tionalized, city and country join to vindicate Deeds. Deeds wins over the judge, who calls him, as the poor farmers and newspapermen cheer him on, "the sanest man in the courtroom." Yokels and city slickers, city and country, rejoice; Deeds and Babe embrace, in love. All is reconciliation. "Goodness, simplicity, disinterestedness," wrote Graham Greene, "these in his hands become fighting qualities." The Broadway crowd, observed Richard Griffith, "end by applauding his rejection of the metropolis and all that it stands for."[19]

Deeds stayed near the top in the box office sales in April and May of 1936. "One of those pictures," said a theatre owner in Eminence, Kentucky, "that people tell their friends about." A theatre manager in Fort Worth was "flabbergasted," and a truly captive audience in Trenton, New Jersey's State Prison told the institution's recreational director "how much they enjoyed it, which is rather unusual, our audience being much more prompt to voice disapproval than approval of films."[20]

Richard Griffith attempted to assess Deeds' popularity and concluded that behind Capra the Humanitarian lay Capra the Coupon Salesman:

> The thesis of this sentimental comedy was welcomed by huge sections of the American public. What need for the social reorganization proposed by the New Deal if prosperity and peace could be recovered by redemption of the individual? This idea, absolving the middle-class from realistic thinking about the forces which governed their lives, has proved perennially popular.[21]

But faith in the easy melting of social tension and appreciation of the New Deal were certainly not contradictory impulses. In 1936, Franklin Roosevelt proved at least as popular as Longfellow Deeds. Farm belt and city, middle class and poor voted for the buoyant, endlessly resourceful President. An illusory electoral unity reigned.

Capra would not concern himself with national politics until Mr. Smith Goes to Washington and Meet John Doe. In Deeds, he was concerned with constructing a nearly all-embracing unity by having his village type force the urbanites to accept his values. The film ran the "back to the earth" formula in reverse; rather than advocating return to the land, Capra attempted to bring the values of the country back to the city. Alistair Cooke observed that the director was "starting to make movies about themes instead of people" and Robert Stebbins told New Theatre readers of Capra's "underlying . . . implication, if not recognition, that the world is a place of sorrows, where the great multitude of men suffered for the excesses of a few."[22]

But socially conscious Weltschmerz was scarcely Capra's stock in

trade; his optimism was infectious, his contrivance of unity stunning, and his manipulation of the old symbols of shysterism the work of a Hollywood virtuoso. He was steeped in Hollywood's character types. The wide-eyed immigrant boy could effortlessly pull social synthesis out of the America which existed in his imagination; the coupon salesman sensed friendly territory in 1936.

1937–1941

Where could Capra go from the social unity of *Deeds*? Into the ethos of World War Two. In 1937, he took James Hilton's tale of Shangri-La and filmed *Lost Horizon*. The social togetherness wrought on Broadway was assumed to exist in the Himalayas. Perfect peace reigned in Shangri-La: inner and outer tranquillity kept men from aging. Because no social conflict existed to begin with, Capra found himself with nothing to work toward. He repeated himself, was talkier than usual and, seen today, *Lost Horizon* suffers, despite many beautiful touches. Its static quality was inevitable once unity was assured.

Capra returned to more familiar ground in filming the Moss Hart-George S. Kaufman play, *You Can't Take It with You,* but began changing his villains, once he had disposed of the shysters. The heroes are individualists: a carefree, zany family and its satellites living in a house scheduled to be demolished in the construction of a giant munitions plant. Grandpa Vanderhof (Lionel Barrymore) has not worked in years, but contentedly maintains his stamp collection; his daughter (Spring Byington) writes plays in order to make use of a typewriter; a son-in-law makes fireworks; one granddaughter studies ballet and pirouettes about the house, and the other granddaugher is Jean Arthur. Capra set this crew against the banker and munitions king Kirby (Edward Arnold), linked Jean Arthur romantically with Kirby's son (James Stewart), and laid the groundwork for a final unity. This involved Kirby's seeing the wisdom of Grandpa's crackerbarrel bohemianism and giving up his cartel. Kirby whips out his harmonica and plays along with Grandpa as the film closes, having totally accepted a subversive philosophy of absolute freedom and tolerance for everybody's foibles.

While the unity was an absurdity, Kirby's character indicated the shift in Capra's demonology. While he is surrounded by shyster lawyers, Kirby is no early thirties crook. He seems very much the cold-blooded monopolist, building a munitions empire to capitalize on the day of conflict. As noted in a profile in *The New Yorker,* Capra was very conscious of how he was developing his characters:

Realizing that Messrs. Kaufman and Hart had somehow overlooked the true implications of their major characters, Capra . . . changed Grandpa Vanderhof from a whimsical old madcap to a serious denouncer of those who prefer gold to friends, and the mild and inoffensive Mr. Kirby, who had been a rich boy's father, to a sinister munitions man who causes at least one suicide.[23]

Capra's ending broke him down, but how much longer could the Kirbys of the world be contained?

In *Mr. Smith* and *Meet John Doe,* the comic mode would take second place to Capra's exploration of the evils larger than simple shysterism which seemed to be enveloping the world. Europe's crumbling made simple portrayals of unity impossible. Even Capra couldn't end a movie with Hitler playing the harmonica.

Jefferson Smith and John Doe

Capra's Jefferson Smith, U.S. Senator, was a variation of the character of Deeds placed in Washington. Played by James Stewart with a genuinely felt conviction, Mr. Smith discovers that the institutions and personalities he revered as the head "Boy Ranger" of his state are rotted from within. After he has been named junior senator of his state, Smith is shocked to see that his state's revered senior senator, Joseph Paine (Claude Rains), is the puppet of Edward Arnold. His power escalating with each film, Arnold now controls the state's newspapers, industries, and politics. Smith decides to buck this near-totalitarian grip, drawing inspiration from the Lincoln Memorial and Capitol Dome (Capra evoking patriotic spirit from these symbols with the clarity and fervor of the successful immigrant, like no one has before or since). Smith learns the consequences: the Arnold-controlled press and radio are turned against him. The one paper that supports his position (the "Boy Ranger" weekly) is seized by Arnold's thugs and, getting even uglier, his supporters are hosed and beaten. Senator Paine erects an elaborate lie to wreck Smith's career, but the young idealist embarks on a filibuster, refusing to stop talking until he, and his nation, have been vindicated.

Why Capra was doing all this, in 1939, suddenly becomes very clear. As Smith held the Senate floor, the director brought in the veteran radio newsman H. V. Kaltenborn to spout breathlessly into a large, round CBS microphone, "democracy in action," and to announce that German and Italian diplomats were in the gallery to see how the process worked. The relationship between the Arnold machine and the politics of these diplomats was far from esoteric.

As Smith held out against everything that was rotten in the world, Capra really began orchestrating the symbols of the 1940s. A simple American like Jefferson Smith, with plenty of idealism and gumption (and the urgings of Jean Arthur, again in the role of cynic turned believer), could fight the complex, shadowy, and undemocratic forces that were darkening the globe. Capra managed the situation like the virtuoso he was: Smith on the Senate floor, sapling-straight and eyes teary; Smith going to the Lincoln Memorial for a chat with the Great Emancipator; fat Edward Arnold screaming orders into telephones. A nation in its movie theatres was being girded for war, by the old master of belief. When Senator Paine admits the truth, Smith is vindicated, but the end was not unity, rather it was a reinforcement of faith in the emblems of democracy.

In *Meet John Doe,* Capra expressed his faith in common Americans ("I have a definite feeling," he told *The New Yorker,* "that the people are right. People's instincts are good, never bad.")[24] in the face of the kind of threat raised in *Mr. Smith Goes to Washington.* Edward Arnold repeats his role, except that by 1941 Capra made even more explicit the kind of danger he was talking about: Arnold, the wealthy publisher, industrialist, and politician, now has a private police force. He sets up "John Doe" clubs all over the country—clubs of average citizens rallied to the "cause" of common decency and neighborliness—to establish his own political base independent of the two parties. He seems to have absolute control over big business and big labor, leaders of both kowtowing to him throughout the film. But the spirit of John Doe (Gary Cooper—a washed-up baseball player picked to be the public symbol of John Doe) was the spirit Capra brought to the approaching war: "We're the people and we're tough. A free people can beat the world at anything . . . if we all pulled the oars in the same direction." Recognizing their common interests (the defeat of antidemocratic evil), Americans could rejoice in their classlessness and vanquish the Nazis.

Cooper had beaten back the "threats" of the early thirties in *Deeds;* now he confronted the steely menace of the forties. Instead of being a stooge, Cooper turns against Arnold at a huge ballpark rally and reveals the plans for political power. He is chased by Arnold's private police force, but his decent voice, like Smith's, like Deeds', could not be stilled. After *Meet John Doe,* Capra would direct the "Why We Fight" series for the United States Government, shoring up the home front. But he had, in fact, begun showing why we would fight with *Mr. Smith.*

To see the Capra films from 1934 to 1941 is to learn more about a nation's image of itself than one has any right to expect. How much did

Capra create, and how much did he respond to? His classlessness was an obvious fantasy, but the myth obviously was dear to Americans. He created a tradition in effecting the screwball social peace of *It Happened One Night* and responded to tradition in *Deeds* by neutralizing the shyster world, a world very much Hollywood's creation. Once the thirties had been crossed with the nation's basic institutions intact and relatively unscathed, Capra was free to argue from greater strength; fascism was neither his nor Hollywood's creation.

The way in which Capra manipulated images—city, small town, village hero, profiteer, little man, government, radio—represented genius. He understood enough of what people wanted, after the revelation of the screwball comedies' gigantic success, to help create a consciousness, and to build himself into the system. His fantasy of a social unity entered into the quasi-reality of all mass media. Robert Warshow's remarkable insight that, although Americans rarely experienced gangsterism in their lives, "the experience of the gangster *as an experience of art* is universal to Americans."[25] is extremely relevant to Capra. His America was an experience of art.

That world of Deeds and Smith and Doe had become part of the nation's self-image. No one knew that better than Frank Capra. "I never cease to thrill at an audience seeing a picture," he said. "For two hours you've got 'em. Hitler can't keep 'em that long. You eventually reach more people than Roosevelt does on the radio."[26] By the time he started the "Why We Fight" series, Capra could know that Americans were fighting for, among other things, Frank Capra films.

Notes

1. Richard Griffith, "Frank Capra," *British Film Institute,* New Index Series, no. 3, 1951, p. 6.
2. Frank Capra, "Sacred Cows to the Slaughter," *Stage,* July, 1936, p. 41.
3. Quoted in Knight, *The Liveliest Art,* pp. 241–42.
4. Ibid., p. 241.
5. Alva Johnston, "Capra Shoots as He Pleases," *Saturday Evening Post,* May 14, 1938, p. 8; Griffith, "Frank Capra," *op. cit.,* p. 6.
6. Ibid.
7. Cf. Bob Thomas, *King Cohn* (New York, 1967).
8. Griffith, "Frank Capra," *op. cit.,* p. 15.
9. Not being able to locate a print of *Lady for a Day,* I was forced to base my analysis on a reading of the script, located in the Theatre Collection of the New York Public Library.
10. Capra, "Sacred Cows to the Slaughter," *op. cit.*

11. Barbara Deming, "The Library of Congress Film Project: Exposition of a Method," *Library of Congress Quarterly,* November, 1944, p. 26.
12. Robert Stebbins, "Mr. Capra Goes to Town," *New Theatre,* May, 1936, p. 17.
13. Robert and Helen Merrell Lynd, *Middletown in Transition,* pp. 446–47.
14. Deming, "The Library of Congress Film Project," *op. cit.*
15. Robert Stebbins, *New Theatre,* November, 1936, p. 22; F. Scott Fitzgerald, "The Rich Boy," in *Babylon Revisited and Other Stories* (New York, 1960 ed.), p. 152.
16. Crowther, *The Great Films,* p. 102.
17. William Troy, "On A Classic," *The Nation,* April 10, 1935, pp. 416–17.
18. Thomas, *King Cohn,* p. 121.
19. Griffith, "Frank Capra," *op. cit.,* pp. 4, 21.
20. *Motion Picture Herald,* May 30, 1936, pp. 44–45; June 17, 1936, pp. 30–31; August 15, 1936, p. 69; November 28, 1936, p. 91.
21. Griffith, "Frank Capra," *op. cit.,* p. 14.
22. Ibid., p. 22; Stebbins, "Mr. Capra Goes to Town," *op. cit.,* pp. 17–18.
23. Geoffrey Hellman, "Thinker in Hollywood," *The New Yorker,* February 24, 1940, p. 29.
24. Ibid., pp. 23–24.
25. Warshow, *op. cit.,* p. 86.
26. Hellman, "Thinker in Hollywood," *op. cit.,* p. 28.

CAPRA'S COMIC SENSE

ROBERT WILLSON

The title of this essay is a pun. I want to talk about the inherent talent of Frank Capra to know and depict on screen what is movingly humorous and sentimental. But I also mean "sense" to suggest intelligence or wisdom: whenever I watch a Capra film, I rest assured that the hand at the controls will never race the engine solely for effect. I know as well that Capra will not simply hold a mirror up to reflect his audience's vices and flaws, most of which are all too evident—he has more *sense* than that. Instead he will show me what I want to believe about human nature: that goodness and courage to defend right causes (what one might call the director's social sense) are still powerful enough forces in the American hero to deflate pretension, or to scuttle the ship of political corruption.

In the best films the comic sense serves the social sense. Laughter dissolves away differences created by class and wealth to expose a fellowship of feeling among people. The power of ingenuous humanity, tempered by humility and eccentricity, proves to be strong enough to prevent totalitarian figures from enforcing their wills on the common man, at the same time it works to convert those figures. Only when Capra succeeds too brilliantly in depicting the pervasiveness of evil (as in *Meet John Doe*), do we feel that moralizing instead of conversion is the result. But most of the films move us to laughter instead of political action because of the presence of a comprehensive comic vision. None of

83

his heroes is devoid of the ability to reflect humorously on his own glaring shortcomings, both physical and intellectual. Capra generates in his films and in his audience an atmosphere in which idiosyncrasy is a heroic virtue, not a flaw; a tool to challenge the feelingless order of big business or government. Thus, at its best his comic sense is not satiric, though a film like *Mr. Smith Goes to Washington* has been praised for exposing corruption in government. Even in so realistic a film, however, one finds no biting, misanthropic tone; no effort is made to deplore the system; only a few characters are portrayed as wholly unregenerate. Instead, the mood of Capra's comedies reflects an idealized vision of human society, even a romantic one, where miracles are possible and desired, not simply because we are Pollyannas, or because movie entertainment is inherently escapist, but because like all good humorists Capra strives to teach and delight. He teaches us not just what is but what ought to be; he believes in an evolution of man toward goodness, not toward evil. At the same time he believes all this, he can refer to his creations as "Capra-corn." This inclination not to take himself too seriously proves irrevocably to me that his comic sense is healthy and spirited.

Capra has told us how his romantic-comic vision evolved in his own life. As the son of Italian immigrant parents, he grew up in a world of hard work and hardship. His own ambitions to become important, a professional, were the butt of family jokes, since to achieve his goal meant continuing in school at the sacrifice of his brothers' and sisters' time. Only the unflinching dedication of his mother helped him to continue in school. His story reads like one of Horatio Alger's, with appropriate variations to fit the Italian family setting. Capra admits that he believed deeply in the American dream of success for all who work hard and practice the rules of democratic capitalism: remain true to your ideals and be your own boss. This dedication and persistence also bred in him the conviction that pretension and stuff-shirtedness were proper targets for his comic scorn, because such manners were the bad result of losing sight of one's true identity. Above all, he fostered a love and respect for the average man, who was to become the central figure of so many of his films:

> Someone should keep reminding Mr. Average Man that he was born free, divine, strong; uncrushable by fate, society, or hell itself; and that he is a child of God, equal heir to all the bounties of God; and that goodness is riches, kindness is power, and freedom is glory. Above all, every man is born with an inner capacity to take him as far as his imagination can dream or envision—providing he is *free* to dream and envision.[1]

This is a résumé of his personal philosophy, sounding almost like a paraphrase of the Declaration of Independence. Capra's unswerving dedication to it emerges from experience, not from books, and the films, almost without exception, treat some aspect of this philosophy. To many, the films suffer as a result from preachiness or rosy-glasses optimism. However, these "many" are primarily critics, requiring of the movies something novel or original in the way of doctrine. What they forget is that movies in America are a popular art form, something Capra's audiences never forgot.

They approved the Capra-corn philosophy because it was what they wanted to believe, especially at a time in world history when democracies were being threatened by totalitarianism. By simply reaffirming the goals of this country, and doing that through the depiction of a hero innocent enough to still believe in them, Capra shared with his audiences a kind of ritual faith in the virtues they suspected were lurking in themselves but needed prodding. All of this is achieved through the sleight of hand of comedy—much of it slapstick and burlesque—by which laughter refreshes and adds to the general feeling that nothing in American life is so sacred or exigent that it cannot withstand a pie in the face. The revival of interest in Capra's films may be directly traceable to the rediscovery, after years of social paroxysm, of the vital power of laughter in helping us to see ourselves and our problems more honestly.

While personal experience contributed greatly to Capra's humanist views, it was only part of his training in the study of man in society. He learned something of comedy and optimism from professionals too. Capra started as a gag writer in Hollywood, a job which gave him a very practical understanding of laugh-provoking incident. In addition he composed plot lines for the *Our Gang* comedies at Roach Studios. Anyone who has seen this series knows that the core of the comedy depends upon a simple premise: the goodness of children gives them an edge in the adult world, allowing them to escape from the tightest predicaments with ease. God and inanimate objects are always on their side. Any door which will not yield to the battering ram of a pursuing policeman opens at the finger-tip touch of one of the children, or his dog. Capra's favorite actors, his Coopers and Stewarts, are able to overcome the onslaught of villainy or corruption through the same eccentricity, this faith that God watches over fools and children. His innocents possess an intimacy with inanimate and nonhuman objects which the fallen and corrupt of their worlds will never comprehend. Mr. Deeds *understands* his tuba, Mr. Smith his homing pigeons.

Capra's days at the Roach Studios were instructive in other ways as

well. He marked the talented style of Leo McCarey, whose Laurel and Hardy comedies deserve the title of masterpieces. Like the *Our Gang* shorts, these classics play upon the same division of innocence and pretension: Oliver's elaborate and cumbersome plots to achieve position or power are regularly defeated by the head-scratching honesty of an unworldly Stanley. In addition to directors like McCarey and other gag writers, Capra met a famous actor-humorist at Roach's, and the encounter proved remarkably fortuitous for him. That man was Will Rogers, who, seeing Capra knocking out his gags on a woodpile one day, invited him to use his dressing room and typewriter in return for one usable joke a day.[2] For four months, the young writer shared doughnuts, coffee, and quips with one of the great humorists in American history.

That contact established the foundation for Capra's later comic-hero creations. Just as Rogers's country wit and wisdom, delivered in cowboy gear to the accompaniment of a twirling lasso, provided a striking contrast in style to his incisive comments on political life, so too the same contrast in manner and perception marks the characters of such figures as Mr. Smith and John Doe. Indeed, one of the oversimplifications in descriptions of Capra's heroes is the claim that they are bumblers and hayseeds: none of them lacks wit, or the ability to isolate what is ludicrous in the behavior of political bosses or business magnates. They are, like Rogers, humorists, not burlesque comedians or clowns. In addition, Rogers's philosophical observations about human nature and society could very easily have jumped from the pages of a Capra script: "I never met a man I didn't like"; "All I know is what I read in the newspapers." We can recognize in these platitudes the very stuff of Capra's faith in the average man and an abiding sense that he comprehends what is going on around him. Capra and Rogers played to a popular audience because both possessed the belief that the source of brotherhood and the reforming spirit was the people and not the intellectuals or politicians. Finally, both men shared a similar sense of humor: they readily noted the ridiculous in human nature, but their first impulse was to poke fun at it, to locate the appropriate gag, rather than to flay mankind.

From Rogers's dressing room and the Roach Studios Capra moved to the domain of the King of Comedy—Mack Sennett. Here, under the firm hand of Sennett, who prided himself on knowing innately what the public thought was funny, Capra honed his talent for stringing together gags in spontaneous fashion for comic talents like Ben Turpin and Fatty Arbuckle. Most of what he wrote was slapstick and pratfall comedy for the inventor of the custard pie. But he also became the studio's resident expert on the "topper" finish to a sequence of connected gags. Here

again his apprenticeship served him well: the courtroom scene in *Mr. Deeds* and the filibuster finish of *Mr. Smith* are themselves topper surprises which joggle and delight an audience. It was also at Sennett's that Capra created his first film version of his later heroes. If Rogers provided something of the wit and philosophy of Mr. Deeds, Harry Langdon's moon-faced waif contributed the manner. Capra tells us how this new comic character was unique:

> Chaplin *thought* his way out of tight situations; Keaton *suffered* through them stoically; Lloyd overcame them with *speed*. But Langdon *trusted* his way through adversities, surviving only with the help of God, or goodness.[3]

Langdon's role was nonviolent as well, and the pictures in which he appeared, such as *Tramp, Tramp, Tramp* (1926), Capra's first major directorial job, generally featured the hero confronting life instead of custard pies. The result was that Langdon's lovable clown left a wake of goodness behind. The success of the role, which Capra had invented for Langdon, no doubt encouraged the budding director to use it in more complex narratives. He learned another lesson from this association with Langdon, who, after feeling the warmth of critical praise, decided to take over the director's job himself, giving his character more pathos than had Capra. Langdon flopped in this enterprise, proving to Capra that a comedian must stay in character to continue to get laughs. Too much pretension to tragedy in comedies could transform the hero into caricatured clown.

Armed with these lessons from personal and professional experience, Frank Capra launched his career as unrivalled entertainer of popular audiences. I have selected for discussion seven movies which represent both the chronology and evolving comic style of Capra's work. These films are also useful illustrations of the growth and change of his average man heroes, characters who reflect the variety of statements about solutions to America's social and political dilemmas.

It Happened One Night (1934) gave little indication of the content and style of Capra's later movies. In fact, though it won five Academy Awards for best actor and actress, best production, best picture, and best director, it was on the surface yet another bus-trip picture, an overworked genre of the early thirties. Capra transformed its characters into human beings, however, and the movie won wide audience support. Its comic center is the taming of a shrew plot. Claudette Colbert, bored with being an heiress, and a brat to boot, runs away from her father's yacht to join her hastily chosen fiancé in New York. On the road she meets Gable, a cynical but admirable reporter, who promises to help her only if she

will give him exclusive rights to her story. Capra brought to bear on this conventional story a good deal of his training as a gag and stunt writer. In one sequence, for instance, all the passengers on the bus join in singing "The Man on the Flying Trapeze," each singer unabashedly pounding out his own off-key rendition. (It is also a central scene for Gable and Colbert, since both find a common ground for affection in the comradeship.) The scene is topped when the bus driver, until now convinced of the insanity of his charges, turns to offer his version while the unattended bus runs into a ditch. This scene smacks of the spontaneity and strung-together gag technique learned in Sennett's kingdom, and it helps to keep the picture moving at a rapid, light-hearted pace, a Capra characteristic. But something of the social sense is here too. The society of the bus becomes happily democratic when the formerly guarded passengers end up in each other's laps. We learn through this comic climax that Colbert's high-society condescension can be overcome through music and laughter, which lead her to an understanding of her own vulnerability.

Yet the lesson is not forced; the comic mood dominates *It Happened One Night.* There are a number of sight gags featuring toppers, and the most memorable recall scenes from silent comedies. For example, man-of-the-road Gable sets out to instruct spoiled heiress Colbert on the art of hitch-hiking. When none of the cars will stop, Claudette takes the stage, hikes her skirt, and gets them a ride on her first try. The scene is almost entirely pantomime, yet Capra makes us feel the tug-of-war between hero and heroine, as well as the melting away of barriers. In another scene, in a tourist cabin, Gable puts up a blanket between their beds, then proceeds to instruct his charge in the art of undressing, carefully removing selected pieces of clothing. When he automatically begins unzipping his pants, she retreats to her side of the blanket. Instead of being salacious or suggestive, the scene takes on humorous warmth because Capra has shown us Gable's heart of goodness under his rough exterior, and has also made it perfectly clear that Claudette is obnoxious only because she has always had her way. In the same way he transforms Gable's editor and Colbert's father from types into characters with human feeling, another modification of comic technique which marks Capra's later films. When he discovers his daughter has escaped, Claudette's father responds to the ship captain's remark that modern girls are terrible with an unexpected and refreshing frankness: "Nothing terrible about her. She's great! Got a mind of her own. Knows just what she wants. (*Smiling*) She's not going to get it though."

In *It Happened One Night* these traits are still in embryonic stages: the film depends rather heavily on the surface flashy repartee of

many sophisticated thirties comedies. The mixture of farce and realism creates a product whose comic energy comes from a succession of well-turned scenes rather than an overall vision. And though Gable and Colbert are greatly humanized we can still recognize the handy types—jaundiced newsman and pouting heiress—on which they are based.

It is no simple coincidence that the first film in which Capra's name appeared above the title should be his first film with an unmistakable social message. *Mr. Deeds Goes to Town* (1936) reflects a full-fledged philosophy of comedy as a tool for instructing us in the power of simple honesty to forge a new alliance between individual and community. Here the hero brings country values to the sophisticated city.[4] Gary Cooper is Mr. Deeds, a lovable, small-town eccentric who plays the tuba and writes corny jingles for greeting cards. In the hands of most other directors he would be the butt of sneering jokes; as a natural he qualifies as prime target. But Cooper's strength is his simplicity. His face and manner can up an image of the Western hero, a myth in his own time. He is as different in appearance and style from Gable in *It Happened One Night* as night and day. And this difference signals the full control of Frank Capra over the comic and social aspects of the film. His message is that the rural, honest man, driven into a corner by so-called civilized and cultured society, can reach down into his native resources and come up with the courage, wit, and love to conquer, and in the process win over confirmed cynics to his persuasion. Mr. Deeds's act of giving away his inheritance of twenty million dollars to needy small farmers asserts the will of the little people against a greedy, mercenary world of elitists. A touch of fantasy and idiosyncrasy in Capra films always marks the truly sane man or woman.

Capra has not forgotten the crucial element of romantic love story in *Mr. Deeds,* but this relationship, unlike the one in *It Happened One Night,* is more central to the fabric of social philosophy in the film. Jean Arthur plays a cynical reporter who dupes Mr. Deeds into believing she is his friend while she writes inside stories about his cluckish reaction to the big city. She is finally won over by his genuine belief in the principle of sincerity, however, and she becomes one of the central voices raised in his defense during the climactic trial scene. This ability to convert the jaundiced (who are usually newspaper reporters) to true believers, especially in romantic situations, will become a major characteristic of the Capra heroes.

Despite the running commentary on city society's blindness to country strength of character in *Mr. Deeds,* the film retains the stamp of Capra's love of visual humor. The lunacy commission hearing has about it a zany, bittersweet quality, depending heavily on parody and caricature

for its effect. (Some contemporary reviewers believed it was intended to spoof alienists and the legal convention of expert testimony.) It is topped when the judge declares that Mr. Deeds is the sanest man in the room. But the best visually comic scene stars the hero and an inanimate object. As the train leaves Mandrake Falls, presumably with the new millionaire on board, Deeds is nowhere to be found. Suddenly, the camera discovers him in the midst of the home-town band playing "Auld Lang Syne," bass part, on his tuba. It is clear from the smile on his face that he is happier here than in the mansion his new-found fortune might buy. His expression and movements recall the mood of the early Langdon comedies, and, like that character, his love of poetry and music is genuine and all-consuming. He has the unique gift of concentrating his attention on these activities so completely that to others, more concerned with appearance or getting somewhere on time (in this sequence, the train is almost symbolic of hurried modern civilization), he seems mad. In addition, the scene is treated as a topper, giving the audience a delightful turn or surprise when they least expect it. Otis Ferguson aptly describes the general tone of *Mr. Deeds*:

> Capra's comedy hasn't the hard universal brilliance of a Clair [René Clair] at his best—his prize effects happen in twos, rather than one-two-three—but his is more homey, less apt to make his sentiment slush, closer to the lives of his audience, enlisting more of their belief and sympathy.[5]

Enlisting more of the audience's belief in their own power to convert others to goodness seems to be an overriding aim in *You Can't Take It with You* (1938). The reason for this attempt at universal appeal—it is the first Capra picture about family and domestic life—can be tied to the moral, Love Thy Neighbor. *It Happened One Night* implied a similar ethic but concerned itself more directly with taming the shrew on a cross-country, picaresque journey. *Mr. Deeds* involved the use of comedy to instruct us in the virtues of honesty and loyalty to principle and their superiority over values of wealth and sophistication. It is a better plotted film than *It Happened One Night,* finishing with a melodramatic but convincing trial scene in which the hero's beliefs are sorely tested. In *Mr. Deeds,* moreover, Capra combined the roles of comedian and hero, something he had not done since his films with Harry Langdon; and the revival of this old principle worked splendidly, largely because of the mythic quality of the small-town innocent in the big city, and because of the masterful acting of Gary Cooper. In *You Can't Take It with You,* however, we face a new experiment with comic characterization: Capra gives us a villain-hero in Kirby Sr., the lion turned lamb. His conversion from Wall Street heavy to loving father and free spirit is the

surprising topper of the plot, and it is at least partly initiated by his son's (Jimmy Stewart) love for the daughter (Jean Arthur) of a simple but eccentric family. Stewart, like Cooper before him, rejects the life of wealth and power for one of unself-conscious joy and love. In fact, the love story bears a striking resemblance to *Romeo and Juliet*; but the lovers are not required to die in order to unite the families. Capra can bring this scheme of conversion off so brilliantly because of his modification of Kaufman and Hart's light-hearted farce, full of caricatures and drawing-room skits, into a serious comedy with greater feeling and warmth than the original. Again, characters emerge from types.

Another comic achievement here is the creation of the Sycamore-Vanderhof household as lovable lunatic asylum. The eccentricity we have seen in individual Capra heroes has here become a communicable disease. The residents cannot be distracted from their pleasurable pastimes of stamp collecting, fireworks-making, or harmonica playing despite the fact that Kirby Sr. (Edward Arnold) plans to demolish their house to build a munitions plant. But, if they fight him on his terms they are bound to lose: fireworks cannot counter bullets and bombs, Capra seems to tell us. Grandpa Vanderhof's (Lionel Barrymore) weapons are words by which he skillfully defends eccentricity, individualism, and the pleasure principle. Capra is at his best here treating serious questions of the proper way of life in the midst of zany events: Barrymore and Arnold are frequently interrupted by Mr. Sycamore's announcements of new discoveries in his basement fireworks laboratory, or by the frustrated cries of the family ballet instructor, delightfully played by Mischa Auer. The film succeeds because its director never takes himself too seriously, nor does he allow his spokesmen on screen to do so. Still, we are pleasantly surprised to discover that underneath the screwball exterior of this home there can be found a rich vein of sense and intelligence.

James Stewart's role in *You Can't Take It with You* suffers because of the focus on Edward Arnold's villain to hero conversion. However, he is recognizable as a descendant of Cooper: he has the power of the simple man, the strength which comes from independent thinking. His part demands that he show more breeding and education than his predecessor, but these shadings do not obscure his inner warmth and ingenuousness. His choice of the happy domestic life is much more conscious than Cooper's in *Mr. Deeds*, and the film turns on Stewart's realization that his father's world does not allow for the kind of eccentric behavior which encourages fellow feeling. The comic sense of the film is that Jean Arthur's beauty is a symbol of the family's togetherness, a force which restores faith in the strength of the spirit. Kirby Sr.'s impetuous act of playing Grandpa's harmonica, something he has wanted to do since he

was a kid, signals the uniting of the two families through music, a device Capra had used effectively in both *It Happened One Night* and *Mr. Deeds.* Here Capra's comic sense urges us to see how blind acquisition of money leads us to block out our basic ties to others and to our own childhood as well.

If the moral of *You Can't Take It with You* is Love Thy Neighbor, then the message of *Mr. Smith Goes to Washington* (1939) must be Love Thy Country. And because this theme has political and historical proportions, the film requires a hero with more mythic dimensions than were revealed in the Kirbys. Mr. Smith, like Mr. Deeds, comes to a worldly city with little knowledge of his new home or of its view of him. All he can bring is his eccentric equipment. As head of the Boy Rangers, he is an expert on rocks and animals; he has put out a major forest fire; and he totes a crate of homing pigeons, his means of communication with his mother, to his Washington office. But what gives Mr. Smith his mythic stature is his association throughout the picture with former great and idealistic Presidents (his first name is Jefferson), in particular Abe Lincoln. Mr. Deeds was the Western hero, Mr. Smith is the midwestern political innocent. Indeed, one of the key scenes takes place inside the Lincoln Memorial, where a little boy reads Smith the Gettysburg Address from a plaque on the wall. In Lincoln, Capra found the perfect historical model for his hero: Abe and Smith are good-hearted but tough-minded; both buck the system to champion the cause of the little people; and both are the butt of jokes from those so deeply entrenched in corruption that they cannot laugh at themselves. Capra has even given Smith lines which echo the homey wit of Lincoln: "Well—I haven't needed much law so far—what I'd like to get first is a little common sense—"; "Boys forget what their country means—just reading 'land of the free' in history books. And they get to be men—and forget even more." James Stewart's boyish "Aw, shucks!" delivery and his scheme to found a boys' camp remind us that his Lincolnesque qualities are defined by Capra as signs of his having retained a childlike but fresh outlook on questions of morality. His filibuster, an *apparently* impetuous act, is the key gesture by which he forces the Congress to see how it has been diverted from its proper function. The comic and social senses are combined ingeniously in *Mr. Smith.*

Capra concludes the action, as he had in *You Can't Take It with You,* with the conversion of villain to repenter. In this case Claude Rains, the once respected senior senator gone wrong, responds to the collapse of his junior colleague after the filibuster by rushing out to attempt suicide, then returning to the Senate floor to disclose all. Such melodramatic conversions skirt the bounds of the ridiculous, but in this film the

transformation in Rains's character seems more plausible because it constitutes a return to his basically honest nature, before it was corrupted by the movie's arch-villain, Edward Arnold. This ending demonstrates Capra's belief in the power of goodness to move others to perform uncharacteristic but inspired acts; and it has been prepared for by Smith's earlier conversions of the cynical Jean Arthur and Thomas Mitchell. But while the villain-hero scheme worked smoothly in *You Can't Take It with You,* primarily because of the domestic situation, it strikes one as forced and a deus ex machina in *Mr. Smith.* Some contemporary critical comment about the film remarked on its failure to offer solutions to political corruption after it had so honestly portrayed its existence. One sees a personal solution for Mr. Smith, but none for the country. While this criticism is valid when directed at baldly propagandistic films, it ignores the function of comedy in exploring vice and corruption and exposing it to laughter in movies whose primary aim is entertainment. What can be observed in *Mr. Smith* is a movement toward satire: Edward Arnold, as the head of the powerful machine, looms larger as a caricature of the totalitarian figure than he did in *You Can't Take It with You.* He cannot be changed by a harmonica tune here!

Though satire implies a mood of sombreness and cynicism, the film rarely descends into such dark depths. Consistent comic relief comes from the performances of Jean Arthur, Thomas Mitchell, and Harry Carey. Mitchell is particularly impressive as a tippling Washington reporter who takes a genuine interest in Smith's plight. He engages in a brilliant drunken scene with Jean Arthur in which they decide to use their talents to help the young reformer. Even more memorable is the image of Harry Carey as vice-president, looking on sympathetically as Smith attempts to counter the brutal insults hurled at him from the Senate floor. His attitude seems to typify the comic lesson of the film, one we have been taught before in *Mr. Deeds*: here is the only sane man in the room, overcoming his ignorance of the system by means of sincerity and dedication to principle. Smith may be laughable in his ineptitude as speaker, but laughter serves the purpose of awakening us to corruption in high places without prodding us to scrap the entire structure of government. Smith overcomes by turning the enemy's weapon—the filibuster—to his own good ends. *Mr. Smith's* optimistic ending grows out of Capra's fiercely individualistic reading of American history, whose first article of faith is that the country will always spawn at the right moment the strong and honest man to cure its critical problems, and, he will be someone who possesses the saving grace of a self-effacing sense of humor.

Meet John Doe (1941) changes at least the background and atti-

tude of the Capra comic-hero. He is not at first a man of the people but a bindle-stiff, a former ballplayer whose sore arm he hopes to restore to health through an operation. Transformed into a champion of the common man as a result of a cynical stunt by reporter Barbara Stanwyck, Doe (Gary Cooper) becomes a pawn in a scheme to defraud the very people whose cause he pretends to be championing. When he discovers his role in this sham, Doe vows to confess and reveal the dangerous threat to democracy in the promotional scheme. As the film reaches its climax in a dramatic rally of the John Doe clubs at a baseball stadium, Doe finds himself united in spirit with the little people for the first time, even though he realizes his confession means personal failure. This failure will lead him to contemplate suicide. Such an eventuality, so foreign to the characters of earlier Capra heroes, is ironically foreshadowed by the rain falling on hundreds of black umbrellas. Nowhere else in Capra's films has he attempted to give his hero such tragic proportions, and this shift signals the dominance of the social sense over the comic in *Meet John Doe.*

On the surface, however, this is another awakening movie, like *Mr. Smith,* in which a threat to the democratic system is exposed. There is also another drunk scene, this time featuring James Gleason; and Barbara Stanwyck is transformed from a hard-boiled newspaper woman into a devoted lover. Yet, unlike *Mr. Smith, John Doe* has a strikingly cynical mood, growing out of its vision of creeping totalitarianism. Though not devoid of humor, the film depends heavily on the satiric variety. For example, when Cooper announces his hope that all neighbors will tear down the fences which separate them, his skeptical friend the Colonel (Walter Brennan) responds: "Tear down one picket of your neighbor's fence and he'll sue you." Only occasionally do we see touches of the earlier comic sense, which had at its heart elements of eccentricity and zaniness, when Cooper and Brennan play a game of pantomime catch, or when Cooper struggles with the microphone and with technicians' instructions in an unfamiliar radio station. But these incidents are few, and the film relies on talk to carry it through. Cooper's performance is outstanding in a more complex role than that of the other comic-heroes—he must convince us of Doe's transformation from has-been to victimized innocent. Moreover, Doe is a symbol, a conscious composite of the traits of average men, and Capra seems preoccupied with using him as an example of the vulnerability of such innocents to the manipulation of power-hungry plutocrats.

The dilemma of finding an appropriate ending for *Meet John Doe* suggests the philosophic corner into which Capra had painted himself. His hero has changed into someone with greater social and political

dimensions than had earlier protagonists—he is common man *as* common man, not as senator or millionaire, or Wall Street broker's son. I believe that Capra had raised issues so serious and near-tragic that suicide as a solution for hero and plot had to be considered as a strong alternative. The comic vision had to a great extent gotten lost in the frightening depiction of evil, a force which bears striking resemblance to despotic movements in Europe. Edward Arnold as the schemer behind the John Doe clubs is at his menacing best in *John Doe* as a Hitler-like threat to American democracy. While Cooper's salvation by his own kind has the ring of poetic justice, it does not answer the question about the potency of goodness and honesty in redeeming society from its fallen state. Capra's comic sense falters not because he is losing that touch but because he has become so successful at depicting villainy's well-run machine. There is no villain converted to hero here, and little romance in the relationship between Cooper and Stanwyck. Like Shakespeare in *Measure for Measure,* Capra revealed too much of the real viciousness in man to allow for a magical transformation of him in the end. *Meet John Doe* thus breaks a pattern which was dependent on the hero's and director's ability to laugh at themselves and at the enormously complex problems which face American society. The film teaches, but it rarely delights.

With *It's a Wonderful Life* (1946) Frank Capra found a new approach to the comic vision which would mark his final films. He turned to the miracle, to fairy-tale fantasy as a way of presenting answers to questions about the effectiveness of good-heartedness. The result is a much more strikingly sentimental product than we have seen before. James Stewart, as George Bailey, small town helper of the poor and needy, reaches a point in his life when he thinks his benevolence and philanthropy have left him no life for himself. So he wishes he had never been born—and gets his wish! With the help of a guardian angel, sent down to win George back to heaven's side (and brilliantly played by Henry Travers), Bailey glimpses what life in his home town would be like without him. What he sees is a horror story, as Lionel Barrymore, town skinflint banker, seizes all the property he can get and destroys as many lives as he can in the process. The vision inspires George to go on living, realizing that he must assert human values against material ones or see destroyed his own life, as well as the spirit of the town.

It's a Wonderful Life preaches yet another lesson about the strength of the individual, and Capra's own words best describe his state of mind on the subject in the period following World War II. For him, the film was intended

to show those born slow of foot or slow of mind, those oldest sisters condemned to spinsterhood, and those oldest sons condemned to un-schooled toil, that *each man's life touches so many other lives.* And that if he isn't around it would leave an awful hole.[6]

That the film succeeds in demonstrating these beliefs cannot be con-tended; audiences generally opened their hearts to it. Capra was con-vinced this was the most appealing film he had ever made because it was designed to reach his kind of people. Yet while he was reasserting his comic sense in *It's a Wonderful Life* (it is marked by the warmly human portrayals of Thomas Mitchell, Beulah Bondi, and other long-time Capra associates), he also allowed sentiment to overflow the cup. The scene is set at Christmas; Barrymore looks and acts for all the world like a modern-day Scrooge; and Tiny Tims seem to abound in George Bailey's town. The hero is in fact the most "common" of all, without the eccentricities of Deeds, Grandpa Vanderhof, Smith, or even John Doe. As a result, *Wonderful Life* seems to be a reassuring statement that it *still is* a wonderful life for Americans despite the horrors of the war years.

Interestingly, Capra himself was alone in the making of the film, producing it through an independent company. I am not here implying that the movie only mirrors the director's desperate attempt to prove that he could still make warm and entertaining comedies reminiscent of the mood of his early successes. I am only suggesting that the comic sense had been changed by time; the good-hearted hero now needs some divine guidance to reassure him that his way of life is useful and not foolish or wasted. Whereas Mr. Deeds needed only converts—he knew *his* impulses were sound—George Bailey requires a kick in the pants to assure him that his generosity has not been misplaced. And here is where the miracle of hindsight comes in. Capra gives his hero a second chance, using his art as screen magician to perform divine stunts, and to win his audiences once again to the belief that individual acts have some power against materialistic oppressors. Though he would no doubt blanch at this comparison, Capra's shift in focus, his seizing upon a sentimental optimism, is Shakespearean. Plays such as *The Winter's Tale* and *The Tempest,* written near the end of Shakespeare's career, reveal a similar manipulation of the stuff of dreams, reassuring their audiences that in spite of the pervasiveness of evil revealed in *Lear* and *Hamlet,* the artist can perform miracles to restore the world of romantic regeneration they desire. Regardless of Capra's and Shakespeare's success in this effort to restore faith in the renewing power of love and sacrifice, we feel that both have resorted to dramatic trickery, or the deus ex machina, to achieve their ends.

The Strong Man: Harry Langdon single-handedly defeats a mob of reprobates.

Platinum Blonde: Stew Smith (Robert Williams) must choose between aristocrat Anne Schuyler (Jean Harlow) and fellow newspaper reporter Gallagher (Loretta Young).

American Madness: Bank president Tom Dickson (Walter Huston), apparently ruined by the panic of his depositers, is comforted by his secretary (Constance Cummings).

The Bitter Tea of General Yen: American missionary Megan Davis (Barbara Stanwyck) is wooed by warlord General Yen (Nils Asther) amidst the Oriental splendor of his palace.

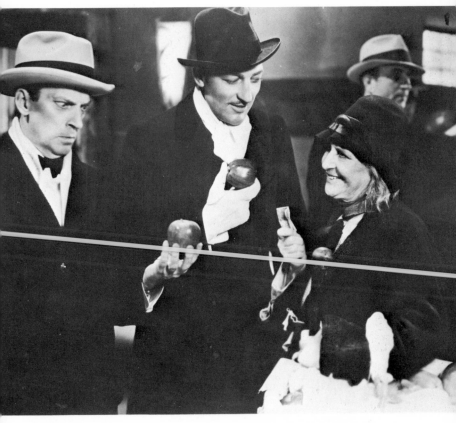

Lady for a Day: Dave the Dude (Warren William) selects a lucky apple from
Apple Annie (May Robson); his dour sidekick, Happy (Ned Sparks), is, as usual,
displeased.
Copyright 1933 © Columbia Pictures Corporation. All rights reserved.

It Happened One Night: Reporter Peter Warne (Clark Gable) pursues runaway heiress Ellen Andrews (Claudette Colbert) on an overnight bus from Miami to New York.

It Happened One Night: Forced to hitchhike, Colbert will shortly demonstrate
to Gable that her shapely leg will sooner get them a ride than his outstretched
thumb.

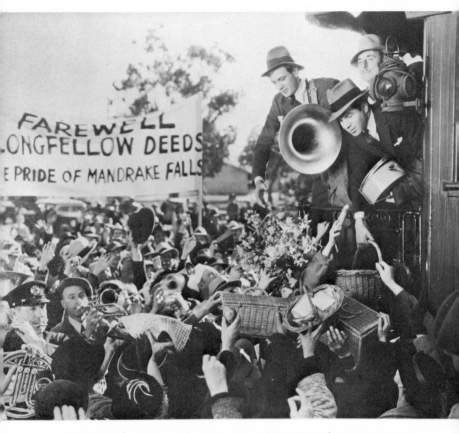

Mr. Deeds Goes to Town: Longfellow Deeds (Gary Cooper) leaves Vermont
for New York with cynical public relations man Corny Cob (Lionel Stander) and
slick lawyer John Cedar (Douglas Dumbrille).

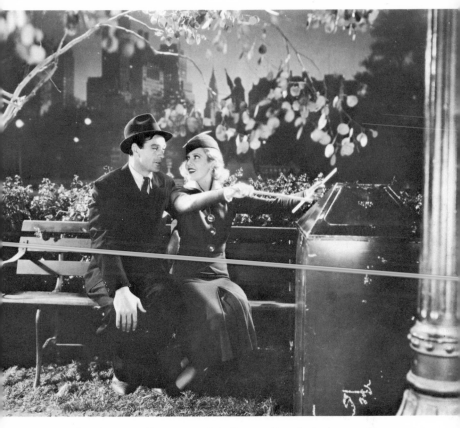

Mr. Deeds Goes to Town: Newswoman Babe Bennett (Jean Arthur) entertains
"Cinderella Man" Cooper with an impromptu song in Central Park.

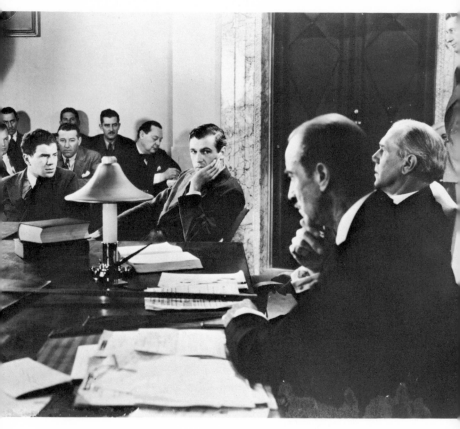

Mr. Deeds Goes to Town: Apathetic Cooper refuses to defend himself against the allegation that he is insane.

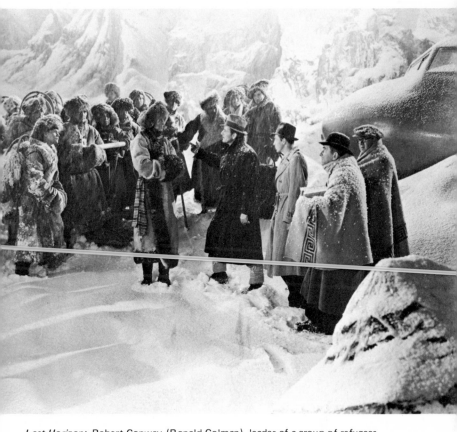

Lost Horizon: Robert Conway (Ronald Colman), leader of a group of refugees
from war-torn China, meets with emissaries from Shangri-La.

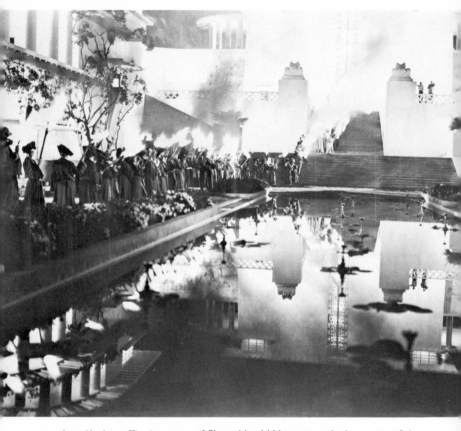

Lost Horizon: The Lamasery of Shangri-La, hidden among the icy wastes of the Himalayas.

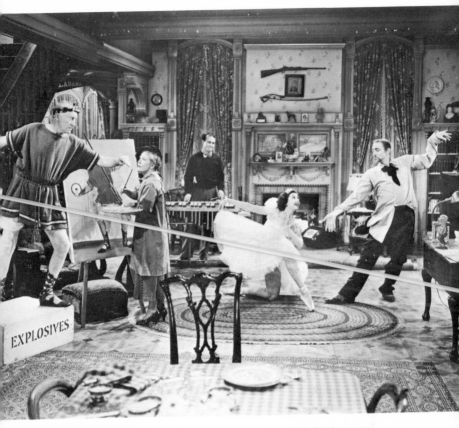

You Can't Take It with You: Inspired zaniness in the Vanderhof living room:
De Pinna (Haliwell Hobbs) poses as a discus thrower for Penny Sycamore's
(Spring Byington) painting, while Ed Carmichael (Dub Taylor) plays the
xylophone to accompany the ballet lesson given by Kolekhov (Mischa Auer)
to Essie Carmichael (Ann Miller).

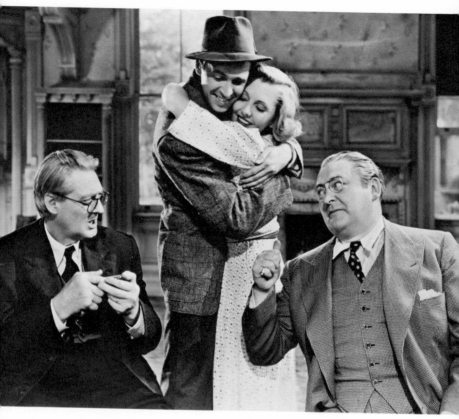

You Can't Take It with You: Lovers Tony Kirby (James Stewart) and Alice
Sycamore (Jean Arthur) are reunited when Grandpa Vanderhof (Lionel
Barrymore) persuades munitions magnate Anthony P. Kirby (Edward Arnold)
to renounce his plutocratic ambitions.

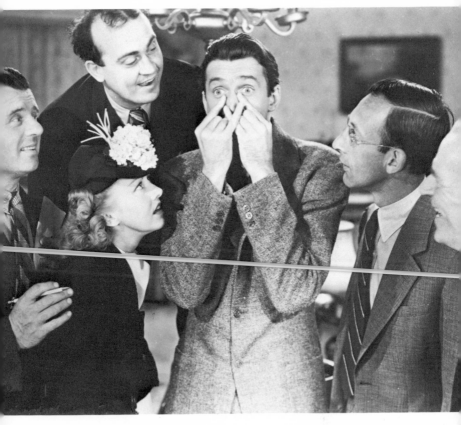

Mr. Smith Goes to Washington: Newly appointed Senator Jefferson Smith
(James Stewart) demonstrates duck calls for the amusement of the Washington
press corps.

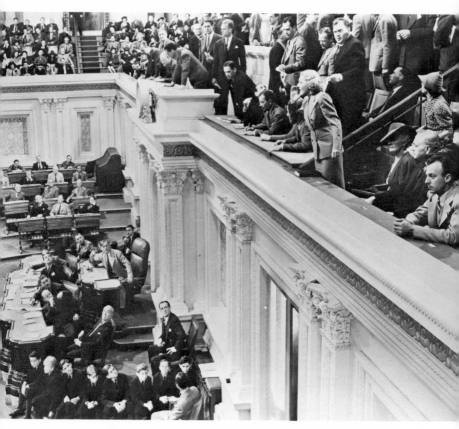

Mr. Smith Goes to Washington: Saunders (Jean Arthur) shouts encouragement from the Senate gallery to Stewart, who is carrying on a one-man filibuster against a corrupt appropriations bill.

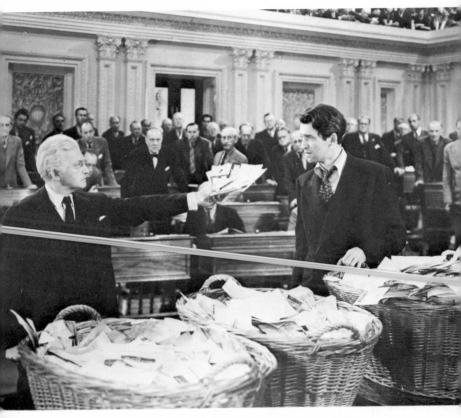

Mr. Smith Goes to Washington: Senator Joseph Paine (Claude Rains), the puppet
of a political machine, shows Stewart telegrams from constituents demanding
that he stop his filibuster and resign.

Meet John Doe: John Doe (Gary Cooper), directed by Ann Mitchell (Barbara Stanwyck), poses for photographers with the representatives of "the little people."

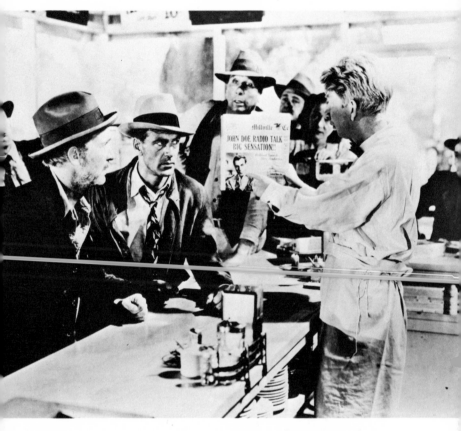

Meet John Doe: Cooper and his hobo friend, the Colonel (Walter Brennan), are unable to escape from the notoriety imposed upon them by the success of the John Doe movement.

Meet John Doe: Cooper vainly protests his innocence of wrongdoing at the massive rally of the John Doe clubs.

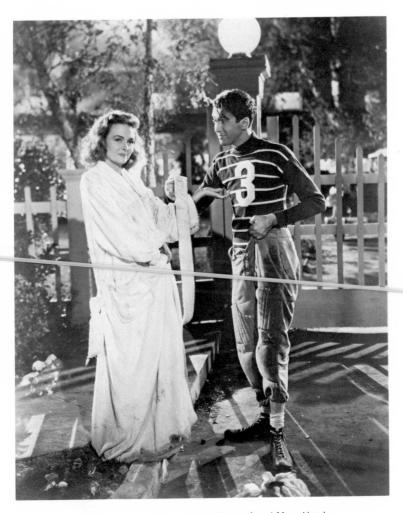

It's a Wonderful Life: George Bailey (James Stewart) and Mary Hatch
(Donna Reed) stroll home after an evening of mishaps at the high school
commencement dance.

It's a Wonderful Life: Stewart, wanting to escape from Bedford Falls to see something of the world, dejectedly ponders the circumstances which keep him there.

It's a Wonderful Life: Newlyweds Stewart and Reed, off to their honeymoon, woefully watch the crowd lining up to withdraw their savings from the Bailey Building and Loan.

It's a Wonderful Life: Stewart, whose guardian angel Clarence (Henry Travers) granted his request never to have been born, inspects the undamaged tree that his automobile hit while he was "alive."

In *Pocketful of Miracles* (1961), Capra's last film, one can see the logical terminus of this trend toward the use of fantastic magic. In this connection, it should be no surprise that *Miracles* is a remake of Capra's first personal success, *Lady for a Day* (1933). Based on a Runyonesque fairy-tale about an underworld attempt to bring off a miracle for Apple Annie, down-and-out organizer of street beggars who wants her European-educated daughter to believe she is American royalty, the film falls into a clichéd pattern of lauding hard-boiled gangsters with hearts of gold. Dave the Dude, off-handedly played by Glenn Ford, is the chief architect of the charade, a task he undertakes reluctantly but superstitiously because he believes Annie's apples have brought him luck in his climb to the underworld top. He bears no resemblance to Capra's other heroes, whose dedication to goodness had no strings attached; and his final act of engineering the appearance of New York dignitaries at Annie's daughter's marriage is clouded by suspicion that they consent because he has something on them. These conversions are tainted, as is the film, by the impression that someone has manipulated our sense of character for the sole purpose of pulling off a happy ending. It seems to me no fluke that Capra's people, *his* audience, rejected *Miracles* at the box office.

Capra believes he knows the true reasons for this failure. The film was made as a multiple corporation venture, with Ford having final say on his leading lady and on the direction of certain scenes (shades of Harry Langdon!). The aging director also feels his own faltering courage, which led him to seek the security of money instead of the happier uncertainty of personal integrity, resulted in a picture without purpose or meaning.[7] These are plausible reasons. But it is likewise true that Capra made the film to assert the entertainment value of fantasy in the face of movies which were consciously exploiting sex and violence. His aim was to prove that an engaging and heartwarming story, reminiscent of his early achievements, could still work its magic, and even appear novel or experimental in the Hollywood climate of the early sixties. But *Pocketful of Miracles,* though stuffed with good comedy scenes and seasoned character actors, is missing that characteristic comic sense. It is missing the ingenious construct of the kind-hearted innocent going up against the forces of evil armed only with native wit and possibly a tuba. It is missing the unstated belief that American society can find solutions to its most urgent problems by looking more deeply into its unique character, and at the same time laughing at its enormous flaws. It is missing that spirit of human warmth which transforms villains into heroes (most of its villains are *already* sympathetic figures), and comic-heroes into giants of truth and decency. Most of all, *Pocketful of*

Miracles lacks the vision of the earlier films; a comic vision which makes us in the audience believe the melodrama of one man, like us but possessing more naive faith in individual virtue and the resiliency of the system, standing courageously to expose the sham and corruption among those who are spiritually poor but materially powerful. Caught up in such a vision our hearts as well as our heads are engaged, and this totality of involvement is the essence of Frank Capra's comic sense.

Notes

1. Frank Capra, *The Name Above the Title* (New York: Bantam Books, 1972), p. 519.
2. *Name Above the Title,* p. 45.
3. *Name Above the Title,* p. 72.
4. Andrew Bergman, *We're in the Money: Depression America and Its Films* (New York: Harper and Row, 1972), pp. 140–42.
5. Robert Wilson, ed., *The Film Criticism of Otis Ferguson* (Philadelphia, Pa.: Temple University Press, 1971), p. 128.
6. *Name Above the Title,* p. 422.
7. *Name Above the Title,* pp. 538–39.

CAPRA AND THE PICARESQUE

WILLIAM TROY

One has often wondered why our American story-tellers, in their effort to get quantitatively more of the variegated abundance of American life into their works, have not considered the advantages of that form of the novel, now practically extinct, known as the picaresque. It is true that the picaresque novel, made up of a series of not always too closely articulated escapades of one or more characters journeying across some region, is an elementary and artistically unrefined type of novel form. But it happens to be a form admirably suited for those periods in history when the dissolution of an existent social structure gives to experience a random, disorganized, centrifugal quality which makes an orderly treatment of it difficult or impossible. As a means of revealing the grotesque contrasts between the old and the new, between the still surviving ideals of feudalism and those of the triumphant Renaissance, it was exactly appropriate for Cervantes and his many French and English followers in the sixteenth and seventeenth centuries. And as a means of bringing out the dizzy contrasts presented by life in the United States during the present period—a period in which social and moral ideals are also undergoing a profound change—it should be no less appropriate a device. Moreover, it makes possible a larger geographical inclusiveness, a more complete survey of the so-called American scene, than any form now

From *The Nation* 138 (March 14, 1934): 314. Reprinted by permission.

being practiced. It alone might save us from the increasingly morbid inbreeding of regionalists like Faulkner and Caldwell. In fact, there are any number of reasons why our novelists should reread their Cervantes, their Lesage, and their Smollett, and think about doing something of the same kind for their own country.

In the meantime the film writers in Hollywood have taken the jump on them. Very probably the original intention of these writers was the quite innocent one of attempting the same kind of melodramatic rewards out of the cross-country bus that had been got out of the railroad train in *Shanghai Express* and the steamship in *Transatlantic*. But by keeping close to their chosen vehicle of transportation those responsible for *Fugitive Lovers, Cross-Country Cruise,* and *It Happened One Night* have stumbled upon what is in all essentials the old picaresque method. In the last-mentioned film, which had a real success at the Music Hall, the parallels are inescapable: overnight tourists' cabins and hot-dog stands for the inns and taverns of Smollett and Sterne, gas stations for the way-side shrines. Clark Gable, as an unemployed newspaperman, is a convincing "rogue," full of the tricks and subterfuges of the most traditional *picaro.* In Claudette Colbert's spoiled daughter of a yacht-loving capitalist (played with charming futility by Walter Connolly) one might see a contemporary reincarnation of Dulcinea. Perhaps also one might detect a burlesque of modern bourgeois chivalry in the scene in which her fiancé, a worthless society climber, arrives at his wedding in a gyroplane. As far as the action is concerned, we are plunged almost immediately into the life of the road—concrete and macadam, of course, but this makes little difference, and not much that might happen on the road between Florida and New York is left out. The film has exceptional movement, variety of every kind, and an ample infusion of tart commentary. The selection of American types in the scenes on board the buses and along the road is excellent. So much do these things count that one is willing to accept the defects as necessary evils in a Hollywood production of this kind. To claim any significance for the picture, apart from its successful use of what may turn out to be a very good method for the screen, would of course be a mistake. But it can be recommended as one of the most uniformly amusing films of the season.

THE BUSINESS OF PROMOTING A THESIS:
FOUR REVIEWS

OTIS FERGUSON

It Happened Once More

Frank Capra is not the genius of the age, but he is a careful, talented director who has made a Hollywood success and earned an office of his own, and still not been taken in by blobs of gilt. Thus far he has used his prerogatives as a sure-fire moneymaker to hold out on one important thing: it will either be good comedy before he is through with it, or he won't be through with it.

His latest production for Columbia is *Broadway Bill,* the story of a young man who got stifled by the smell of his in-laws' money, and went back to horse racing, and got overtaken by a good many disasters, but finally won the Derby, bringing all to their senses and himself to an appreciation of the rebel kid sister and so forth. If you look at it that way, there is little there. It is nice to see someone stand on his own legs and abuse the filthy rich, and the horse race is pretty exciting: but anyone can do that. Where the film stands out is for its incidental human warmth and naturalness; and more than anything, for its continuous

From *The Film Criticism of Otis Ferguson*, edited by Robert Wilson (Philadelphia: Temple University Press, 1971), 58—59, 127—28, 273—75, 349—51. © 1971 by Temple University. All rights reserved. Originally published in *The New Republic* 81 (December 19, 1934): 167; 86 (April 22, 1936): 315—16; 100 (November 1, 1939): 369—70; 104 (March 24, 1941): 405—6.

sideshow brightness. There is a crazy tie-up between the racehorse and the rooster, with the latter crowing at odd moments and the former chewing around on its tail feathers; there is a drinking scene, and one of the neatest con-games you'd care to watch, and a breakaway from an unpaid meal that is so well worked out as to be a model for all directors in what, if we were speaking of music, we would be sure to call phrasing—everyone going on enough to deafen you, a perfectly atrocious hubbub, and yet every detail coming clear, so that you follow in each case why he is yelling, and what.

Where the film stands out, really, is for what Mr. Capra has to give it in the way of painstaking supervision (there is a certain individual stamp on dialogue, incident, and smoothness of technical attack); and for what he can get out of all the people in it, which is a great deal when the people are as good as they are here. Anyone familiar with Warner Baxter's sad succession of recent duds might suspect the hand of God in his present transformation; those who saw Clark Gable in *It Happened One Night* will recognize, in Baxter's quick, breezy, offhand naturalness, the hand of Mr. Capra. The cast is fine from top to bottom, including Walter Connolly, Raymond Walburn, Lynne Overman, Clarence Muse, Harry Todd. As for Myrna Loy, I have never seen her so fresh and touching and really lovable; but the hand here is her own, one feels, sensitive and firm. Mr. Capra has the wisdom of being able to mold them or leave them alone, as the case requires.

And where Mr. Capra himself stands out, after you have granted him intelligence, technical skill, a sense of character, is for his mastery of two of the most vital factors in comedy: timing and accent. There is no need to be too intellectual on this: it is merely the old difference between the man who can, and the man who can't, tell a joke—extended from the point in a two-line gag to the interwoven points of a sequence, and from the innumerable separate parts of a picture to their relative duration, the way they run into one another and carry along the mood without spilling a drop. And it is largely this precision and instinct for where the swing of the words or of the body should be, that makes everything so natural and irresistible here. (The René Clair pictures show the same thing, more complex, more highly developed.) *Broadway Bill* has faults, there's no denying that—an almost unbelievable false uplift in the end, a song about the split-pea soup and the succotash that is given too much extension, and Mr. Capra tends to repeat things out of his old pictures. In substance it is a little thing. But we can finish with it quickly and definitely by saying that it will be a long day before we see so little made into so much: it is gay and charming and will make you happy, and I am sorry to say I do not know recommendations much higher.

Mr. Capra Goes to Town

Frank Capra's new movie, *Mr. Deeds Goes to Town,* is every bit as good as its logical predecessor, *It Happened One Night,* possibly better. But I doubt if this will be accepted so very generally, mainly because of what may be called the growth of legend in art. *It Happened One Night* had a peculiar and interesting career. It was not so much the first thing of its kind as the best thing of its kind then made. But it opened simply as a movie and how is such a thing to be recognized at the time of release? No splurge, no spectacular press-agenting. It was rated just another comedy and quite good if you like that sort of thing. Then it began to build. People who saw it told other people, and people who saw other people who had seen it said, Didn't you just *love* the part where he, etc. And people who had truly enjoyed it but would, in the course of two normal months, have forgotten the title said, Yes and do you remember the part where, etc. It built up strongly in repeat engagements. It became a classic. And so after more than a year, with everybody keeping Capra's memory green and talking classics and all, there hastened in some really grave beards from the critical world to announce it was certainly certifiable as a classic. And so now it is a certified classic, too bad.

It is too bad because now, just when *Mr. Deeds* is ready for showing, the *Happened One Night* legend makes it difficult to remember that the story of the earlier film, as originally seen, was really so much dishwater, and leaked through here and there in spite of a beautiful film treatment. The myth and hullabaloo have overshadowed the real lesson (also found in *Mr. Deeds*) this picture might have taught, namely that it is purely foolish to consider films in terms of what their story would look like on paper. And that a movie can be made out of anything or nothing so long as it is in the hands of the best picturemakers—which is to say, those with the best feeling for life and for the intricate possibilities and effects of films.

What any director can do is pretty much limited by what he is given to work on and how far he is allowed to go with it. But Capra, by luck, persistence, and (mostly) ability, has got to a place where he can keep by him his familiar in the writings of scripts (Robert Riskin) and be choosy over what he works on and with whom. He takes a plot with as few restrictions as possible (it has the necessary sentimental angle and forward motion but is fairly empty of anything else) and proceeds to fill it up with situations and characters from life—working the situations into some direct line with wonderful care both for their speed and clarity as parts and for their associative values, their cumulative effect in the whole story; working over the casting and combined performance of the best

actors he can get hold of; making his own show with genius and humble labor from start to finish. His type of comedy differs from that of Clair in minor respects (with the possible exception of Lubitsch, there have been no others so far who can keep up with him); but the two have in common the same basic drollery, good spirits, and human sympathy, the same quick perception and whatever magic it is that can keep several irons in the fire all the time, and the fire blowing bright. Capra hasn't the hard universal brilliance of Clair at his best (some years ago now) and his prize effects happen in twos rather than in Clair's one-two-three formation; but he is more homey, less apt to make his sentiment slush, closer to the lives of his audience, enlisting more of their belief and sympathy.

Mr. Deeds is simply about a corn-tassel poet (Gary Cooper) who inherits millions and goes to the city, where everyone upsets his naive faith and honest good-fellowship by ridiculing or trying to swindle him, from the directors of the opera to the girl, who starts out by playing him for a boob and ends up breaking her heart over it. Gary Cooper is not the I-swan stooge of tradition but a solid character, shrewd and not to be trifled with, sincere, gay, charming, the girls will want to muss his hair. And Jean Arthur is well set off, smart, a little husky, with good emotions in reserve. And then Lionel Stander, press-agenting his way with vowels like iron filings, and Douglas Dumbrille, the legal snake from Cedar, Cedar, Cedar and Budington. Everywhere you go in this picture there is someone who is a natural in the part—Raymond Walburn, Warren Hymer, Walter Catlett, George Bancroft, Ruth Donnelly, H. B. Warner, Gene Morgan, there is no end to them.

And everywhere the picture goes, from the endearing to the absurd, the accompanying business is carried through with perfect zip and relish. The entourage tracks down the new heir and there he is, polite but abstracted, getting a round, clear E-flat out of his tuba to help him think. Budington, he says, funny I can't think of a rhyme for Budington. They are at the station waiting for him, Lionel Stander's hair still on end from the thought of poetry and where is he now? The town band is playing, the train is coming in, and no heir—or leastwise not until the camera closes on the band and finally on the new millionaire in the middle of it, working over the stock-arrangement bass part to "Auld Lang Syne" on his tuba and proud as all get-out. The film has some prime examples of the spoken gag ("What's that, who said that?" the boss says, his staff filing out after a terrific dressing down; and the chap says, "Uh, I was saying you got dirty plaster") and it has prime examples of purely visual comedy—precisely timed kicks in the pants, banister glides, headers over garbage cans, etc. It has this and it has that, and I begin to realize about here that it is the kind of thing there is no use

talking on about. It is a humdinger and a beauty, but—like anything so conceived and expressed in terms of motion—literally too much for words, more to be seen than heard about.

Mr. Capra Goes Someplace

Frank Capra's *Mr. Smith Goes to Washington* is going to be the big movie explosion of the year, and reviewers are going to think twice and think sourly before they'll want to put it down for the clumsy and irritating thing it is. It is a mixture of tough, factual patter about Congressional cloakrooms and pressure groups, and a naive but shameless hooraw for the American relic—Parson Weems at a flag-raising. It seems just the time for it, just the time of excitement when a barker in good voice could mount the tub, point toward the flag, say ubbuh-ubbah-ubbah and a pluribus union? and the windows would shake. But where all this time is Director Capra?

I'm afraid Mr. Capra began to leave this world at some point during the production of *Mr. Deeds Goes to Town,* his best picture. Among those who admired him from the start I know only Alistair Cooke who called the turn when *Deeds* came out. Writing in England, Cooke confessed to "an uneasy feeling he's on his way out. He's started to make movies about themes instead of people." When *Lost Horizon* appeared, I thought our Mr. Capra was only out to lunch, but Cooke had it. *You Can't Take It with You* in the following year (1938) made it pretty evident that Capra had forgotten about people for good. He had found out about thought and was going up into the clouds to think some. From now on, his continued box-office triumph and the air up there being what they are, he is a sure thing to stay, banking checks, reading *Variety,* and occasionally getting overcast and raining on us. Well, he was a great guy.

Mr. Smith Goes to Washington is the story of how a leader of Boy Rangers was sent to the Senate by the state political machine because he was popular, honest, and dumb. Washington is a shrine to him. So as he gawps around lost for a whole day, throw in thousands of feet of what can only be called a montagasm, buildings, monuments, statues, immortal catchphrases in stone. But before we go any farther, what's the payoff? It is that this priceless boy scout grew up as the son of a small-town editor so staunchly against the interests that they shot him for it under the boy's nose; after which he read American history so widely and fiercely that he knew the Constitution and the cherry tree by heart.

The story goes farther, of course, more than two hours' worth. The boy thinks he falls in love, and then falls in love without thinking so. From these personal relations he learns that he has been a chump. He starts a filibuster (the honest-man-in-court scene Capra has found so successful he won't be without it) in which he says some fine things for liberty and the better world. And it is so harrowing on all concerned that just after he passes out his colleague shoots himself, and the American way is straight again.

Politically, the story is eyewash. The machinery of the Senate and the machinery of how it may be used to advantage are shown better than they ever have been. But the main surviving idea is that one scout leader who knows the Gettysburg Address by heart but wouldn't possibly be hired to mow your lawn can throw passionate faith into the balance and by God we've got a fine free country to live in again.

There are some fine lines and there is a whole magazine of nice types; but the occasional humor is dispersed and the people are embarrassed by just the slugging, unimaginative sort of direction that Capra became famous for avoiding. When the hero is supposed to be made innocent, they write him down an utter fool; when there is supposed to be evil, wickedness triumphs as slick as pushing a button. James Stewart was made fairly ridiculous; Jean Arthur couldn't be; Edward Arnold, Thomas Mitchell, and Eugene Pallette also withstood all such assaults. Claude Rains for once was just right for the part, and Harry Carey was there, fine as ever. But it was everybody for himself, which is a hell of a state of things in movies. The only good sequence was the lovely bit where Miss Arthur and friend got very tight by degrees, and by degrees more reckless and tearful, until they weave up to tell little boy blue that somebody swiped his horn. This seems a case of winning by a lapse; it is like the old Capra, and pretty lonesome.

Democracy at the Box Office

Though Frank Capra is still right in the formula he has been holding to for five years now, *Meet John Doe* is at least a promise that he may be coming back to pictures. It is almost a point-for-point replica of *Mr. Smith Goes to Washington,* but some of the old felicity is there again and there are actually comedy sequences in it. I am not holding out too much hope, for today there is nothing Americans so like to be told from the screen as that they are Americans. So why should anybody with a formula and a credit line like skywriting bother with making a swell simple movie as his "production for 1941"?

The John Doe of the story is Capra's familiar and favorite American type, the easy shambling young man, shrewd and confused, rugged, a lovable innocent but don't tread on him—the uncommon common man, in short, with a heart of gold and a limestone fist, and integrity in long fibers. Eyewash, of course, but there is something in it, for a national hero is some sort of national index after all, and it is not so much how miserably short we fall of being an ideal as what ideal we choose to dream of. Anyhow, this young man, a bush-league baseball player with a glass arm, is caught up in a freak stunt for tabloid circulation-building which turns out to be dynamite both ways. As J. Doe, he is supposed to be a social reformer with a deadline for a suicide of protest; as a national news personality, he becomes so arresting and eloquent in his plea for love and understanding—the Sermon on the Mount with a drawl—that miracles are passed and John Doe clubs are formed, and it is presently worth someone's while to own him as political property. It started as fraud but eventually led to the young man's believing his own spiel and wrecking the sinister plans when he found out their antidemocratic aim. Love was a part of it, of course, and there are various clever wrinkles; but the outline is enough.

The fascination of gossip and the awe of prestige make it impossible that the question of what makes a picture should ever have a chance against the question of who. But while the names of Robert Riskin and Frank Capra are behind the production and writing and direction of *John Doe,* I think we can see even behind the names to what is under our noses. The message is that since it is all the little men who truly make the big world, they should live together and hang together, doing away with hate and suspicion and bad-neighborliness. Fine. Ringing. Of course there are present among us oppression and injustice and scorn for all unsung heroes whose names are Moe Million. Too bad; an outrage; something should be done. So the lift of the story comes in the doing, in the rallying to a new simple faith, as people and as Americans, through homely things but as a mighty army under the flag. In this story the powers of darkness are able to check the advance, but the victory in defeat is that there will be advance again.

I have no doubt the authors of such theses believe in them, just as it is easy for a songwriter to believe that God should bless America after he has glanced over the recent sheet-music sales. But sifted in with any such half-thought-out hoorah must be the true motivating conviction that the box office is out there and will be terrific. And that is where the thing begins to crack like Parson Weems's Liberty Bell, for in art there is a certain terrible exaction upon those who would carry their show by arousing people to believe, and it is that any such show must be made

out of belief, in good faith and pure earnest, in the whole of belief itself. This rhetoric and mortising of sure-fire device of a success today is its sure betrayal by tomorrow—the flag in a game of charades, the mock prayer at a picnic.

As a picture, it does well the things which have proved highlights before: the tender concern over the little fellers with great faith; the underdog finally getting on his hind legs to tell them off; the regeneration of even a hard-boiled newspaper gal; the final blow-off scene with the nation as audience. But it talks too much to no purpose and in the same spot. The musical score is both arch and heavy (the most undeveloped department in all Hollywood anyway). And one of the saddest things is to find Capra so preoccupied with getting over a message of holy-hokum that he lets in half a dozen of the worst montage transitions—mumming faces, headlines, wheels and whorls—that have been seen in a major effort since the trick first turned stale.

Whether this much of hollowness and prefabrication will spoil the picture for you, I wouldn't know. There are things in it to see. The business of promoting a thesis has distracted Frank Capra's attention from much that he was superb at doing, and he still skips over many of the little fitted pieces which make a story inevitable. But now and then he lingers and you can see the hand of the loving workman bringing out the fine grain—as in the direction of the little crowd around the local mayor when Joe Doe is apprehended, with its naturalness and light spontaneous humor; as in the edge of satire in the management of the radio broadcast; as in the bringing out of homely humorous quirks in John Doe himself; and as always in the timing of a line, its cause and effect, so that it comes out with just force and clarity among the shifting images. But Capra and Riskin now seem content to let good actors fill out a stock part and stop at that, so Edward Arnold, Walter Brennan, Gene Lockhart, J. Farrell McDonald, and several others have nothing more incisive to do than they would in any B picture. Barbara Stanwyck has always needed managing, and apparently got it here, though her idea of a passion is still that it is something to tear to firecrackers. But one man the director did give a chance to and smooth the way for, and that is James Gleason, who made more of this chance than there was in the lines and their meaning. The one scene which came through all these streamlined Fourth of July exercises with true sincerity and eloquence was Gleason's drunken talk in the bar, the one that starts, "I like you, you're gentle. Take me, I've always been hard. Hard. Don't like hard people, you hear?" It was just talk, with business, but he made it his, and it will remain one of the magnificent scenes in pictures.

That leaves only the star, who is so much an American John Doe type you could never say whether he was cast in a part or vice versa—Gary Cooper. It is he who has the human dignity which this two hours of talk is talking about, and talking about; and it seems impossible for him to be quite foolish even in the midst of foolishness. His is the kind of stage presence which needs no special lighting or camera magic; he makes an entrance by opening a door, and immediately you know that someone is in the room. *Meet John Doe* has its humor, inspiration, and interest in uneven degrees; but whether you find it good, fair, or merely endurable depends more on Cooper than on what we know as sound moviemaking.

A DIRECTOR OF GENIUS: FOUR REVIEWS

GRAHAM GREENE

Mr. Deeds Goes to Town

Mr. Deeds is Capra's finest film (it is on quite a different intellectual level from the spirited and delightful *It Happened One Night*), and that means it is a comedy quite unmatched on the screen. For Capra has what Lubitsch, the witty playboy, has not: a sense of responsibility, and what Clair, whimsical, poetic, a little precious and à la mode, has not, a kinship with his audience, a sense of common life, a morality; he has what even Chaplin has not, complete mastery of his medium, and that medium the sound-film, not the film with sound attached to it. Like Lang, he hears all the time just as clearly as he sees and just as selectively. I do not think anyone can watch *Mr. Deeds* for long without being aware of a technician as great as Lang employed on a theme which profoundly moves him: the theme of goodness and simplicity manhandled in a deeply selfish and brutal world. That was the theme of *Fury,* too, but Capra is more fortunate than Lang. Lang expresses the theme in terms of terror, and terror on the screen has always, alas! to be tempered to the shorn lamb; Capra expresses it in terms of pity and ironic tenderness, and no magnate feels the need to cramp his style or alter his conclusion.

From *The Spectator* 157 (August 28, 1936): 343; 158 (April 30, 1937): 805; 161 (November 11, 1938): 807; 164 (January 5, 1940): 16. Reprinted by permission of Laurence Pollinger, Limited.

Mr. Deeds is a young provincial who inherits twenty million dollars from an uncle he has never seen. An ardent tuba player in the local band, he makes his living by writing verses which are printed on postcards on such occasions as Mothers' Day. The uncle's solicitors, who have absorbed, with the help of a Power of Attorney, half a million dollars of his money, hope to continue the process with his unsophisticated nephew who is quite unexcited by his fortune and only wants to do good with it. They bring Deeds up to town. Wealth educates Deeds, he learns the shabby side not only of business, but of art, with the help of the opera directors and the fashionable poets; he learns, too, the deceit which may exist in ordinary human affection (the girl he loves, and who loves him, is all the time writing newspaper articles which make front-page fun of the activities of the Cinderella Man). A revolver and a would-be assassin's nerveless hand educate him socially, and he is arranging to use the whole of his fortune in providing ruined farmers with free land and free seed when society—controlled by racketeers—strikes its last blow at the elements it cannot absorb, goodness, simplicity, disinterestedness. Claimants are found to dispute his sanity and to try to remove the management of the estate from his hands.

It sounds as grim a theme as *Fury*; innocence lynched as effectively at a judicial inquiry as in a burning courthouse, but there is this difference between Lang and Capra; Lang's happy ending was imposed on him, we did not believe in it; Capra's is natural and unforced. He *believes* in the possibility of happiness; he believes, in spite of the controlling racketeers, in human nature. Goodness, simplicity, disinterestedness: these in his hands become fighting qualities. Deeds sees through opera-directors, fashionable intellectuals, solicitors, psychologists who prove that he is insane merely because he likes playing the tuba and isn't greedy for money. Only for a few minutes in the courtroom does he lose heart and refuse to defend himself: he is never a helpless victim, like the garage man behind the bars watching the woman lift her baby up to see the fun, and he comes back into the ring with folk humour and folk shrewdness to rout his enemies for the sake of the men they have ruined. The picture glows with that humour and shrewdness, just as Lang's curdles with his horror and disgust; it is as funny, most of the time, as *Fury* was terrifying. It is not a question of truth or falsehood: two directors of genius have made pictures with curiously similar themes which present a conviction, a settled attitude towards life as it is lived. The pessimist makes a tragedy, the optimist (but how far from sweetness and complacency is Capra's optimism) makes a comedy. And Capra, as well as Lang, is supported by a perfect cast. Every minor part, however few the lines, is completely rendered, and Mr. Gary

Cooper's subtle and pliable performance must be something of which other directors have only dreamed.

Lost Horizon

Nothing reveals men's characters more than their Utopias: the scientific sentimentality of Mr. Wells, the art-and-craftiness of William Morris, Mr. Shaw's eternal sewing-machine, Samuel Butler's dusty alpaca. Shangri-La must be counted among the less fortunate flights of the imagination, the lamaserai in Thibet ruled by a Grand Llama, a Belgian priest who discovered the rich valley among the mountains in the eighteenth century and who was still alive when Robert Conway, explorer, diplomat and— rather improbably—Foreign Secretary elect was kidnapped from a Chinese town and brought there by aeroplane. This Utopia closely resembles a film star's luxurious estate on Beverly Hills; flirtatious pursuits through grape arbours, splashings and divings in blossomy pools under improbable waterfalls, and rich and enormous meals. "Every man carries in his heart a Shangri-La": but I prefer myself the harps and golden crowns and glassy seas of an older mythology. Shangri-La is intended to represent a haven of moderation, beauty and peace in the middle of an uncompromising and greedy world, but what Conway finds there, what he loses in a weak moment of disbelief, and struggles across the Himalayas to find again, is something incurably American; a kind of aerated idealism ("We have one simple rule, Kindness") and, of course, a girl (Miss Jane Wyatt, one of the dumber stars), who has read all the best books (his own included) and has the coy comradely manner of a not too advanced schoolmistress.

It is a very long picture, this disappointing successor to *Mr. Deeds,* and a very dull one as soon as the opening scenes are over. These are brilliantly written and directed, and show Conway (Mr. Ronald Colman) organising the aerial evacuation of the white inhabitants from a Chinese town in the middle of a revolution before he takes the last plane himself in company with a crooked financier wanted by the police, a prostitute (sentimental variety), a scientist (comic), and a younger brother. Here the Capra-Riskin partnership is at its best, and we are unprepared for the disappointments which follow: the flavourless uplifting dialogue, the crude humour, the pedestrian direction, and the slack makeshift construction. "You shouldn't look at the bottom of the mountains. Try looking at the top." So Chang, the suave philosophical second-in-command of Shangri-La, addresses the prostitute who believes that she is dying of consumption (one of the virtues of this mysterious valley is

health, the body beautiful, and a life which goes on and on and on). It might be Wilhelmina Stitch translated into American prose, and one can hardly believe that this script is from the same hands as *Mr. Deeds,* though perhaps Mr. James Hilton, the author of the novel and of *Goodbye, Mr. Chips,* may be responsible for the sentimentality of these sequences.

Of course, the picture isn't quite as bad as that. It does attempt, however clumsily and sentimentally, more than the average film; a social conscience is obscurely at work, but at work far less effectively than in *Mr. Deeds,* and as for the humour—it consists only of Mr. Edward Everett Horton wearing Eastern clothes. The conscious humour that is to say, for the glimpses of English political life give a little much needed relief. "The Far Eastern Conference must be postponed. We cannot meet these nations without Conway": the Prime Minister's measured utterances to his Cabinet gathered Gladstonianly round him fall with an odd sound on ears accustomed to more dispensable foreign secretaries. But it is in the last sequence that the Capra-Riskin collaboration fails most disastrously. Conway, persuaded by his younger brother that the Grand Llama has lied to him, that there is misery and injustice in this seeming Utopia, makes his way back to China across the mountains. A few newspaper headlines tell us that Conway has reached safety, and it is only at secondhand in a long uncinematic scene in a London club that we learn what we should have seen with our own eyes: Conway's reaction to "civilization." If the long dull ethical sequences had been cut to the bone there would have been plenty of room for the real story: the shock of western crudity and injustice on a man returned from a more gentle and beautiful way of life.

You Can't Take It with You

It is really what we should have expected from Frank Capra, whose portrait hangs outside the cinema; bushy eyebrows, big nose and the kind of battered face which looks barnacled with life, encrusted with ready sympathies and unexacting friendships, a good mixer. It is always danger-ous, of course, to generalize about a director's subjects—he hasn't in-vented his own stories; but the Capra-Riskin combination is strong enough by now to dictate, and we can assume Capra is doing what he wants to do. What he wants is increasingly what the public wants. It will adore the new picture which contains what it treasures most—a good laugh and a good cry.

As for the reviewer, he can only raise his hands in a kind of despair.

The new picture is the *Christmas Carol* over again—with its sentimentality and its gusto and its touches of genius: no technical mistakes this time as there were in *Lost Horizon.* The director emerges as a rather muddled and sentimental idealist who feels—vaguely—that something is wrong with the social system. Mr. Deeds started distributing his money, and the hero of *Lost Horizon* settled down in a Thibetan monastery—equipped with all the luxury devices of the best American hotels—and Grandpa Vanderhof persuades, in this new picture, the Wall Street magnate who has made the *coup* of his career and cornered the armaments industry to throw everything up and play the harmonica. This presumably means a crash in Wall Street and the ruin of thousands of small investors, but it is useless trying to analyse the idea behind the Capra films: there *is* no idea that you'd notice, only a sense of dissatisfaction, an urge to escape—on to the open road with the daughter of a millionaire, back to small town simplicity on a safe income, away to remote, secure Shangri-La, into the basement where Mr. Vanderhof's son-in-law makes fireworks with the iceman who came seven years ago with a delivery van and stayed on. A belief, too, in bad rich men and good poor men—though Mr. Vanderhof doesn't, when you come to think of it, seem to lack money. Like the British Empire, he has retired from competition with a full purse.

That is really all there is to the film—a contrast between life on Wall Street and life in the Vanderhof home, where everybody is supposed to lead the life he likes and like the life the others lead. A granddaughter practices ballet-dancing while she lays the table, a boy friend plays on the marimba, a daughter writes novels which will never be published, just for fun—what an extraordinary idea of fun! It is very noisy with the fireworks going off, and good-hearted and Christian in the *Christmas Carol* tradition. The most embarrassing moments in a film which is frequently embarrassing occur at meal-times when Grandpa Vanderhof (Mr. Lionel Barrymore) talks to God in a man-to-man way instead of saying Grace. "Well, sir, here we are again. We been getting on pretty well for a long time now" This whimsical household is meant, I think, to be symbolic of life as it should be lived (one prefers Wall Street), and mixed up in the whole thing is the routine love story of Vanderhof's granddaughter and the magnate's son, played sensitively by Miss Jean Arthur and Mr. James Stewart.

It sounds awful, but it isn't as awful as all that, for Capra has a touch of genius with a camera: his screen always seems twice as big as other people's, and he cuts as brilliantly as Eisenstein (the climax when the big bad magnate takes up his harmonica is so exhilarating in its movement that you forget its absurdity). Humour and not wit is his line,

a humour which shades off into whimsicality, and a kind of popular poetry which is apt to turn wistful. We may groan and blush as he cuts his way remorselessly through all finer values to the fallible human heart, but infallibly he makes his appeal—by that great soft organ with its unreliable goodness and easy melancholy and baseless optimism. The cinema, a popular craft, can hardly be expected to do more.

Mr. Smith Goes to Washington

Here is Capra, without the help of Riskin, back to his finest form—the form of *Mr. Deeds*. It has always been an interesting question, how much Capra owed to his faithful scenario writer. Now it is difficult to believe that Riskin's part was ever very important, for all the familiar qualities are here—the exciting close-ups, the sudden irrelevant humour, the delight—equal to that of the great Russians—in the ordinary human face. (Claude Rains has not got an ordinary human face, and for that reason he seems out of place and histrionic, great actor though he is, in a Capra film.)

The story is regulation Capra in praise of simplicity and virtue and acting naturally. As a fairy tale it is a little Victorian: it is not that we are less moved by virtue in these days, but we are more aware of how the author cheats—virtue is not bound to win, and the easy moral of a Capra tale comes dangerously close to a Benthamite apothegm about honesty being the best policy. Young Jefferson Smith, acted with a kind of ideal awkwardness by James Stewart, is appointed a senator to fill an unexpired term: he is a leader whose guilelessness is considered useful by the other State Senator, Joseph Paine, and his business boss, Jim Taylor. They are putting over a tricky piece of graft and they don't want a new senator who can see his way. So Smith goes up to Washington with his naive ideals and his patriotism (he knows Lincoln's speeches off by heart) and his sense of responsibility: he feels rapture at the sight of the Capitol dome, stands like a worshipper below the bony marble fingers of the Lincoln statue, and Paine entertains him and sidetracks him.

Then suddenly Smith's secretary, with all the harsh, don't-give-a-twopenny-curse charm of Miss Jean Arthur, opens his eyes to the real Washington, where you can't look round a monument without starting a grafter. He refuses to be a party to fraud and Jim Taylor (Edward Arnold) proceeds to break him—papers are forged, witnesses perjure themselves, he is declared by a Committee of the Senate unworthy to hold his seat. "Beautiful," says a reporter at the framed inquiry, "that Taylor machine." But Smith won't surrender; when the Senators refuse

to listen to him, he takes advantage of the Constitution and holds the floor for 23 hours, hoping that his State will support him—in vain because the newspapers have been bought by Taylor. This constitutional battle of one man against the Senate is among the most exciting sequences the screen has given us. But it is a fairy tale, so Smith wins: Joseph Paine, like a Dickensian Scrooge, is caught by conscience, and I imagine it is easier for us, than for an American who knows his country's politics, to suspend disbelief.

It is a great film, even though it is not a great story, acted by a magnificent cast, so that Capra can afford to fling away on tiny parts men like Eugene Pallette, Guy Kibbee, Thomas Mitchell and Harry Carey. A week later one remembers vividly the big body of Pallette stuck in a telephone box, the family dinner of the weak crooked Governor (Kibbee) whom even his children pester over the nomination, the whole authentic atmosphere of big bland crookery between boss and politician—the "Joes" and the "Jims," the Christian names and comradeship, the wide unspoken references, and one remembers too the faces chosen and shot with Capra care—worried political faces, Grub Street faces, acquisitive social faces and faces that won't give themselves away.

MR. CAPRA GOES TO TOWN

ROBERT STEBBINS

In the event that no one has mentioned it before, let us state, without fear of contradiction from our colleagues, that reviewing movies is a very dull business. There are few surprises. By the time you've read the advance production notes, the commercial publicity and the preview notices you know just what you're getting. Besides, to make it easier, a good quarter of the stories have already been produced as old silents and early talkies. But nothing we had read in advance prepared us for the amazing qualities of *Mr. Deeds Goes to Town.* According to all the rules, Frank Capra, director, and Robert Riskin, screen author, could only have been expected to go on turning out dilute imitations of their 1934 Academy winner, *It Happened One Night.* Their *Broadway Bill,* a pallid assemblage of whimsies about horses and followers of the sport, pointed the way to such a prediction.

For that matter, *It Happened One Night,* stripped of its pace and interest of incident, was a pretty indefensible affair. The film was based on a notion dear to the hearts of a people reared in the school of wish-fulfillment—that if you stepped up to a grumpy plutocrat, who, of course, had a heart of gold despite it all, bawled him out, told him his daughter was a spoiled brat, he'd at once grow enamored of you and

From *New Theatre* (May, 1936): 17–18. Reprinted by permission of Dr. Edna O. Meyers.

you'd come into his millions. Produced in the fifth year of the crisis, *It Happened One Night* took place in a social and economic vacuum. People behaved lovably and for the most part went through recognizable actions but the realities of 1934 were barred from the lot and integrity checked at the gate.

Now along comes *Mr. Deeds* to astound with its unexpected warmth and indubitable sincerity of purpose. The whimsies are still here, the wit of line and action still crackles as in few other films, but underlying all is the salutary implication, if not recognition, that the world is a place of sorrows where the great multitudes of men suffer for the excesses of the few.

As the story begins a Mr. Longfellow Deeds (Gary Cooper) comes into a fortune of twenty million dollars left him by an eccentric uncle who dies in an auto crash in Italy. Deeds, a young post-card poet, tuba player in the village band and voluntary captain of the fire-squad, reluctantly leaves the only life he knows and goes to the big town to shepherd his fortune. At once his name is front-page news. Babe Bennet (Jean Arthur), star reporter on the Gazette, is put on the job of splitting Deeds wide open. She succeeds by palming herself off as a poor out-of-town steno looking for work. By dint of deliberately turning everything he does or says to ridicule she makes him the most derided man of the hour, but in the process she falls for him and vice-versa. On the day Deeds is to propose marriage to Bennet, he's tipped off to her true identity. Thoroughly disheartened and sickened by the savagery of the big city, he prepares to leave for his home town—"Mandrake Falls, where the scenery enthralls, where no hardship e'er befalls, welcome to Mandrake Falls."

Up to this point in the narrative we've a brilliant, though characteristic, Boy meets Girl—Boy loses Girl situation, with Boy gets Girl not far in the offing. Then something unanticipated happens. As Deeds is about to descend the huge marble staircase of his Drive mansion he hears a commotion down below and sees a shabbily-dressed stranger struggling to get into the house. Deeds comes down and asks what he wants. The stranger, a dispossessed farmer, breaks out into tirade against Deeds for sitting on his millions and not reaching out a hand or penny for the relief of human suffering. Deeds, who has been betrayed by everyone in town, thinks he's in the presence of a new racket.

To quote from the script:

Deeds: "A farmer, eh? You're a moocher, that's what you are. I wouldn't believe you or anybody else on a stack of Bibles. You're a moocher like all the rest of them around here, so get out."

Farmer: "Sure, Everybody's a moocher to you. A mongrel dog eating out of a garbage pail is a moocher to you."

Suddenly the farmer pulls a gun on him.

Farmer: "You are about to get some more publicity, Mr. Deeds. You're about to get on the front page again. See how you're going to like it this time. See what good your money's going to do when you're six feet under ground."

At this stage, according to all the sanctified rules laid down by years of custom, Jean Arthur should have rushed in, kicked the gun up, and gotten prettily pinked in the process. Then, after the maniacal worker, now frothing at the mouth, is led away by the police, the film should have faded out in a clinical clinch. But Arthur somehow doesn't appear. Instead, the farmer continues.

Farmer: "You never thought of that, did you? No. All you ever thought of was pitching pennies. You money-grabbing hick. You never gave a thought to all those starving people standing in the bread lines, not knowing where their next meal was coming from; not able to feed their wife and kids; not able to"

He is unable to go on. Drops his gun, falls into a chair, weeping.

Farmer: "Oh, oh I'm glad I didn't hurt anybody, Excuse me. Crazy. You get all kinds of crazy ideas. Sorry, didn't know what I was doing. Losing your farm after twenty years' work, seeing your kids go hungry, a game little wife saying everything's going to be all right. Standing there in the bread lines. Killed me to take a hand-out. I ain't used to it. Go ahead and do what you want, mister. I guess I'm at the end of my rope"

Deeds sits down to eat with him and the scene is at an end.

Here we have not only a magnificently conceived and acted sequence (the part of the farmer is played by John Wray), but even something more significant—for the first time in the movies we have been given a sympathetic, credible portrait of a worker, speaking the language of workers, saying the things workers all over the country say. How far removed this is from the beery, rapacious radical of *Little Man, What Now?* the feeble-minded ego-maniacs played by Paul Muni and Spencer Tracy in *Black Pit* and *Riff-Raff,* the howling foreman of *Men of Iron!*

Deeds decides to spend his entire fortune on farm lands for the unemployed. For his pains, he is taken into custody as insane. The trial scene during which Deeds establishes his sanity, gets the girl and the farmers their land, is probably the most brilliant piece of screen writing to come out of Hollywood.

Now, the captious will undoubtedly point out that *Mr. Deeds Goes*

to Town is as flagrant a flaunting of reality as its predecessor, *It Happened One Night.* "Certainly Mr. Capra and Riskin don't think the world can be pulled up from the mire that way. In the long run pictures like Mr. Capra's only serve to dull the militance of labor. Pure wish-fulfillment all over again." To which we can only reply by pointing out the difference between wish-fulfillment based on a sincere and under-standing awareness of the world's ills and the pure soothing syrup that constitutes the staple export of Hollywood. For Hollywood, *Mr. Deeds* is a tremendous advance.

After commending the work of the cast, Gary Cooper, Jean Arthur, Lionel Stander, Walter Catlett, the greatest share of praise must be Capra's and Riskin's. If Mr. Capra could trick us once more and in some unaccountable way avoid the chauvinist, jingo pitfalls of his next picture, *Lost Horizon*—which places Ronald Colman among Chinese "bandits"—our pleasure in *Mr. Deeds* would be quite complete.

THE IMAGINATION OF STABILITY: THE DEPRESSION FILMS OF FRANK CAPRA

ROBERT SKLAR

Frank Capra tells a remarkable story in his autobiography which, if true, casts a revealing light on the United States government's conception of its goals and purposes in fighting the Second World War. The time is 1942, the early months of America's participation in the war, the setting the Pentagon, in the office of the chief of staff, General George C. Marshall. The general concentrates on his work, writing memos, checking off items on papers across his desk. When a nervous officer, Major Frank Capra, enters the room, he barely notices. Then he looks up and begins to tell his visitor about the needs of the vast armed force of citizens the United States was building up to win the war. Above all, said Marshall, the soldiers must know why they were fighting, what values they were asserting, what principles they were defending. It had been decided that a series of movies would be made for the troops, telling the story of "why we fight." He was placing full responsibility for the films in Capra's hands.

Capra raised a question. How would he know what to say? What if no one, not the White House nor the State Department nor the Congress, could tell him why the United States took a course of action or adopted a policy? "In those cases," replied Marshall, "make your own best estimate, and see if they don't agree with you later."

One can accept this anecdote as fact, or as a product of the motion picture director's ample imagination. If accurate, it provides additional confirmation of the great difficulties the United States government experienced during World War II in defining American social and political institutions, in articulating to the world and its own citizens the system of principles and beliefs it was defending against the Fascist challenge. But what in a way is even more extraordinary is the apparent willingness of the nation's highest ranking military leader to entrust complete control over such influential and widely-disseminated government propaganda to a stranger—a stranger who had spent the past twenty years of his life making mass-entertainment comedies, and who had been born in Italy, a country with which the United States was then at war.

Of course Capra may have been an entirely fortuitous choice, who emerged by chance out of the grab bag of bureaucratic chaos in the early war months, of whose national origin and work experience Marshall knew nothing. The coincidence, however, is not a likely one. Long before 1942 Frank Capra's reputation as a filmmaker with an exceptional ability to dramatize American values and ideals had penetrated even to Washington, D.C. In the decade prior to America's entry into the war, the years of the Great Depression, he had made a remarkable series of motion pictures—beginning with *Platinum Blonde* in 1931 and followed by, among others, *American Madness* (1932), *Lady for a Day* (1933), *It Happened One Night* (1934), *Mr. Deeds Goes to Town* (1936), *Lost Horizon* (1937), *You Can't Take It with You* (1938), *Mr. Smith Goes to Washington* (1939), and *Meet John Doe* (1941)—that succeeded in winning the acclaim of audiences, critics, and his moviemaking peers alike. From the record of his Depression films, indeed, one might argue that it was precisely Capra's vision of American life that the government desired to enlist and present to its citizen-soldiers as its own. What themes and images had Capra put into his films, that they pleased so many different viewers, and prompted the government to give him a free hand in explaining why the nation went to war? It is a question critics of American motion pictures have wrestled with ever since Capra emerged in the Depression years, a unique creator of entertainments that gave Americans a pleasing and convincing image of themselves.

II

As an essential foundation for understanding the world of Capra's movies it is necessary to remember that the relationship between Hollywood and the centers of power and prestige in American society was considerably different in the Depression period than it was later to become. The

intimate and obviously symbiotic relationship which came to exist by the late 1960s between political power and the publicity and glamor of the entertainment and sports worlds was a new phenomenon in American culture. Presidents before Richard M. Nixon were not accustomed to telephoning football coaches in the middle of the night, and presidential assistants with the power of Henry Kissinger, whether or not they might have enjoyed dining in night clubs with Hollywood starlets, certainly would not have liked to be photographed doing it. Marshall's grant to Capra of power and responsibility, even of recognition, was thus considerably more daring and unconventional that it may at first, from a later perspective, seem.

Moreover, Hollywood deviated from the norms and practices of the American social system in a highly significant way. It should not be forgotten that in the United States in the first half of the twentieth century one's religion and national origin, if they were not Protestant and Northern European, were likely to be barriers to opportunity and advancement much more than they were in later decades, when race and sex remained the principal prejudices. In Hollywood of the 1930s, however, the situation seemed almost reversed. Disgruntled onlookers even asserted one had to be Jewish or Catholic or foreign-born as qualifications for finding work in the movie capital. Yet there were sound reasons why members of the white minorities were so extraordinarily successful in Hollywood. The limitations which American society imposed on them as Catholics or Jews or foreigners or children of immigrants were also sources of their strengths. Their struggle for advancement in American society gave many of them a keener sense of the realities of social and political power, and the structure and functions of its myths and ideals, than they would likely have had, and than they later were to have, when they were comfortable and secure.

Such precise antennae to detect the pressures and needs of American social groups were of special importance to Hollywood filmmakers in the Depression years. They had attained the awesome power to influence the minds of millions, and scores of watchdogs from middle-class American culture constantly monitored that power to see that they did not subvert their traditional moral order and social values. Since the early 1920s the motion picture producers had employed a Protestant middle western Republican, Will H. Hays, as their shield against efforts of his own class to attack and control their operations. The Hays Office had considerable authority to impose self-censorship upon the stories the producers selected and the scenes they shot. In spite of his frequent intervention, however, Hays had little effect on the movies' natural propensity to reflect public morals rather than to idealize and elevate them.

What decades of Protestant indignation had failed to achieve, however, the Catholic clergy accomplished in 1934 when they threatened local or even national boycotts of objectionable films. Thereafter a Catholic layman, Joseph I. Breen, was appointed head of a Production Code Administration set up within the industry rigorously to enforce the Production Code of 1930. For more than twenty years the Breen Office made certain that a vast catalog of words, scenes, and subjects would not endanger the morals of movie audiences. Early directives from the Breen Office, for example, warned the studios to keep out of their scripts such words as: broad, dame, fanny, housebroken, on the make, virtuous, and want you. But it was a rather ambiguous achievement, after all, to eliminate all things potentially offensive or controversial from movies. Hollywood would not have assumed so central a place in the popular imagination during the Depression years had it not be able to rise above an adversary relationship with traditional American culture and present a positive and convincing portrayal of national values in an entertaining (and therefore, for itself, profit-making) way.

Such a skill Frank Capra preeminently possessed. It brought him recognition during the 1930s as the most successful of Hollywood directors—successful not only at the box office, Hollywood's principal standard of judgment, but successful also as an artist, a word with prestige value second only to money. He proved again and again in his movies of the thirties that he could create characters, settings, and stories that pleased nearly everyone in the huge movie audience, whose feelings and preferences have often been a mystery to motion picture producers. Capra's admirers went so far as to say, indeed, that the audiences *were* the people in his movies. The key to Capra's success, it was said, was his ability to convince audiences they were watching their own strengths and foibles, their own dreams and values, their own selves dramatized on the screen. If this argument is correct, that Capra was capable of presenting a satisfying and coherent mass identity to millions of Americans at a time of social stress and change, it goes a long way to explain why General Marshall tapped Frank Capra, despite his foreign origins and lack of establishment pedigree, as the man to tell the armed forces the War Department's version of their nation's story.

III

What does it mean, however, to claim that the audiences *were* the people in Capra's movies? Such assertions often do no more than reflect a basic confusion, or perhaps one might better say a lack of definition, in the

methods of motion picture criticism. It is one thing to say of a director's art that it makes certain statements through its themes and images about the nature of human life and values. It's quite another thing, however, to say of a director's work that it represents, or distills, or expresses the society and culture of his time—or that it reflects, or confirms, or helps to create the mental and emotional states of his audience. Critics, and especially movie critics, are often not quite aware of the theoretical and methodological pitfalls that await them when they leap from analyzing an artist's creations to postulating the relationship between art and society. The aims and ambitions of Frank Capra's films, more than the work of most other Hollywood directors, particularly invite his interpreters to make that leap, often with incongruous results. The assumption that the audiences *were* the people in Capra's movies, for example, does not make clear whether Capra presented an accurate picture of American society that audiences affirmed, or created myths and fantasies about the American people with which his audiences wanted to identify.

There are means to clarify such issues and provide sturdier supports for an effort to understand the relation between an artist's work and his or her society. One step is to study social institutions, beliefs, and values, building up a basis of social fact against which the artist's created image may be compared. Another is to place the artist's works within the broad framework of imaginative communication in society, to see how they relate to the recurring themes, images, characters, situations and resolutions that make up the conventions of artists and entertainment workers in many media. One can discover if the artist follows the conventions, alters them, or defies them; can find out their sources and how they are used; can consider intentions with respect to subject, techniques, and audiences. The end result may be a considerably more accurate idea of what messages an artist's works seek to communicate.

Though Capra's films have given rise to more than their share of unexamined generalizations, his self-conception as a filmmaker and his mode of work, on the other hand, provide an almost unique opportunity to examine a commercial director's notion of his social context and purpose. Among the many successful Hollywood directors of the 1930s, he was perhaps the most conscious of his role as an entertainer and communicator. The popular appeal of his films was a result not of the usual Hollywood serendipity but of painstaking, calculated effort. At the core of his professional identity Capra seemed to consider himself a servant or, more exactly, a catalyst to his audience. Within the Hollywood system he was among the most articulate spokesmen for the view that a film must be the responsibility and ultimately the creation of one person, the director, to whom all the necessary collaborators in produc-

tion are subordinate. The title of his autobiography, *The Name Above the Title,* suggests how much importance he placed on having that special recognition, which he first gained with *Mr. Deeds Goes to Town* in 1936; and elsewhere he stresses the precept, "one man, one film."

Yet he also believed that a film was not finished before audiences had had an opportunity to respond to it; in a sense he made the audience his final and most influential collaborator. " . . . You don't know what you've got until you play it before an audience," Capra has insisted. He adopted the practice of tape-recording prerelease previews, to have an accurate record rather than an impressionistic memory of audience response. He conducted several previews for each film, collecting and comparing reactions from theaters in rich and in poor neighborhoods. Back in the cutting room he would lengthen some scenes to give audiences more time to laugh, and cut others where audiences showed signs of fidgeting or boredom. Capra was successful in pleasing mass audiences in good part because he believed that moviegoing was fundamentally a mass experience, the coming together of a thousand strangers in a darkened theater to mingle their emotions with the larger-than-life figures on the screen.

Capra's career during the Depression years presents the anomalous picture of a man striving for autonomy and authorship in the production and crediting of his films, yet seeking to efface the visible evidence of his own directorial hand in the films themselves. The fact that he achieved both his goals has had a curious effect on his reputation over the years. The most controversial and influential theory of film aesthetics in the past quarter century, the *politique des auteurs* of the French New Wave critics, focused its attention primarily on Hollywood directors of the Depression period, but Capra was not a figure in whom the *auteur* theorists were particularly interested. They wished to assert that the director—not the screenwriter nor the producer nor the actors and actresses—was the principal creative force in the making of motion pictures. They claimed they could discern the personal style of the true *auteur* directors even in the factory-produced films of a period when ten movies came off the Hollywood assembly line every week, five thousand over the span of a decade. Since directors in the Hollywood system had so little control over the scripts they were assigned, the players whom they cast, or the editors who assembled their pictures, the *auteur* critics looked for the recurring touches that marked the signature of a director, the signs of a coherent style throughout a series of films by the same man. Such touches might be a predisposition to certain camera angles or set-ups or movement, a preference for certain kinds of lighting or fields of focus, placement or movement of actors. Whatever its ultimate

validity as a critical theory, the *politique des auteurs* has considerably sharpened the eyes of viewers to subtle aspects of cinematic form and style.

Capra's films, however, did not seem particularly amenable to this form of criticism. He had become all too obviously an *auteur,* for he had struggled until he attained control over scripts, casting, and the final cuts of his films. But he had no interest in displaying a personal style or signature for its own sake. His interest in technique was always in what it would do for an audience. He wanted his viewers so entranced by what was happening, so concentrated on the action, that they wouldn't have time to think about his style. "In my pictures people's eyes are riveted on the screen," he has said. "You can't take your eyes off because something is going to happen."

He devised a way to play back the sound track of the master shot while shooting close-ups, so that in the final print expressions and emotions would meld so closely together that the audience wouldn't notice the cutting back and forth from medium shot to close-up. He sped up the tempo of the acting to give each shot an urgency compelling the audience to follow the actions from shot to shot. His most noticeable technical devices, the frequent use of wipes (that is, when one shot appears to move across the screen, pushing out or wiping away the previous shot), particularly at the start of films, and what Hollywood called the montage sequence (a series of rapidly superimposed shots, for example, in *Mr. Smith Goes to Washington,* of printing presses producing a newspaper) are designed to accelerate tempo and increase audience involvement. The vast majority of shots in a Capra movie are medium shots and medium close-ups, carefully composed to focus audience concentration on the characters in action. When one thinks of Capra's Depression films one thinks first of a succession of superior actors and actresses, James Stewart and Jean Arthur, Clark Gable and Claudette Colbert, Gary Cooper and Barbara Stanwyck, Ronald Colman, Lionel Barrymore, Edward Arnold, Claude Rains, performing at the top of their skills. This is precisely what Capra worked to attain. His technique was above all made to serve the presentation of human character.

Over the years, therefore, Capra became known as a director with a subject rather than a style. By 1936, the year of Capra's second Academy Award for best direction for *Mr. Deeds* (after first winning it for *It Happened One Night* in 1934), audiences and critics had come to recognize a distinctive Capra subject and approach, a unity of theme from film to film. By the beginning of World War Two, with *Lost Horizon, You Can't Take It with You, Mr. Smith Goes to Washington* and *Meet John Doe* added to his successes, Capra had all but appro-

priated the subject to himself. To Capra's admirers that subject was nothing less significant, as a reviewer was later to summarize it, than "the simple common man, his essential goodness, and the inevitable triumph of that child-like faith over the forces of evil."

Capra of course had his detractors as well, and they did not disagree about the subjects of Capra's films. Only to them Capra's themes expressed a mawkish sentimentality. To his stories of the inevitable triumph of the childlike common man they gave the name "Capra-corn." It is significant that in his autobiography Capra has no qualms about these judgments: he accepts the view that his films were sentimental and he affirms the value of "Capra-corn." This is of crucial importance: it indicates that the social world Capra created in his movies was intended less to represent American society than to stimulate and support the ideas and values of his audiences. His goal was not to present reality, it was to persuade audiences to accept his vision of proper belief and behavior, or perhaps to reinforce their own. He might also have expected that some part of his audiences already were acting or would act on the basis of these values.

In recent years, nevertheless, Capra's self-confessed sentimentality has been the object of increasing hostility from film critics and historians. Andrew Sarris's *The American Cinema,* a catalog of judgments that attempts to force the history of American sound movies within a framework of a *politique des auteurs,* describes Capra's films with such words as populist sentimentality, populist demagoguery, tyranny of the majority, fascist, anti-intellectual, and conformist. The key word here appears to be populist, for it has been picked up by British critics of Capra, and it serves as a handy hook on which all sorts of social and political generalizations may be hung. Populism is used pejoratively by Capra's critics. It implies a series of elite assumptions about "the people" that were fashionable about a decade ago: that small town and "middle" Americans view the world as a battleground for a Manichean struggle of good against evil; and among their devils are lawyers, bankers, intellectuals, artists, and urbanites. "The people," according to these elite critics, are convinced that they can do no wrong because their motives are pure; and they like nothing more than using force to teach a lesson, as exemplified by the prominent scene in many Capra films of the hero punching someone in the nose.

One has every reason to feel uncomfortable with the critical or historical use of a generalization like "Populism." It simplifies both the films and social reality, and provides a whole structure of answers before one even knows the right questions to ask. But many viewers of Capra's Depression films will sense the discomfort that underlies this critical

hostility. There are obviously ideological scenes in Capra's films that seem to be making no coherent point, and their implications are often disquieting. When Lionel Barrymore as Martin Vanderhof baits the income tax man in *You Can't Take It with You,* one laughs because he makes the government look foolish, but the core of his argument seems to be only a petit bourgeois selfishness. Jefferson Smith's apparent vindication in the final scene of *Mr. Smith Goes to Washington* cannot erase from memory the scenes of police hoses being turned on marchers and of hired thugs beating up little kids, both in the service of the crooked publisher and tycoon whose power seems untouched by Smith's Senate filibuster. One leaves the theater after watching one of Capra's Depression films a little moved and renewed by his evocations of popular American social myths, yet wondering how those myths could ever have seemed adequate to one's experience of social reality.

What has served up to now for criticism of Capra's films will not go very far toward providing an understanding of their power. The definition of "Populism" which critics have found in Capra's movies has in turn imposed its own rigid categories on their criticism. They tend to interpret Capra's films as presentations of conflicts between social opposites. Beginning with country versus city and simple versus sophisticated, these oppositions are extended as far as critical ingenuity can go. One initial step in the process of comprehending the vision of society in Frank Capra's Depression movies and its popular appeal is to discard much of the conventional critical wisdom.

Begin with the "little man"—the simple, average, common man of childlike faith, innocence, and naiveté. Can one find this straw man in Gary Cooper as Longfellow Deeds, in James Stewart as Jefferson Smith, in Lionel Barrymore's Martin Vanderhof of *You Can't Take It with You?* Not really, in my view, and certainly not in Ronald Colman as Robert Conway in *Lost Horizon* nor Clark Gable as Peter Warne in *It Happened One Night.* Nor does "Populism," as historians normally understand that word, have much to do with Capra's inventive humor and his ability to please so many types of audiences, as the *New York Times* critic wrote in 1934, to manufacture "the kind of entertainment which pleases the thin-nosed sophisticate as well as the ribbon-counter empress and the affrighted defender of the public morale." Moreover, to speak of dualities and oppositions is an unimaginative way to depict the social conflicts in almost any work of art. The happy endings of Capra's films imply in particular a basis of social relationships between contending forces. To understand the source of social relationships rather than simply to describe categories of conflict is an essential task in grasping the significance of Capra's Depression films.

IV

The source of social relationships in Capra's films is a social hierarchy determined by the possession of wealth and power, an accurate reflection of the nature of American society. The catalyst who sets these relations into motion, however, who reveals them, criticizes them, alters them, but ultimately ensures their preservation, is the Capra hero—not the simple common man, but a man of unusual will and imagination, whose special qualities present both a threat and an opportunity to the established social system, whose strengths and weaknesses inspire the social virtues which serve to knit American society into a stable whole.

The willful imaginative hero, prototype for the figure Capra created, was a familiar face in American literature before he began to appear in the movies. He was a staple of middle-class popular fiction, the self-consciously commercial side of the genteel tradition in American literature, from the mid-nineteenth century until the very recent past. Capra was probably introduced to this figure by Robert Riskin, the New York playwright who began collaborating with him on *Platinum Blonde* in 1931 and went on to write the screenplays for eight other Capra films in the Depression years, *American Madness, Lady for a Day, It Happened One Night, Broadway Bill, Mr. Deeds Goes to Town, Lost Horizon, You Can't Take It with You,* and *Meet John Doe*—all the important Capra films except *Mr. Smith Goes to Washington.* They found their inspiration for *It Happened One Night* in a *Cosmopolitan* magazine serialized novel, "Night Bus," by Samuel Hopkins Adams, and for *Mr. Deeds* in an *American Magazine* serialized novel, "Opera Hat," by Clarence Buddington Kelland; Adams and Kelland were two of the notable practitioners of middle-class formula fiction. They took *Lost Horizon* from the best-selling novel of the same name by James Hilton and *You Can't Take It with You* from the long-running stage play by Moss Hart and George S. Kaufman. There is no question but that Capra and Riskin were fully aware of the conventions of popular literature they were putting to use.

The figure of the imaginative hero was the significant convention in the genteel stories Capra and Riskin adapted. Imagination was this hero's form of willful self-assertion. It was his strength in social competition with the wealthy, the powerful, and the pretentious. Above all it made him interesting. The genteel story is typically a story of boredom and restlessness among the rich—particularly rich young unmarried women. The imaginative young man, without status, wealth, or position, enters her world and cures her boredom with his comic inventiveness and visionary force. The genteel story is a comedy of submission and reward. The rich girl gives up her rebellious freedom for the pleasure of the hero's

wit and imagination. In exchange for the girl the hero weds his vitality and vision to the dominant social class. It is a fantasy of upward social mobility and romantic love. Its purpose is to secure social order and stability by promising ample rewards for recognizing traditional modes of dominance. When aspiring young men recognize the legitimacy of upper class power they are admitted to its prerogatives; when unhappy young women recognize the legitimacy of male dominance they are offered wedded bliss.

One might say that *It Happened One Night* was the classic genteel romantic story, except it is more than that. Capra and Riskin brought as much to the genteel formula story as they took from it. Above all they took it out of the drawing rooms of the rich and filled it with the settings and people of everyday life. They vastly extended its range, breaking through the bounds of its narrow social scene. Almost alone among the powerful imaginative worlds that Hollywood created in the Depression years, the Capra-Riskin world seems more than a separate special world, the world of the West, or of male heroism, or of show business, or even of the downtrodden; it appears to encompass nearly all of American social life.

Capra and Riskin accomplished this by adding at least four new elements to the genteel formula. They can be identified as follows: the working woman; the ubiquitous presence of the press and the importance of publicity; a slightly altered conception of the imaginative hero, which makes him more vulnerable and incomplete than the standard fictional version of this figure (the difference is particularly obvious between the Longfellow Deeds of Kelland's "Opera Hat" and Gary Cooper's role in the movie); and finally, to compensate for the vulnerability and incompleteness of the hero, the appearance of public crowds at decisive moments to support him and validate his social importance.

There were significant changes in the conception of the imaginative hero and his social relationships in the later 1930s and the 1941 film *Meet John Doe,* as will be shown; but it is useful first to see how these new elements operate generally throughout Capra's Depression films to create a version of social order and stability all his own.

The introduction of the working woman demonstrates how Capra and Riskin developed the conventional form. In movies as well as literature it had normally been assumed that audiences preferred to get out of their own lives and vicariously share the lives of the rich. Capra and Riskin found a way to take audiences out of their own lives by showing them the marvelous things that could happen to people who worked for a living just as moviegoers did. The director and screenwriter evolved their new perspective gradually. In their first picture together,

Platinum Blonde, the first half of the movie is the traditional genteel story of the imaginative hero winning the rich girl (Robert Williams as Stew Smith and Jean Harlow as Anne Schuyler, respectively). In the second half the working woman wins the hero away from the rich girl. The hero and the working woman had worked side-by-side as newspaper reporters, but he had been oblivious to her feelings toward him until his wife recognizes her as a rival. Oh no, he protests, she's just one of the boys, he only knows her by her last name, Gallagher. It's only when Gallagher, played by Loretta Young, shows up to report on a society party in a backless evening gown that Smith realizes she's a woman, and begins to switch his loyalties from the wrong woman to the right one. He splits from his rich wife and ends up living in Gallagher's apartment, writing the play that will presumably make him famous, while she supports him.

Claudette Colbert as Ellie Andrews in *It Happened One Night* was the last of the rich girls given sympathetic treatment in a Capra film. And she finds happiness for the first time in her life when she is living without money. "I'd change places with a plumber's daughter any day," she says. Thereafter the rich girl served only briefly, if at all, as an impressive but unsuitable contrast to the qualities of the working woman. Capra selected Jean Arthur as the actress for the working woman role, as Babe Bennett the reporter, in *Mr. Deeds Goes to Town;* Alice Sycamore, a secretary, in *You Can't Take It with You;* and Saunders, another secretary, in *Mr. Smith Goes to Washington.*

But just as in the traditional genteel story, happiness in Capra's romantic vision comes from the woman submitting to the man. The imaginative hero conquers the working woman with his dreams and humor just as he used to conquer the rich girl and convinces her to give up career and freedom for home, marriage, and dependence. There is a strong suggestion as well that the hero rescues her from a hard, unfeeling, mannish style of life as a working person and gives her a chance once again to be feminine and lead a full emotional life. Nowhere is this theme better presented than in the scene from *Mr. Smith Goes to Washington* when James Stewart as Jefferson Smith breaks down the cynicism of the mercenary secretary Saunders and wins her loyalty and love. In a long, effective sequence of shots he displays his vision by describing the pleasures and promise of nature in his Western state, then playfully pierces her reserve by trying to guess her given name. When she tells him her name, Clarissa, it is as if he had created her true self.

Loretta Young as Gallagher, Jean Arthur as Babe Bennett, and Barbara Stanwyck as Ann Mitchell in *Meet John Doe* work as newspaper reporters; so also do two of the imaginative heroes, Stew Smith in

Platinum Blonde and Peter Warne, played by Clark Gable, in *It Happened One Night.* Jefferson Smith was editor and publisher of a paper for boys. Reporters appear in supporting roles or as extras in *Platinum Blonde, It Happened One Night, Mr. Deeds, You Can't Take It with You, Mr. Smith,* and *Meet John Doe.* Montage sequences of headlines and running presses are used in *Lost Horizon* and *Mr. Smith* for swift continuity and plot development. Though McLuhan wrote in *Understanding Media* that the content of the film medium was the book, in Capra's case one might say the content of film was newspapers and newspaper work.

In Capra's genteel romantic plots the press plays the fundamental role of exposing his characters' private affairs to public scrutiny and participation. Capra's Depression movies raise to the mass cultural level a traditional theme of American middle-class values, that personal lives should not be kept hidden from public scrutiny, that the desire for privacy implies one has something to hide. Newspaper reporters serve as eyes and conscience for the public. The ability of Longfellow Deeds and Jefferson Smith to win over the hard-bitten, sarcastic reporters from hostility to support is evidence of the validity and persuasiveness of their visions; the desires of the rich Schuylers in *Platinum Blonde* and the rich Kirbys in *You Can't Take It with You* to avoid publicity is a sign of their moral weakness. And when the personal details of his characters' lives are chronicled every morning and evening in banner headlines, Capra is also signaling that their fates have more than private significance.

This public aspect of Capra's heroes differs from the traditional mold of the character; only Peter Warne in *It Happened One Night* is an old-fashioned hero, autonomous, clear-headed, and self-contained, the quintessential individualist, requiring only marriage to the proper woman to make his life complete. The later figures, as well as Stew Smith in *Platinum Blonde,* are something new in imaginative heroes: they are vulnerable and incomplete. To be sure, they possess imagination, strength, and integrity; their vulnerability and incompleteness stem from inexperience and naiveté when confronted with the motives and behavior of selfish, self-important, or corrupt people. These gaps in their personal armor are central to the social mechanism of Capra's fables. They provide the opening for individuals to recognize the humanity of others, for the building of relationships. The imaginative hero receives as he gives, laying the foundation for the mutuality that lies at the heart of Capra's social ethic—the ethic that Jefferson Smith describes as plain, ordinary, every-day kindness, a little looking out for the other fella, loving thy neighbor.

Mutual recognition in Capra's Depression films begins, as we have seen, with the working woman and the hero. As he revives her capacity for love and emotion, she provides her worldly experience as an aid to his

sound instincts: Saunders in *Mr. Smith Goes to Washington,* for example, instructs Jefferson Smith from the Senate gallery how to conduct his filibuster. Mutual recognition also comes to the hero from someone in public authority, invariably a sage, kindly old man, a judge, as in the courtroom scenes of *Mr. Deeds Goes to Town* and *You Can't Take It with You,* or the vice-president presiding over the Senate in *Mr. Smith Goes to Washington.* They demonstrate that law and procedure can give preference to honest values and right instinct. But these figures of authority do not throw their support to the hero until they have ample evidence that the public is on the hero's side. The turning point in *Mr. Deeds* and *You Can't Take It with You* occurs in the courtroom scenes when the public demonstrates its solidarity with the hero, the same scenes in which authority tilts in favor of the hero, too. Vulnerable and incomplete as he is, the hero triumphs when the public showers affection on him, and his opponents realize what they have lost by forfeiting the people's respect. Through his scene of mutual recognition with representatives of "the people," the hero extends his web of relationships to all of American society, including the audience as well.

V

As the Depression years advanced, Capra found it increasingly difficult to maintain the myth that genteel forms, even as he had adapted them to his own medium and skills, were enough by themselves to present a convincing picture of order and stability. When his heroes extended their range into a wider experience of American life, they began to encounter possessors of wealth and power with greater ambitions than to make the right match for their bored and restless daughters. In the last three films Capra made before the outbreak of World War II, *You Can't Take It with You, Mr. Smith Goes to Washington*, and *Meet John Doe,* his heroes openly oppose wealth and power for the first time.

Their conflicts with men in high places emerge over the issue of industrial-technological change. They begin to function as social critics and crusaders when technological change threatens to destroy human values—when Anthony P. Kirby's munitions factory in *You Can't Take It with You* would displace the Vanderhofs and their neighbors, when political boss Jim Taylor's dam in *Mr. Smith Goes to Washington* would flood the land Jefferson Smith wants for his boys camp. The heroes' imaginations were pressed into service not merely to secure class harmony and male dominance, but also to struggle against environmental or social change. Upward mobility and a chance to share in the power and

prerogatives of the traditional elite became less important than the preservation of the status quo, as Martin Vanderhof says in *You Can't Take It with You,* "just to go along the way we are."

In fact, however, "the way we are" in any broader social sense can hardly be commensurate with Capra's social vision, since the usual order of business in the United States includes the industrial growth and the reshaping of the natural landscape that Kirby and Taylor propose. Capra wanted rather to turn back the clock to an imagined past social stability founded upon an image of the American small town, with comfortable homes, close-knit families, friendly neighbors, a modest but prosperous community, with bountiful farms and a benign wilderness nearby. To call Capra a Populist in any precise historical sense is clearly a misnomer— unlike actual Populists in the American past he was not making a critique of the American social and economic system, did not even want a redistribution of the wealth and power in American society so that his little people might have more. He simply wanted more neighborly and responsible people to be at the top of the social and economic hierarchy. It is closer to the truth to describe him as a Jeffersonian agrarian, or more simply, a pastoralist.

When Capra's Depression movies are looked at from this perspective, the 1937 film *Lost Horizon,* the only product of the Capra-Riskin collaboration not set in contemporary American society, takes on a much greater significance. *Lost Horizon,* both in James Hilton's novel and in Capra's film, offers an image not so much of social stability as of sanctuary from social disorder—Shangri-La, a monastery hidden away in Tibetan fastness to preserve the Christian ethic (and its simple rule: be kind) from the orgy of greed and brutality that was engulfing the world. Capra himself has called the Vanderhof living room in *You Can't Take It with You* their Shangri-La, and there are sanctuaries in nearly all his films: the small town, Mandrake Falls, in *Mr. Deeds Goes to Town;* the lake and the boys camp in *Mr. Smith Goes to Washington;* auto court cabins in *It Happened One Night;* Gallagher's apartment in *Platinum Blonde.*

But Capra's films are concerned more with character than they are with place. One of their basic themes is that the values and ideals of the middle class can be maintained in hostile or indifferent settings, in the blasé New York of *Mr. Deeds Goes to Town* and *You Can't Take It with You* or the cynical Washington of *Mr. Smith.* What is required is character, and character of a special kind. Longfellow Deeds, and Jefferson Smith, and Martin Vanderhof, and the others may be common folk at heart but they are different from most of us in their audience. They are leaders. They are leaders with the right kind of strengths and the right

kind of vulnerabilities. They are able to offer their public an appealing system of values and beliefs, a mutual relationship within that system, and a supporting role of real significance in trying to make those values and beliefs realities.

Nevertheless, once they begin their open struggles with wealth and power Capra's heroes find themselves unable to triumph by asserting their strengths and invoking their alliances. Wealth and power prove simply too wealthy and too powerful. Their only hope of success lies in their power of persuasion, their ability to convince their opponents to make a change of heart and voluntarily join the hero's side. They attempt this by demonstrating the efficacy of their own values in action, then by prodding the villains to express the humane values they have suppressed within themselves during all their days of wealth and power. The tactic works perfectly in *You Can't Take It with You,* ambiguously in *Mr. Smith Goes to Washington,* and not at all in *Meet John Doe.*

In *You Can't Take It with You* the gift of a harmonica is the symbolic act that recalls Edward Arnold, as the tycoon Kirby, to his humanity. Kirby cancels the business deal that would have destroyed the Vanderhof house and also wrecked his son's chance for love and happiness with Alice Sycamore, Martin Vanderhof's granddaughter. In the movie's happy ending the Kirbys are sharing the human warmth and recognition of the Vanderhof household.

The conclusion of *Mr. Smith Goes to Washington,* however, is much more equivocal. As Smith exhausts himself in an apparently futile filibuster against the crooked Taylor machine, Claude Rains, as Senator Joseph Paine, is torn between his connivance with Taylor and his admiration for Smith's courageous fight in a lost cause. Paine fires a gun in the Senate cloakroom, apparently an attempted suicide, then enters the Senate to throw his support to Smith. But his change of heart does not ensure that the man of wealth and power, the backroom political boss and businessman Jim Taylor, will change his heart, too. At the end of *Mr. Smith Goes to Washington,* the United States Senate is thrown into pandemonium and the outcome of the struggle remains in doubt.

In *Meet John Doe,* Capra's last prewar film, the hero is hardly willful or imaginative in the old formula sense at all, and the villain is more powerful and ambitious than ever. Long John Willoughby, played by Gary Cooper, is merely an ex-baseball pitcher on the bum who allows himself to be used as a symbolic common man—*the* John Doe in a nation of John Does—as part of publisher D. B. Norton's scheme to gain national power. Willoughby can only picture himself as an old-fashioned genteel hero in a dream, but when called upon to address the public he discovers in himself precisely the rhetoric of Jefferson Smith—everybody

pull together, join the team, love your neighbor. By the time he begins to believe in his own words he finds himself powerless in the face of his past compromises and Norton's political and media control.

Capra describes in his autobiography the difficulties he and Riskin experienced in finishing *Meet John Doe.* He filmed four different endings and played them all in different theater previews. None was satisfactory. "I *knew* Riskin and I had written ourselves into a corner," he recalls. "We had shown the rise of two powerful opposing movements—one good, one evil. They clashed head on—and *destroyed each other!* St. George fought with the dragon, slew it, and was slain. What our film said to bewildered people hungry for solutions was this, 'No answers this time, ladies and gentlemen. It's back to the drawing board.' " But at last they shot a fifth ending and put it on the film.

Long John Willoughby, trapped in a situation he cannot control, remorseful about his own role, determines to fulfill the original phony John Doe promise by jumping off a building in "protest against the state of civilization," a civilization in this case that has allowed his good impulses to be used falsely, that has turned people against each other and against him. Capra and Riskin had to decide—does he jump, and if not, why not? In their fifth and final ending Doe is persuaded not to jump, because their solution was to transmute the Capra hero into a modern Christ. He doesn't have to die, as the woman who loves him says, because someone else—the first John Doe—already died for the same purpose.

The parallel between Long John Willoughby and Jesus Christ has its obvious shortcomings, but it is more of an answer than Capra is willing in his autobiography to admit. It linked the Capra hero, his leadership, and his sustaining followers directly to the Christian faith. Representatives of the common people confront the villain Norton atop the skyscraper from which Doe is prepared to jump, and it is their veneration, their need, that changes his mind. "There you are, Norton— the people," says the cynical reporter in the last words of the film, "try and lick that." Good and evil were not destroyed, as Capra claims, but rather had fought to a standstill, and both sides lived on to fight another day.

In the process of turning John Doe into a Christ-figure Capra transformed the myth of his American hero into a defense of Christian morality. No longer is it Shangri-La, it is the United States that is the sanctuary for the Christian ethic. After Pearl Harbor the struggle between good and evil moved out from the realm of an internal conflict into the titanic battle of Fascism versus Americanism. And what was Americanism? It was the rewards of social stability—wealth, success, and the girl for the hero, fellowship, happiness, and trustworthy leaders for the rest

of us. It was a religious faith in a secular ethic that equated with patriotism and American democracy as easily as it did with Christianity.

Capra made the point vividly in his War Department film *The Negro Soldier,* which tells its story through the device of a worship service in a black church, and though its capsule summary of black history never mentions slavery, it conveys the overwhelming impression that the black congregation gives its witness and sings its hymns in worship of America. Whether by blind luck or genius General Marshall found in Frank Capra a man ready to take control of wartime film propaganda for the millions of new soldiers and sailors—a man whose many successful commercial movies of the Depression years already amply conveyed his vision of why America was worth fighting for, and the rewards of following one's leaders.

MEET JOHN DOE: AN END TO SOCIAL MYTHMAKING

RICHARD GLATZER

As of 1935, *It Happened One Night* had enlisted an enthusiastic follow-ing of millions, almost put the undershirt industry out of business, and gathered a bushel of Oscars for its deserving director. Frank Capra's immediate response to his success was a feeling of elation, but elation soon gave way to anxiety and self-doubt: would his future film-making career merely prove to be an anticlimax? "Then it came to me," Capra writes in *The Name Above the Title,* "—a brilliant out! Burnish my halo with martyrdom—get sick!" Capra's illness, at first purely imaginary, soon became a brutal physical reality: he was wishing himself to death. Then an anonymous stranger visited him, and chastized him for wasting his God-given talents. Capra tells us that he listened to the man, was overcome with shame, and abruptly began to recover. It was at this point in his career, he insists, that he became a socially dedicated film-maker: "I knew then that down to my dying day, down to my last feeble talent, I would be committed [to the service of man] Beginning with *Mr. Deeds,* my films had to *say* something."

Clearly, Capra's earlier films often "said" something; *American Madness* in particular ambitiously and successfully dealt with timely social questions in a manner somewhat similar to his post-1935 works. Yet *American Madness* is severely, pragmatically focused in a way the important later films are not. *Madness* straightforwardly confronts partic-ular problems and suggests particular solutions while minimally dealing

with classic American types and broad national preconceptions. In *Mr. Deeds Goes to Town,* for the first time, Capra meticulously and self-consciously attempted nothing less than to create an American mythology that might reinforce the nation in its time of financial and social crisis.

In assuming this responsibility, Capra linked himself irrevocably with an American tradition of conscious mythmaking that harkens back to William Bradford and the Puritans. Bradford wrote his history of the Plymouth Colony to awaken a spirit within third generation Puritans that was apparently dying—that pioneer spirit that had underlain their ancestors' bold decision to travel to a new world. Similarly, Capra, in *Mr. Deeds Goes to Town,* attempted to remedy, not merely the concrete financial, political, and social problems that the Depression presented, but the more profound and difficult problem of national morale. Army veterans were marching against their government; radical political ideologies were growing in popularity; the power of charismatic celebrities seemed unlimited: Americans' belief in their country was crumbling under diverse pressures unlike any they had felt previously. Frank Capra—in 1936, a man very sure of his control over a mass audience—wanted to revitalize their faith by renovating dusty national archetypes and dreams.

In *Mr. Deeds Goes to Town,* and later (to a somewhat lesser extent) in *Mr. Smith Goes to Washington,* Capra accomplished this revitalization in part by creating his heroes and their small town communities as incarnations of the composite ideals and philosophies of historical figures whose enthusiasm for the possibilities this country presented had been deeply felt—figures like Jefferson, Lincoln, Thoreau, and Washington. The rural village comes to symbolize such values as a stress on personal relationships, the celebration of unself-conscious individualism, a healthy lack of interest in irrational progress and excessive materialism, and an acute sense of the worth of strong spiritual ties to one's friends.

Yet Capra was very much aware of the idealized nature of the small towns he envisioned. *Deeds* and *Smith* gain their mythic power and drive when Capra's rural protagonists make archetypal journeys to the city, and there encounter Capra's notion of the chaotic, very unidealized "present"—a world where political and moral corruption abound, where moneylove is the prime motivating factor, and where interpersonal relationships, even within families, prove to be pragmatic, selfish, and loveless. Atomization and mass conformity result.

Clearly, the values of the cities are inimical to those of the small towns. Deeds and Smith (the emissaries from the past) must inevitably

confront the urban present; and in their ultimate victories over their foes lies Capra's prognosis for the future—a future in which the spiritual will triumph over mindless progress. Yet, when Deeds and Smith finally conquer the city, enabling us to glimpse the happy future, only the most irretrievably villainous—the political bosses and the shyster lawyers—are truly defeated: the majority of the urbanites are converted to a belief in traditional values. Longfellow Deeds and Jefferson Smith merely awaken a moral sense that the city has lulled to sleep. As such, they are symbols of the basic decency of every American, a decency so strong that, once tapped, it is capable of overcoming any evils and of carrying this country through to a glorious future. In *Deeds* and *Smith,* Capra used national types and placed them in the urban present so as to ultimately update the mythical notion of the American national character. Capra gave his countrymen a positive self-image.

In 1940, the dangers which Americans faced were perhaps greater than any they had encountered previously. In addition to the still unresolved economic problems at home, totalitarian Fascism ranged virtually unchecked over the European continent and threatened to engulf liberal democracies everywhere. For the United States, war was on the horizon. All the values Capra had celebrated in *Mr. Deeds* and *Mr. Smith* were in danger of being eclipsed. A restatement and reaffirmation of those values—a vote of confidence—was sorely needed.

When Capra began working on *The Life and Death of John Doe,* he had every intention of casting that vote. "The people are right," he told an interviewer at the time, "people's instincts are good, never bad." In *Meet John Doe* (as the film was finally titled), Capra would attempt to dramatize once more his faith in America and its people by creating another variation on the *Deeds* formula of the guileless rustic reawaking the finer instincts of the misguided urbanites. Ironically, however, the film proved to be the bleakest work of the director's career. With insight gained after the fact, Capra would write thirty years later that *Meet John Doe* was made, not so much to show faith, but rather to prove that he could "handle hard-nosed brutality with the best of [them]." A dark vision of the dangers implicit in American democracy, rarely permitted to surface in *Deeds* or *Smith,* erupts in *Doe,* and instead of reaffirming those values he had advertised so successfully in the previous films, Capra here discovers that they are inadequate to a new set of problems posed by the rise of Fascism. *Meet John Doe* marks the end of Capra's career as social mythmaker: after it he would turn to the more personal cinema of *It's a Wonderful Life.*

The seed of *Doe*'s problems is apparent in its enormous physical

scale. *Deeds* had taken place in a limited arena—New York City—but *Doe* encompasses the entire nation in its scope, indicative of Capra's desire to give the film a comprehensiveness which would underline its mythic intent. The mythological resonance of *Mr. Deeds,* however, was a result not of sheer numbers, but of Capra's inspired manipulation of meaning-ful, well-defined symbols which were a part of a shared American experience. Deeds's victory over his adversaries clearly implied the tri-umph of individualism over conformity, of the personal over the mass, of the spiritual over the material. There was no need to render explicit the importance of this victory by painting on an exceedingly large canvas.

Mr. Smith Goes to Washington represents Capra's first increase in the scale of his national mythology over that of *Deeds:* in it one can see the germ of the problems *Doe* would later present. The courtroom of *Deeds* in *Smith* becomes the Senate of the United States. Deeds's activities are the talk of New York; Smith's are the talk of the entire nation. And the public media that, in *Mr. Deeds,* is apparently contained by the big city, branches out to reach Smith's home state. Rather than heighten our sense of the traditional, the increased scale of *Smith* brings with it an increased sense of modern corruption. We find evil in the person of Boss James Taylor in a rural (and presumably traditional) western state. And since Smith's foes are not entirely urban, Capra could not easily tie up all the strings in one neat, decisive victory. Conse-quently, the film's original ending, depicting the dismantling of Taylor's political machine following Smith's Senate victory, proved to be anti-climactic. Capra chose to cut it, leaving us somewhat in doubt as to Taylor's fate. Still, the present ending is hardly open-ended; in *Mr. Smith Goes to Washington,* the mythological *Deeds* structure remains basically intact.

With the further increase in scale of *Meet John Doe,* this structure breaks down completely. The distinction between small town and city, so important to *Mr. Deeds,* virtually disappears. Although *Doe*'s back-drop is the entire map of the United States, the moral geography of the film is urban; no longer is there any contrast between citified and rustic views of social reality. Correspondingly, the idealized past of *Deeds* and *Smith* is dissolved. There is in the first half of *Meet John Doe* no traditional moral sense similar to those that energized Longfellow Deeds and Jefferson Smith.

The film opens with the changing of the *Daily Bulletin*'s motto from "A Free Press for a Free People" to "A Streamlined Newspaper for a Streamlined Era," and we immediately find ourselves in the center of a modern moral chaos. Ann Mitchell (Barbara Stanwyck), a reporter for the *Bulletin,* is fired along with many of her colleagues for being out

of step with the times. In retaliation, she composes a letter under the name of "John Doe" protesting the injustice of the modern world and threatening to commit suicide by jumping off City Hall on Christmas Eve if social conditions do not improve. This letter becomes her final column for the *Bulletin*. When a political, social, and journalistic controversy ensues, Ann is rehired—provided she reveals the identity of John Doe. Ann admits to having penned the letter herself, then convinces the *Bulletin's* editor (James Gleason) to hire a John Doe rather than publicly acknowledge the letter as a hoax. (If no sincere moral figure exists in the modern world, then fake one—especially if it will boost your circulation.) Long John Willoughby (Gary Cooper), a freight train hopping ex-bush-league pitcher, is chosen from a long line of eager derelicts. In return for posing as John Doe, he will receive an operation that will mend his bad arm and a one-way ticket out of town on Christmas Eve.

Doe's premise is as unrelentingly cynical as any Capra has ever treated. Yet a traditional, ethical figure does emerge out of this world of self-serving fast-talkers, improbably enough: Long John's tenuous link with the past (the speeches Ann writes for him, containing the wisdom of her dead father), and his growing sense of responsibility that comes of being a public figure finally transform him into a moral force in this chaotic present. The John Doe letters attract public attention—including the attention of D. B. Norton (Edward Arnold), the *Bulletin's* Fascistic owner, a powerful monopolist, and a man with extreme political ambition. Norton puts Long John on the radio to increase Doe's following, and it is at this point that Willoughby finally awakens both to the extent of his control over his audience and to the moral dubiousness of the Doe affair. He runs from the studio at the end of his speech; he and his friend the Colonel (Walter Brennan) hop the first freight train out of town. However, Long John's anonymity is short-lived: when he and the Colonel stop over in Millville, a nearby small town, he is recognized as John Doe, cornered by the townspeople, and told how positively he has affected community relations. Willoughby is deeply moved by these testimonials. His moral transformation is now complete, and he decides to pose once again as John Doe, this time hoping to promote brotherhood among his followers.

It seems, for a while, that the newly transformed Willoughby might conquer the corrupt present and lead us to an ideal future. The John Doe movement gains momentum. Willoughby is sent on hectic speaking tours; John Doe Clubs—encouraging a sense of community and personal relationships among average Americans—spring up across the continent; a national John Doe Convention is planned. But D. B. Norton has had

personal reasons for promoting the movement. The night of the convention, Norton privately demands that Willoughby choose him as the John Doe's third party candidate for the Presidency of the United States. Willoughby refuses, and leaves for the convention stadium, planning to tell the John Does the truth about the movement. Before he can speak, however, Norton rushes upon the stage, reveals Willoughby as an impostor, and has his private police force cut the microphone wires. Hearing no explanation from Willoughby, the violently disillusioned mob turns on him. He is lucky to escape with his life.

Long John decides that he can only prove his sincerity and thereby resurrect the John Doe movement by committing suicide on Christmas Eve as the original John Doe letter said he would. In the film's present ending (Capra shot five different endings, all of which he found unsatisfactory), a group of John Does—the very Millville citizens who first persuaded John to become a public crusader—now convince him that he is more valuable to the movement alive than dead. But is he? The film's finale, with the small group exiting from the City Hall roof to the strains of Beethoven's Ninth, is utterly unresolved. Lacking a clear notion of an idealized past, Capra is unable to provide us with a convincing realization of an ideal future. The struggle of these few to revive the John Doe movement just begins as the film ends, and we are left anchorless in an ugly, tempestuous present.

Clearly, this breakdown of the *Deeds* structure results in a drastic departure in meaning from Capra's earlier films. What forces within the film make it much darker and more troubled than either of its predecessors? *Doe*'s magnification of the evils of *Deeds* and *Smith* is in large part responsible. The relatively limited danger of the city shysters in *Deeds* has grown cancerlike, paralleling the film's increase in scale, giving us the Hitlerian national menace that D. B. Norton poses. Norton's villainy surpasses Cedar's and Taylor's financial greed: Norton lusts after cold power. Capra introduces him brilliantly, immediately impressing upon us the enormity of his ambition. We see a long shot of a motorcycle troop preparing to drill on a large field, then a medium shot of Norton on horseback, watching the drill through binoculars. We then return to the field, where a dazzling, dangerous pattern involving dozens of speeding, intersecting motorcycles is being performed. All this is for one man's benefit. It comes as no surprise, then, to learn that Norton believes "What the American people need is an iron hand" or that he controls almost every important communications medium in the country.

Indeed, it is the mass media that serve as Norton's prime means of controlling America. Capra's ambivalence toward this impersonal means of communication, a tangential issue in earlier films, here becomes a

focal point. Radio and the newspapers, in *Meet John Doe,* exert an almost supernatural influence over Americans. The media become arbitrary fates: if Doe's climb to fame is achieved through them, his decline—the result of the simple clipping of a microphone wire—is likewise, in a sense, their work.

Yet, after all, D. B. Norton and his villainous use of the media do not entirely account for the darkness of the film: to isolate the aspect of *Doe* that makes it so much more pessimistic than either of its predecessors, one must look beyond the obvious dangers of Norton to the more subtle ones Long John Willoughby suggests. Unlike Longfellow Deeds and Jefferson Smith, Willoughby, when he is anonymous, is absolutely amoral. He accepts the *Bulletin*'s offer so that his bad arm may be mended—thinking nothing of the moral consequences of his action. Only when he becomes a celebrity does he grow into the moral decency that Smith and Deeds possess from the start. If taken symbolically, Willoughby's conversion implies, not that most Americans are traditionally ethical, but rather that the anonymous "little man," so long as he remains anonymous, is little more than a moral blank slate.

This is obviously an atypical notion for Capra, and one would be tempted to disregard it if the bulk of *Meet John Doe* did not bear it out. When Ann Mitchell selects Cooper as her choice for John Doe, she tells her editor, "That face is wonderful. . . . They'll believe him." As a veteran newspaperwoman, she believes that the American public can be manipulated by mere appearances. And her belief is shared by her colleagues. In an almost surrealistic sequence, reminiscent of Nathanael West, we see newspapermen create perverse symbols for an undiscriminating public: just prior to his first radio broadcast, Long John is being photographed for the newspapers when a young woman in a bathing suit is ushered in, a banner draped across her breast. "I'm getting a Jane Doe ready," a newspaperman explains. She is photographed with Willoughby, then leaves, and two midgets are brought into the room. The midgets, "symbols of the little people," we are told, perch on John's shoulders, and again a picture is taken.

Soon after this sequence, we are given a direct indication of the eagerness with which ordinary Americans accept symbols produced by the mass media, when John and the Colonel visit Millville. One can easily see how far Capra has travelled from the solid community of Deeds's Mandrake Falls: Millville residents illogically worship John Doe, a man whom they at this point have only heard once, on the radio. The owner of a small diner (Sterling Holloway) becomes inordinately excited when he recognizes Doe eating in his restaurant, then telephones an operator: "Tell everybody in town! John Doe was just in my place!" The situation

of John Doe—the symbol of the average man—receiving this perverse celebrity worship is extraordinarily ironic. Similarly, Millville's Mayor Hawkins (Harry Holman) lures John to the town hall, then patrols the main entrance. "Don't do anything to disgrace a little town," he tells some townsfolk as they push their way in to see their god. He denies entrance to others because they did not vote for him. "Haven't had so much excitement since the city hall burnt down," he remarks; "people were so excited they nearly tore his clothes off." The small town, once the locus of traditional values, is fast becoming a center of selfishness and ugly credulity.

There is a huge potential for disillusionment among these Millville residents, a potential that is realized in the film's climactic convention sequence. The crowd, gathered together from many states, is at first a model of harmony, a sea of umbrellas, singing together in the rain. The people are, as Long John tells us, "hungry for something. . . . Maybe they're just lonely and [want] . . . somebody to say hello." They are at their most open, their most vulnerable, yet this vulnerability renders them more volatile. They need only vaguely sense that they have been duped, and they will emotionally snap shut like clams. D. B. Norton gives them that sense, and in the ensuing bitter turmoil ("We've been taken so long, we're getting used to it," one man snarls), the latent dangers of unthinking innocence are brilliantly realized. What began as Capra's denouncement of Nazi tactics finds the seeds of Fascism lying dormant in American Democracy. *Meet John Doe* presents America, not with the good self-image that *Deeds* and *Smith* provided, but with the underside of that image—with all of Capra's doubts about democracy and the American people.

Yet Capra's consciousness of his role of social mythmaker, coupled with his fundamentally comic world vision, did not permit him to be comfortable with *Doe*'s pessimism. The more the film shows us his disillusionment with the American people, the more it tells us of his love for them. His sentimental scenes, normally so poignantly effective, are unconvincing in *Meet John Doe*. The sequence in which Long John is convinced by the Millville residents to resume his posture as John Doe is typical of the film's unsure treatment of sentiment. One townsperson after another bears witness to his faith in Doe. The first speeches are somewhat affecting, but by the time old Mrs. Delaney (Emma Tansey) tells Long John (in close-up), "God bless you, my boy," the sequence has become excessive.

Similarly, the decision on the part of the three Millville "John Does" (Regis Toomey, Ann Doran, J. Farrell MacDonald) to journey to the City Hall roof to prevent Doe from committing suicide is unbeliev-

able. We have just witnessed their profound disillusionment in the convention sequence, then suddenly they are racing to the roof, insisting that they trust Willoughby.

Indeed, Capra himself seems to be often acutely aware of the implausibility of such sequences. His characteristic comic undercutting of the potentially maudlin (Cooper, in *Deeds,* trips over a trash can after a romantic scene with Jean Arthur) here becomes extreme, rendering the film's tone uncertain and disconcerting. The character of the Colonel seems to have been created solely to serve as a constantly cynical (yet sympathetic) reference point throughout the film. When Stanwyck first explains the John Doe letter to him, the Colonel replies, "You couldn't improve the world if the buildings jumped on you." Long John, in his first radio speech, suggests that people tear down the fences separating them from their neighbors: later, the Colonel insists that, "If you tore one picket off of your neighbor's fence, he'd sue you." The Colonel summarizes his world view in one phrase: "The world's been shaved by a drunken barber." And in the aforementioned sequence in which Millville residents tell John of how his speech has helped them to understand each other, the Colonel's skeptical scowl, repeatedly shown in reaction shots, constantly punctures the scene's mawkishness. Yet the Colonel is never proven wrong: unlike other likable cynics in *Deeds, Smith,* or even *Doe,* the Colonel is never converted to optimism.

At times, the corrosively skeptical aspect of the film, embodied primarily in the Colonel, seems to take on a perverse sense of self-parody. The midget sequence preceding Long John's radio debut in particular seems to have a self-directed irony to it. When the two midgets are placed on Long John's shoulders, and Willoughby is told that he is supporting twin symbols of "the little people," Capra seems to come dangerously close to commenting caustically on his own conception of himself as social mythmaker.

And therein lies a possible key to one of the most perplexing questions *Meet John Doe* poses: why did Capra, so aware of his influence over the American public, so socially dedicated, allow himself to create as disturbing a film as this? The answer lies in the autobiographical nature of *Doe;* for the film, obsessed as it is with the importance of mass media, proves to be Capra's only work to deal directly with the issue of American mythmaking. Long John's accidental transformation from drifter to national figure parallels Capra's own early drifting experience and subsequent involvement in moviemaking. Willoughby's awakening to his power over the studio audience during the key scene of his first radio speech, his initial fear of that power and his subsequent responsible acceptance of it parallels Capra's emotional and physical illness which

followed the success of *It Happened One Night,* and his ultimate decision to create social myth in *Mr. Deeds Goes to Town.* Yet Willoughby eventually learns the fruitlessness of attempting to create community by the impersonal means of mass preaching: the movie's finale ultimately accepts only the personal as a valid manner of dealing with others. Perhaps Frank Capra allowed himself to make as troubled a film as this because the rise of Fascism had caused him to doubt the value of his previous social mythmaking, and he now desired to express himself in a more personal, less strictly symbolic manner than the *Deeds* structure would allow.

Meet John Doe, then, was an attempt to work out his own fears and questions; unfortunately, they were not quite fitted to the structure of the film. It was, however, a fruitful effort: five years and a world war would intervene before Capra would again direct an ambitious feature film, but *It's a Wonderful Life*—a much less mythological work than *Doe,* on a smaller, more personal scale—would prove to be the crowning masterpiece of a long and stunning career.

WHY WE FIGHT

Training films accompanied the soldier through every step from his induction, orientation, and training, to off-duty activities, demobilization, and even preparation for his postwar life. He was shown how to dress, how to keep himself and his gun clean, how to avoid disease, and how to salute his superior officers. The outstanding example of films produced primarily for the education and training of men in the armed forces is the "Why We Fight" series, American war documentary at its best. But there are many other films, showing the wide range of topics with which soldiers and their superiors had to be familiar. A good example is *Know Your Ally, Britain* (1944), first in the "Know Your Allies—Know Your Enemies" series. The British projected themselves in *Listen to Britain* (1942), a film very popular in the United States; *Know Your Ally, Britain* was America's attempt to understand and project British character and culture. It is a tough, simple film, stressing America's roots in England's past, similarities, rather than differences, and unity in the war effort. Through the use of homely figures of speech, athletic metaphors and analogies, and an unfortunately condescending use of stereotypes, the film succeeds in creating a lively impression of the

From *Non-Fiction Film,* by Richard Meran Barsam (New York: Dutton, 1973), 182–91. Copyright © 1973 by Richard Meran Barsam. Reprinted by permission of E. P. Dutton & Co., Inc.

British people. Its main strength is its refutation of Hitler's anti-British propaganda; and although it perpetuates certain silly stereotypes about English life, it is scrupulously fair in trying to understand the truth behind these stereotypes. In human terms, it is an interesting and effective film.

Another film with an honest intent, but also with an unfortunate use of stereotypes that diminishes its force, is *The Negro Soldier* (1944). Meant to instill pride in the role which blacks have played in the nation's defense since Revolutionary War days, the film also shows prominent blacks in sports, the arts, and professional life. It stresses the anti-Negro aspects of Nazi and Japanese propaganda, but it totally overlooks the segregation in the United States armed forces. The only integrated scenes of military life depict a church service and an officer's training course. There is, in fact, no direct reference to segregation; we see it, indirectly, though, but not intentionally, as a typical soldier's experiences are depicted (through a letter read by his mother). We see him going through enlistment, training, and combat in a segregated company. This is unfortunate, for the same film efforts that were made to acquaint fighting men with their allies and enemies might have been directed toward acquainting them also with their mistreated and misunderstood black fellow soldiers. It is not enough, however, that the film depicts segregation without attempting to correct such an injustice; it uses shuffling jazz rhythms and a musical comedy ending that is as offensive as it is destructive to the whole intent of the film. In a final montage, utilizing four images on the split screen, we see black soldiers marching to a jazzy march version of "Joshua Fought the Battle of Jericho." A curious conclusion for a film which begins with the serious fact that the first to die in the Boston Massacre was a Negro patriot.

As the war in Europe drew to a close, with victory over Germany and Italy, homesick troops looked forward to returning to the United States. To boost their morale, but also to prepare them for the inevitability of their transfer to the Pacific front, Frank Capra made *Two Down, One to Go* (1945), a sophisticated use of psychology on film. But more important in Capra's significant work for the war effort is his memorable "Why We Fight" series. Historically balanced, persuasively and dramatically presented, these films did more than any other to answer the doubts in people's minds. They are remarkable pieces of propaganda, made by film experts who had studied and restudied the best of the Nazi and British films. Equally important, they are good films, mostly compilations from many sources, but lucid and fresh in their handling of facts. The "Why We Fight" films filled a very important gap in America's effort to understand and justify the war. For civilian

and fighting man alike, they explained government policy and diplomacy during the decade preceding the war, and stirred emotions through their continual emphasis on Nazi brutality. Looking back on these films, Capra wrote,

> ... the "Why We Fight" series became our official, definitive answer to: What was the government policy during the dire decade 1931–1941? For whenever State, the White House or Congress was unable, or unwilling, to tell us what our government's policy had been (and this happened often) I followed General Marshall's advice: "In those cases make your own best estimate, and see if they don't agree with you later." By extrapolation, the film series was also accepted as the official policy of our allies. . . . Thus it can be truly said that the "Why We Fight" films not only stated, but, in many instances, actually created and nailed down American and world pre-war policy. No, I won't say it. Yes, I will say it. I was the first "Voice of America."

There are seven films in the series: *Prelude to War* (1943), *The Nazis Strike* (1943), *Divide and Conquer* (1943), *The Battle of Britain* (1943), *The Battle of China* (1944), *The Battle of Russia* (1944), and *War Comes to America* (1945). They were made basically in historical order, stressing the rise of Nazi aggression, the major battles of the war, and, finally, the impact of all the prewar and war activities on American public opinion. The final film, *War Comes to America,* is similar to the "March of Time" production *The Ramparts We Watch* (1940) in its cross-section view of isolationist America reluctant to enter another world war. Capra's film is a very persuasive piece of propaganda showing American values and the great shift in public opinion which led to our entrance into the war, while the Louis de Rochemont film is a dramatic reenactment which traces American reaction before World War I, helping people to see the similarities between that period and the period prior to World War II.

Prelude to War, the first of the series, is also the most patriotic and aggressively prowar of the films. Its purpose is to answer the "Why We Fight" question, and it proceeds toward this goal by contrasting the "free world" with the "slave world." The opening focus is on slavery, on German regimentation, on Japanese militaristic opportunism, on organizations of "Fascist stooges led by dictators." The film documents terrorist executions, the destruction of churches and synagogues, brainwashing, and the indoctrination of children. In a brilliant montage of goose-stepping Nazi soldiers, the film makes its strongest point about regimentation. In his treatment of the free world, Capra stressed freedom of the press, of worship, of education, and of elections. But he was tough in charges of alleged United States isolationism and lack of support for the

League of Nations. His overall logic is simple—"It's their world or ours"—and his persuasiveness is tough: "The chips are down." In its vigorous handling of an explosive question, this film sets the tone of the distinguished series to follow.

The Nazis Strike is a highly charged, emotionally told history of the "maniacal will," the "madness," and the "insane passion for conquest" of the Nazi leaders. It stresses their terrorist tactics and propaganda and explains their pincer strategy (an aspect fully detailed in *Divide and Conquer*). It is, perhaps, the most fervently anti-Nazi film in the series, and in its use of music ("Warsaw Concerto" and "Onward, Christian Soldiers") it creates a mood of moral righteousness that, despite its good intentions, detracts today from its effectiveness. But, again, subtlety and reserve are not the hallmarks of wartime propaganda.

Divide and Conquer records the high point of the Nazi Blitz and the low point of Nazi treachery, the period in which Belgium, Holland, Denmark, Norway, and France were invaded preparatory to the Blitz and planned invasion of Britain. The title refers to Hitler's method of using propaganda to confuse and ultimately conquer the little free countries. Methods such as sabotage, the fifth column, strikes, riots, and hate literature are depicted. The tone of the narration is remarkably factual, but it caters to its audience as it compares Hitler's lies and "efficiency" with the tactics of the gangster Dillinger. There is also heavy irony—a Capra specialty in these films—in the comments on the Low Countries' neutrality and the Nazi betrayal of the Dutch surrender in the bombing of Rotterdam and its civilian population. France is portrayed as disillusioned and cynical, mindful of her heavy World War I casualties, dismayed at the failure of the League of Nations, and weary of her own ideals. Such criticism is typical of the overall attitude the "Why We Fight" series takes toward hesitant countries, isolationism, and inaction by allies of the League of Nations. A well-organized film, clear, explanatory, persuasive in its use of charts, maps, and diagrams, *Divide and Conquer* is an especially hard-hitting attack on Nazi policies, "a new low in inhumanity."

Three films in the "Why We Fight" series are devoted to specific military campaigns. Of these, *The Battle of China* is the weakest, and *The Battle of Russia* the strongest. *The Battle of Britain* is a picture of Britain at its lowest point, after the defeat at Dunkirk and during the blitz of London and Coventry: "Hitler could kill them, but damned if he would lick them." As with the other films, there is a stirring use of martial music to excellent purpose and effect; here, for example, the familiar British "Land of Hope and Glory" and "British Grenadier" provide ironic musical comment on the fiery swastikas burning across the map of Europe.

In *The Battle of China,* the commentary is pro-China, but simple to the point of being corny. While the narration is, again, ironic, its tone of moral outrage lessens the impact of the film. Horribly graphic photographs of the wounded and killed do what the narration does not. As with *The Battle of Russia,* the film is a record in praise of the people's resistance against aggression, and, with the other films in the series, it uses colorful figures of speech to make its points. For example, the Burma Road brings the "blood plasma of supplies" and the Yangtze River is "China's sorrow." Ending with the assertion that "China's war is our war," this film, like the others, depicts the consequence of enemy aggression and the necessity of resistance and defense. And, with the others, it makes the indirect point that we fight over there so that we won't have to fight here at home.

The Battle of Russia is a tough, fast, informative film. As usual, an assemblage, with some staged or reenacted scenes, and almost one-half hour longer than the other films, it is a thorough coverage of the depth and breadth of the massive Nazi attack on Russia. The cross-sectional view of Russia's natural and human resources is far too long and far less exciting than similar sequences in *War Comes to America,* the last film in the series. But with the other films, it is hard hitting, heavily ironic, and full of praise for the strength and determination of the Russian people in their fight against the Nazis: "Generals may win campaigns, but people win wars." Capra and his staff were successful, in these films, in their use of music native to the countries whose plight they were portraying; here, there is a colorful use of many types of Russian music from choral songs, to folk ballads, to themes from great classical works. More analytical than the other films, *The Battle of Russia* discusses individual reasons for the final Nazi failure in Russia. More dramatic than the other films, it reaches its climax in the Siege of Leningrad and a final, unforgettable shot of a captured German soldier trudging across the ice in a pair of makeshift paper shoes, an ironic comment on the so-called invincible Nazi juggernaut. And with the other films in the series, it concludes with the ringing of the Liberty Bell and a superimposed "V" for victory.

War Comes to America begins with the usual explanation that it is a War Department film, compiled from authentic newsreels, official films from the United Nations, and captured enemy film, and that, when necessary, for the purposes of clarity, reenactments have been made. It is concerned with the great shift in public opinion in the decade before the war, tracing the gradual shift from isolationism to support of America's entrance into the war. A careful film, it makes several important background points. First, it shows the American fight for freedom from Jamestown, through the westward movement, through the immigration movement which built the country, through World War I. Second, it

emphasizes the attributes of the American people, and shows them to be hard working, inventive, enterprising, educated, sports and pleasure loving. But, more important, it stresses Americans as a free people who believe in the future, in the liberty and dignity of man and peace; people who hate war, but who will fight to preserve freedom. Third, it asks "Is the war necessary?" and answers that world events make it so. To appeal to the average soldier in the audience, it parallels his childhood and adolescent years with actual world events, from the Depression through the Neutrality Act through the Japanese-Chinese conflict to the Munich Pact. It utilizes figures from the Gallup Poll (referred to as an expression of "we the people") to substantiate the rising war sympathy among Americans and footage from the Nazi rally in Madison Square Garden to demonstrate the closeness of a war that some might have thought was limited to foreign shores. As the war effort builds, we see a cross-section of all men who joined up ("This is the Army, Mr. Jones" on the sound track), Hitler's invasion of Europe ("The Last Time I Saw Paris"), and the bombing of Pearl Harbor. It skillfully combines public opinion polls, official testimony, and historical fact and reference in its method; its chief feature is its comprehensive picture of the diversity of American life. Perhaps the most carefully documented answer to the overall question "Why We Fight," *War Comes to America* is a dramatic, fast-moving, patriotic, and ultimately convincing film.

The "Why We Fight" series is persuasive, dramatic, and forceful in its presentation of known facts; and sophisticated, especially, in its use of sound, narration, music, and speech. These films are masterful in their compilation of many kinds of film footage, a brilliant triumph of form over content. The narration is tough and ironic, wholly American in its rhythms, figures of speech, and attitude toward the enemy. Psychologically insightful, these films never admit the possibility of an American defeat; instead, they make a beast out of Hitler and heroes out of the ordinary citizens who were his victims. The American fighting man is encouraged to persist, to believe in the moral necessity of his job, and to have faith in the simple, underlying principle on which these complex films were made: the rights to freedom, to justice, and to happiness are undeniable, worth the fight, and within grasp. The films suggest that Americans need strength and determination to prevail against the enemy. These are strong films determined to help men win. The "Why We Fight" series is not only the best group of films to come out of the war, but also the best film record of the reasons behind that war, the most dramatic account of the battles in it, and the most eloquent tribute to the civilian and military men and women who fought and died in it.

PRELUDE TO WAR

JAMES AGEE

Prelude to War is the first of the army orientation films put out by Lieutenant Colonel Frank Capra's Special Services Unit. It is the sort of thing one can expect when capable film makers work for a great and many-leveled audience—the best, I suspect, which this country has ever had—under no obligation to baby or cajole, and for a serious purpose.

The intention of the film is to tell the history of fascism from the Mukden incident through the invasion of Ethiopia. Interested experts will object that it does not tell that history *whole;* I think it more important that here for the first time an American film tries to give the general dimensions of a theory and practice which has customarily been treated, in government and Hollywood films alike, as if it were the hate that dare not speak its name.

The method is more verbose than I wish it were or am sure it need be; but if the American addiction to word-dominated films is crystal-lizing into an American form, this is a useful model. The profuse text has been vigilantly researched and on the whole is respectably written. More shrewdness has been used here to make screen images point, edge, impregnate, or explode the spoken text than I have seen used before; at times the border line is crossed into full cinematic possibility, and words serve the screen instead or even do it the greatest service, of withdrawal.

From *The Nation* 156 (June 12, 1943): 844. Reprinted by permission.

For a film made up chiefly of old newsreels and confiscated enemy footage, a surprising amount is new, and a surprising amount of the new is excellent. There is an eye for the unprecedented powers which can reside in simple record photographs—the ferocious inadvertent caricature, the moment when a street becomes tragic rather than a mere street, the intricate human and political evidence in unknown faces—which is here equaled only by the quiet, dry-touched forcefulness with which such images are cut in. A newsreel poll of American war sentiment in 1939 is brilliantly used. There is a long, pouring, speechless sequence, intelligently sustained by rudimentary drumbeats, of marching children, youths, and men which is a virtuoso job of selection and cutting, and the grimmest image of fascism I have seen on a screen.

There are also faults. Overall, the film is so crowded and so ramified that it has no ultimate musical coherence. Things like the drummed march, which had every right to be cinematically overwhelming, are merely impressive. I found repeated references to a Mr. John Q. Public embarrassing, for I felt they betrayed an underestimation of the audience of which the picture as a whole is hearteningly free. A few production shots, like the salon bit showing the withered, rosaried hands of an old woman (which may, heaven forbid, be a stock shot after all; the salon manner has infected so much), are unnecessarily dissonant. In the effort to relieve the monotony of one commentator's voice, too many voices are used, and too many of these voices suggest the cheerful drawers peddlers and the flunked divinity students who are the normal cantors for our nonfiction films. I also noticed with regret that many of the shots devoted to demonstrating that John Q. Public's country is a horse of another color were indeed of another color, glossy and insipid; but I blame this less on the country than on the fact that few of us, conspicuously excepting Walker Evans, have yet learned how to make a camera show what a country it is. It was extremely disconcerting at the end to see a "two worlds" image of Vice-President Wallace's overdrawn to a point at which an image of the Western Hemisphere, described as "free," totally eclipses the "slave" hemisphere. The film as a whole indicates that this unfortunate piece of misorientation could not have been deliberate, but it should be rectified.

IT'S A WONDERFUL LIFE

JAMES AGEE

It's a Wonderful Life is a movie about a local boy who stays local, doesn't make good, and becomes at length so unhappy that he wishes he had never been born. At this point an angel named Clarence shows him what his family, friends, and town would have been like if he hadn't been. As I mentioned several weeks ago, this story is somewhere near as effective, of its kind, as *A Christmas Carol.* In particular, the hero is extravagantly well played by James Stewart. But as I also mentioned, I had my misgivings. These have increased with time.

One important function of good art or entertainment is to unite and illuminate the heart and the mind, to cause each to learn from, and to enhance, the experience of the other. Bad art and entertainment misinform and disunite them. Much too often this movie appeals to the heart at the expense of the mind; at other times it urgently demands of the heart that it treat with contempt the mind's efforts to keep its integrity; at still other times the heart is simply used, on the mind, as a truncheon. The movie does all this so proficiently, and with so much genuine warmth, that I wasn't able to get reasonably straight about it for quite a while. I still think it has a good deal of charm and quality, enough natural talent involved in it to make ten pictures ten times as good, and terrific vitality or, rather, vigor—for much of the vitality seems cooked-

From *The Nation* 164 (February 15, 1947): 193–94. Reprinted by permission.

up and applied rather than innate. (The high-school dance floor coming apart over a swimming pool is a sample of cooking-up that no movie has beaten for a long time.) But I mistrust, for instance, any work which tries to persuade me—or rather, which assumes that I assume—that there is so much good in nearly all the worst of us that all it needs is a proper chance and example, to take complete control. I mistrust even more deeply the assumption, so comfortably stylish these days, that whether people turn out well or ill depends overwhelmingly on outside circumstances and scarcely if at all on their own moral intelligence and courage. Neither idea is explicit in this movie, but the whole story depends on the strong implication and assumption of both. Stewart, to be sure, is shown as an "exceptional" man—that is, as a man often faced with moral alternatives who makes choices, usually for the good and to his own material disadvantage; but it is also shown that the whole community depends on his example and on his defense of the helpless.

Yet at its best, which is usually inextricable with its worst, I feel that this movie is a very taking sermon about the feasibility of a kind of Christian semi-socialism, a society founded on affection, kindliness, and trust, and that its chief mistake or sin—an enormous one—is its refusal to face the fact that evil is intrinsic in each individual, and that no man may deliver his brother, or make agreement unto God for him. It interests me, by the way, that in representing a twentieth-century American town Frank Capra uses so little of the twentieth and idealizes so much that seems essentially nineteenth-century, or prior anyhow to the First World War, which really ended that century. Many small towns are, to be sure, "backward" in that generally more likable way, but I have never seen one so Norman Rockwellish as all that. Capra's villainous capitalist—excellently played in harsh black and white, by Lionel Barrymore—is a hundred per cent Charles Dickens. His New Capitalist—equally well played by Frank Albertson, in fashionable grays—makes his fortune, appropriately, in plastics, is a blithe tough, harmless fellow, and cables the hero a huge check, when it is most needed, purely out of the goodness of his heart. Like Stewart, he is obviously the salt of the earth. Some day I hope to meet him.

I am occasionally mystified why the Catholic church, which is so sensitive to the not very grave danger to anybody's soul of watching Jennifer Jones trying to be a sex actress—roughly the equivalent of the rich man worming around in the needle's eye, or Archbishop Spellman as Christ's Best Man—never raises an eyebrow, let alone hell, over the kinds of heresy and of deceit of the soul which are so abundant in films of this sort—to say nothing of the ideas given, in such films, of the life after death. Fortunately, I don't have to wait for ecclesiastical permission to

say that I am getting beyond further endurance sick and tired of angels named Clarence, Mike, et cetera; I am not even sure I want any further truck with Israfel. These John Q. Public, common-man insults against the very nature of the democratic spirit are bad enough, applied to the living. If the after-life is just a sort of St. Petersburg overrun by these retired Good Joes, taking steam baths in nebulae, scratching themselves with stars, and forever and ever assuring themselves and Almighty God that they are every bit as good as He is and a damn sight more homey and regular, then heaven, so far as I'm concerned, can wait indefinitely.

IT'S A WONDERFUL LIFE AND POST-WAR REALISM

RICHARD GRIFFITH

In December, 1941, as did farmers and auto workers, street cleaners and tax collectors, many of Hollywood's film-makers went to war. Most of them ended up practicing their profession in the army and navy, making pictures for and about their comrades in uniform. For the first time these successful weavers of dreams turned their cameras on bare reality and most of us around them wondered what it would do to them, what it would make of them. And what consequences it would have for the future of the screen itself.

It's a Wonderful Life is, in part, the answer. Among the soldier-directors, the man who achieved the most in wartime (as he had in peacetime) film-making was Colonel Frank Capra, creator of the army orientation films known as the "Why We Fight" series. In answering that question, Capra used the screen to interpret complex historic and economic forces for soldier audiences which had scarcely ever stopped to consider them in relation to their own lives. His success is now historic, a turning point in the development of movie technique. In terms of absolute success, as much cannot be said for his first picture as a civilian. Yet it too *may* be a turning point, and a part of movie history. All depends on what follows it. And what the public thinks of it.

From *New Movies: The National Board of Review Magazine* 22 (February—March, 1947), 5—8. Reprinted by permission.

Consider this: George Bailey, son of the head of a small-town building and loan company, wants to get out into the world and do things. He wants to build dams and bridges and skyscrapers, or maybe design airplanes, or maybe fly them. Anyhow, he wants to get away. But it's tough going. In order to give his kid brother a chance to go to college, he stays on and takes a job. Then, when it comes his turn for higher education, his father dies and the building and loan business will fall into the hands of Mr. Potter, his father's enemy, unless he stays on and takes over. He does stay, but all the time he's thinking about making his escape and longing for it—longing for it so much that he hangs back from marrying the girl he loves because he's afraid marriage would tie him down forever. Finally he gives in, settles down to marriage and babies, and to the main business of his life, a prolonged struggle with Mr. Potter.

Mr. Potter doesn't hate George and the Baileys and the building and loan just because he's made up to look like Scrooge. He has his reasons. He owns real estate, slum real estate, and he doesn't like it when the Baileys make it possible for his poor tenants to build their own houses and pay for them on time. The building and loan is, in fact, just about all that stands between Potter and complete control of the town of Bedford Falls, and he's determined to get rid of it. He almost succeeds when the Depression comes and there is a run on the bank and the investors in the building and loan in a panic try to withdraw their investments. He takes over the bank by offering its terrified stockholders fifty cents on the dollar for their holdings, and almost succeeds in getting hold of the building and loan by the same trick, until George convinces the investors that they can save all their holdings by sitting tight. George is learning how to handle himself—learning from Potter. Step by step, in this chess game of small-town business, he checkmates the old man. Without quite realizing it, he becomes the town's leading citizen, admired and loved for his quiet championship of decent living.

But he has got precious little out of it all for himself. Just a living for his wife and four children. When catastrophe strikes, when his absent-minded uncle misplaces the firm's funds, he has no reserves with which to avert Potter's gleeful attempts to have him indicted. Just a $500 equity in a $15,000 life insurance policy. Faced with jail, disgrace, the ruin of his life, he bitterly realizes he would be worth more to his family dead than alive.

This is the stark little story, which somehow recalls Auden's lines "In headaches and in worry, Vaguely life leaks away." But we are not left to the reflections inspired by this small casualty of the American way. We are not let off at all. Not content with the moral law within George Bailey, Mr. Capra invokes the starry heavens above him. Heaven is

disturbed by George's thoughts of suicide; it sends down an angel second-class (he hasn't won his wings yet), by name of Clarence Oddbody, to induce George to withdraw his terrible wish that he had never been born. Clarence accomplishes this by the fascinating expedient of showing him what would have happened to his family, his friends, and Bedford Falls if he had never lived. His mother would have become a worn-out landlady, his wife would remain a spinster, and Bedford Falls itself would have become Pottersville, a town of honky-tonks. And while he is contemplating what, but for the grace of George Bailey, might have been, a less abstract solution to his problems has arrived. Word spreads of his predicament, and the scores of people he has befriended club together more than enough money to make up the loss of the building and loan funds.

Amusing, touching, highly reminiscent of all the Mr. Deedses and Mr. Smiths and John Does with which Capra used to entertain us. Years ago I called the Capra films "fantasies of good will" because their plots pivoted upon the fanciful premise that kindness of heart is in itself enough to banish injustice and cruelty from the world. However pleasant it may have been for Capra and his audiences to toy with that idea, it is out of place in the new picture. The study of dog-eat-dog methods in business is so carefully rendered, so grimly accurate, so entirely a part of the experience of every American, that one demands a solution, or an ending, equally realistic, and feels cheated without it. The mixture of styles refuses to come off;—not only does fantasy intrude into realism but realism into fantasy: the glimpse of the might-have-been Pottersville as a town of honky-tonks and cheap bars is precise substantiation of sociology's dictum that when people live in misery they spend what money they have on luxury and vice. The shifts of mood between the naturalistic and the fantastic are too abrupt, and there are too many of them; you can't make the required adjustments, and the picture leaves you with a tear in the eye and an unresolved dissatisfaction in your mind.

Why, one speculates, did Capra cover the core of reality with the sugar-coating of fantasy? Perhaps as insurance. Perhaps he feared that American audiences couldn't take this direct dissection of their own lives without reassurance that it was part of the divine design. The technique supports this theory. *It's a Wonderful Life* is one of the loudest films ever made, and its pace is dizzyingly fast. The characters are nearly caricatures, everyone recognizable on sight as Spinster, Mother, Taxi-driver, Ineffectual, Scrooge. In effect, we are being spoon-fed reality. This is not to say that Capra's magic falters. His way with incident and situation has never been more brilliant, his understanding and mastery of the film medium is more complete than ever. The acting of the large cast is

magnificent; from the central performance of James Stewart through Lionel Barrymore, Thomas Mitchell, Donna Reed, H. B. Warner, Beulah Bondi, Ward Bond, and many others, each portrayal crying out for individual mention in its polish, its shrewd accuracy. But all these excellencies, intended to assure the success of a daring film, can backfire when they are linked to a theme of real life—of life which the audience has experienced directly. It's all so pat, so sure-fire, that it alienates while it entertains. Behind the film, one feels a certain uneasiness, a fear on the part of the directing intelligence that unless he compensates and over-compensates for the grimness of the material, he will lose his hold on the audience.

Is his nervousness justified? Hard to prove. Certainly the picture as it stands will be an immense success. But so is *The Best Years of Our Lives.* Not so outspoken as the Capra film, it neither conceals nor telegraphs its punches. It deals with us honestly. As between the two approaches, one must award the palm for leadership and courage to the Messrs. Goldwyn, Wyler, and Sherwood. But with a parting salvo to Frank Capra for turning his camera on this new and important subject matter, and an admonition to trust us a little bit more next time.

UNDER CAPRACORN

STEPHEN HANDZO

Optimism is critically suspect. Too often it implies insulation from the evidence of experience, or yeasaying to the status quo—the Norman Vincent Peale, Bruce Barton brand of sales-seminar boosterism that promises individual liberation while leaving the rules of the game unchanged. For Frank Capra, especially in the filmmaking decade beginning with *Mr. Deeds Goes to Town* and climaxing with *It's a Wonderful Life,* optimism was a dynamic force making possible what was thought impossible. His espousal of this philosophy has made him an easy, even willing target for those socially-conscious critics who despise happy endings as the opiate of the masses. And yet, as has often been mentioned, Capra's own life is a success story more preposterous than any in his films.

Contemporary American attitudes oscillate between the poles of Capra (society can be redeemed) and, say, Samuel Fuller (society is so corrupt that the individual can survive only through guerilla warfare). But it should be recalled that the films of the *early* thirties were often as derisively cynical as those of today. It wasn't until the Depression's psychic shocks had been absorbed, and confidence was slowly being rebuilt, that Capra's optimism caught the public fancy. The director has

From *Film Comment* 8 (November–December, 1972): 8–14. Copyright © 1972 Film Comment Publishing Corporation. All rights reserved. Reprinted by permission.

always defended his "platitudes" by saying, "They're all true, aren't they?" If at this point he can still believe in the goodness of man . . . well, blasphemous old Harry Cohn surrounded himself on his deathbed with a priest, a rabbi, and a Christian Scientist, on the theory that "maybe one of them knows something I don't." Maybe Capra knows something the rest of us don't know, or have forgotten. I hope so.

Mr. Deeds Goes to Town (1936) continues to dominate discussion of the films synonymous with Capra's name. The facility with which the film can be attacked—by Raymond Durgnat, among others—indicates its weaknesses: obviousness and too many cheap shots at targets already exhausted by Warner Brothers (e.g. shyster lawyers, greedy heirs, culture parasites).

Interestingly, the theme of country-boy virtue versus city-slicker snobbishness (as well as its underlying anti-intellectualism) is more pronounced in ex-Broadway-playwright Robert Riskin's script than in cracker-barrel-story-teller C. B. Kelland's original "Opera Hat," an "up-to-date" murder mystery from which only the character Longfellow Deeds and some vestiges of the opera background survived. Rooting the film in such traditional American mythology strategically countered its departures: fusing romantic comedy and social urgency, and casting doubt on the hero's sanity. Subsequently, Capra would draw his "little people" from an urban polyglot neighborhood for *You Can't Take It with You,* and attack *rural* political machines in *Mr. Smith Goes to Washington.* The anti-intellectualism charge may be overdrawn, too; the greedy, power-hungry Capra villain—typically Edward ("Business-is-my-hobby") Arnold—is hardly intellectual, but Deeds can quote Thoreau.

Politically, Capra films have something for everybody. His villains are stock characters from the demonology of the Left—an interlocking directorate of industry/press/government that is militarist and incipiently fascist (*Meet John Doe*)—while his heroes counter with 110 percent Americanism: voluntary association, self-reliance, Lincoln, the Boy Scouts. (Marxists found this especially vexing.) Capra films uphold the non-ideological nature of American politics (the most powerful American ideology of all), but the off-screen activities of his characteristic interpreters, James Stewart and Gary Cooper, indicate the practical impact of these values. Of course, the iconography of popular stars transcends ideology. Theoretically, Ayn Rand's ideas are diametrically opposed to Capra's—and yet Cooper's trial in *The Fountainhead* suggests nothing so much as Deeds all over again, with even the same silver-haired Establishmentarian character actors as antagonists.

The politics of these films need not concern us further. The failure of the Durgnat approach is that it gives no sense of what watching *Deeds*

is actually like. Surely, the face of Gary Cooper and *voice* of Jean Arthur are the film's real "content." In their first appearances in a Capra film, Arthur and Cooper join the list of stars (Clark Gable, James Stewart, Ronald Colman) whose screen personalities were forever cast or recast under his direction. He, in turn, would hold up production for months to get the "right" cast, knowing that nothing flaws a film more completely than inappropriate or inadequate performances.

For all the tumultuous precision of Capra's mass scenes, the best moments in *Deeds* are the oases of feeling far from the madding crowd. Arthur and Cooper in Central Park (she playing "Swanee River" on a garbage can) foretell the equivalent Arthur-Stewart scene in *You Can't Take It with You* played in one five-minute unbroken shot, perhaps the longest to that time, that intuitively anticipates Bazin's single-take aesthetic of psychological integrity through space/time unity. The nocturnal love scenes in *Deeds,* played in the semi-darkness of Joseph Walker's backlighting, are some of the loveliest romantic evocations this side of Borzage—something for which Capra is never credited.

While the acting in his films has been a source of wonder, Capra demagicalizes it, saying he doesn't believe in "acting" at all. While critics attacked stars for playing themselves, Capra encouraged them to be hypertypically themselves. With no stage experience, but lots of life experience, Capra pioneered Stanislavsky acting without knowing it, giving every extra an emotional history, cajoling grizzled Harry Carey into believing he really *was* Vice-President of the United States. Always "leery of the Method," Capra found in Peter Falk's total absorption during the filming of *Pocketful of Miracles*—wearing his costume overcoat everywhere—the kind of affinity he always sought to inspire. By *Deeds,* Capra had come so far from the embarrassingly flat line readings in, say, *Dirigible* that the social clash of the film and the psychological "set" of the characters is conveyed in the rhythm of speech. One never doubts the absolute honesty of Cooper's laconic lines, while lawyer Douglas Dumbrille's rapidity and polish seem mentally prerehearsed, a product of too many business lunches with words used as the currency of self-advancement.

Capra's characters are always *doing* something. Arthur plays with a yo-yo; Deeds' trial becomes a fugue of finger-drumming, doodling, and "O-filling." His films are *very* stingy with close-ups, which are used mainly for crucial reactions. Scenes are constructed within the middle distance, where characters can relate to the objects around them and to each other with their whole bodies. Watching Capra, who talks with his hands, makes it easy to see where such previously inert actors as Gable and Glenn Ford suddenly acquired those animated Sicilian gestures.

Capra's reputed pacing isn't just speed; his thirties films are not particularly fast by either today's standards of those of the time. Rather, Capra—a great story-teller on screen, in print, and in person—knows the value of a logical, well-developed narrative that nevertheless allows for digressions. Robert Riskin, who took over as regular script collaborator with his original story and screenplay for *American Madness,* brought to Capra films a craft in story construction and an ear for dialogue previously absent. The earlier *Dirigible* and *Miracle Woman* had been rickety structures whose only function was to frame the novelty elements (polar exploration, evangelical quackery) that absorbed the director's interest. Capra and Riskin eliminated outdated genre elements by creating their own genre.

From his non-Capra scripts—*The Whole Town's Talking* (with a proto-*Deeds* Jean Arthur), *Magic Town,* and *Mr. 880*—it seems probable that Riskin introduced the subject of the little people who march to their own drum and become prey for the cynical. But the undisciplined moralistic mawkishness of *Magic Town* and the low quality of his directed film *When You're in Love* prove him dependent on a strong director. Ironically, Capra's most effective and visually sophisticated films—*It's a Wonderful Life, Mr. Smith Goes to Washington, The Bitter Tea of General Yen*—are all non-Riskin, suggesting that Riskin's virtue and limitation is his conception of film narrative in playwrighting and novelistic terms. (He once said he introduced "invisible act curtains.") Riskin's script for *Deeds,* with its metrical alternation between Deeds and his antagonists, exemplifies Eisenstein's observation in his essay on Griffith: the application to film of Dickensian parallel action.

The "reactive character" is a key to Capra's cinema. It's hardly an original device—Lubitsch played whole scenes through the medium of keyhole snoopers—but Capra perfected it to serve the TV laugh-track function of cueing audience response. More importantly, for a director who walks a slack tightrope between the ridiculous and the sublime, the reactive character anticipates audience skepticism and enables Capra to undercut his own sentimentality (and perhaps express his own qualms). Whenever things get too marshmallowy, there is always an insert of an abrasive Lionel Stander or Peter Falk to object. As Capra puts it: "The *world* objects."

What William S. Pechter calls the quality of "irreducible foolishness" in Capra's heroes necessitates someone else with whom the audience can identify—like experienced, common-sensical Jean Arthur, the hero's simultaneous confidante and betrayer. If a sophisticated newspaperwoman can be "converted," the audience must succumb to the suspension of disbelief. To a great degree, thirties films, especially

Capra's, are a "people's theater": the reaction shot is a kind of Shakespearean aside, and the on-screen crowd in *Deeds* (shifting its allegiance as Cooper gains the initiative) is a continuation of the 19th-century melodramatic tradition of audience participation.

Only three years older than *Mr. Smith*, *Deeds* looks and sounds much more archaic and is often technically ramshackle: the opening shot of a boxy sedan hurtling off a cliff looks like the "sock" opening of one of Harry Cohn's deadly "B"s, and the routine montages of newspaper headlines superimposed on crowds are only a pale hint of effects to come. "Good will" triumphs a little too easily; as "populist" values lose out to the New Deal, Capra films develop internal tensions that make them more interestingly ambiguous.

But *Deeds* still has some of the freshness that made it one of Hollywood's true originals, because the roles and situations are not yet hardened formulae. Longfellow Deeds is a genuine character, the greatest in the Capra gallery, and not a dour "archetype" like John Doe. Also remarkable is the Sicilian-born, slum-raised Capra's talent for evoking the hopes and dreams of Middle America, creating in Cooper the WASP's idealized image of himself. Perhaps the greatest tribute to *Deeds* was paid by the Nazis, who made the film required viewing for officers in their prospective army of occupation for the United States!

That *Deeds* became the basis of Capra's later films was probably the audience's choice rather than the director's. *Lost Horizon* (1937) was a complete departure in setting and plot, and proved one thing: that an urbane Colman was as much a Capra hero as a folksy Cooper.

One of Western man's great delusions, said H. L. Mencken, is that there is a great store of wisdom in the East. With the spell the photography, sets, and music can still cast, "Love Thy Neighbor" admittedly sounds more exotic from marmoset-like Sam Jaffe in a cardboard lamasery, but the great ironic truth of *Lost Horizon* is that Shangri-la is a bore. The power of *Lost Horizon* is in its early images: the hysterical mobs of refugees, the escape in an airplane mysteriously diverted and crashing, the treacherous trek to the hidden city. The dramatic momentum isn't regained until Colman and his brother brave the elements to leave. The implication is clear: without conflict, life stagnates. And so does film. "Utopia," after all, means "nowhere."

"Shangri-la in a frame house" was one critic's view of *You Can't Take It with You* (1938), a huge hit that today seems badly slowed by too many reaction shots, and by ponderous Lionel Barrymore's self-conscious, head-scratching impishness. When few had it, the film's anti-money philosophy was welcome, though today it smacks of sour grapes, since the Depression effectively froze social mobility. Actually, the

Vanderhof clan's income is ambiguously adequate to support (Negro) servants; and massive socio-psychological evidence suggests that the least happy are the very rich and the very poor.

You Can't Take It with You was praised for making the play's madcap menage of cartoon cutouts into plausible people, for bringing warmth and balance to a "screwball" genre already out of public favor. Hawks' contemporaneous *Bringing Up Baby,* in making everybody crazy, left the audience no-one to identify with—and paid for it. Today, diametrically-reversed audience preferences have released the anarchic Id uncensored by the social Superego. But the shortlived "screwball" genre produced fewer important films than the serio-comic viewpoint: Sturges' Capraesque *Sullivan's Travels* and *Christmas in July,* Stevens' last stand of literate populism, *The Talk of the Town,* and the Cukor-Kanin *The Marrying Kind,* which deftly wedded thirties sociology with fifties sitcom.

With three Oscars in five years for best direction under his belt, Capra combined the stars of *You Can't Take It with You,* the general plot line of *Deeds,* and the symbols of popular sovereignty into the archetypal Capra political drama, *Mr. Smith Goes to Washington* (1939). The pitting of Claude Rains, with his noblest-Roman profile demanding perpetuation on the face of coins, against James Stewart, the younger and more emotional counterpart of Gary Cooper, helped produce Capra's best pre-War film, and a significant escalation in aspiration and achievement.

As in *Deeds,* sudden death catapults a good-hearted nonentity into a lonely ordeal on the national stage; but in *Smith* every scene, every shot exudes new assurance. From the opening profile close-up of a hawk-nosed, rat-faced reporter callously spewing the news of a Senator's death in office into the mouthpiece of an old-fashioned pay phone, a swish-pan/wipe sets in motion rapidly successive scenes leading to James Stewart's "honorary stooge" appointment, the expository pace driven relentlessly by wipes to establish the premises and power relationships in one minute flat.

Capra's accidental entry into film inspired a conviction that the neophyte who breaks all the rules, unaware that there are any, can triumph over seasoned mediocrity. Stewart's elevation by the toss of a coin that lands on its edge is even more whimsical. His selection is heralded in a "star-spangled banquet" allowing montage-expert Slavko Vorkapich to gently satirize democracy's rites in a shower of stars, stripes, popping corks, and dutifully clapping hands. During an "Auld Lang Syne" sendoff *à la* Deeds, Stewart receives his first briefcase in a triptych frame uniting the film's three main protagonists: Jefferson

Smith (whose very name symbolizes agrarian democracy and the American Everyman) and, via portraits, Washington (the institutional symbol of America's founding) and Lincoln (martyred hero of its greatest crisis—the original Mr. Smith and Christ-figure of U.S. politics).

The scenes in the Senate rise above the rest, with the Chamber meticulously recreated and every word of the ritualistic procedure authentic, except for party and state affiliations. Though he is today regarded as a sentimental fabulist, Capra's main impact in the thirties was as a realistic director; the veracity in *Smith* is still astonishing, and Jean Arthur's explanation of how Congress works, or doesn't, should be in civics texts. A thousand details are woven into a tapestry: Smith's upheld hand unobtrusively framed against the flag during his swearing in; the microphone feedback adding hollowness to Rains' fraudulent testimony in hearings framing Smith in a land deal after his proposed Boy Ranger camp runs afoul of his mentors' graft schemes; the way Claude Rains' glasses, glinting wildly during his perjury, equate him with Boss Edward Arnold—whose rimless spectacles glare all the time, and whose tool Rains has totally become.

Smith flags a bit at mid-point—with some hollow scenes between Arthur and Thomas Mitchell, and exposition-laden sequences of political machinations given visual interest only by Walker's use of table lamps for sinister low-angle source light—but reawakens with an amazing scene played in semi-silhouette at the feet of the statue of Lincoln (a continuous presence), in which Arthur finds Stewart, in tears, seething with the bitterness of the wounded idealist, and conceives the idea of the one-man filibuster. The last quarter of the film spirals to the most dizzying surge of dialectical frenzy since silent Eisenstein, with Capra orchestrating hundreds of vignettes and reactions into a virtuoso whirlwind.

But unlike Eisenstein's analytic fragmentation, Capra's editing never loses the main character. The central image established early as a visual plot-correlative starts to pay off: Stewart standing behind his desk on the Senate floor, a slightly depressed angle suggesting heroic potential; the walls of the chamber converging behind him so that he is, figuratively and literally, cornered; fuzzily-focused spectators—The People omnipresent—looking down from the galleries, passing judgment. The classical repetition of this core image makes Stewart an immobile bastion as the Senate Chamber becomes both the eye of a cyclone and a gladiatorial arena. (Such imagery makes *Smith* a *film,* rather than a good script well-directed, like *Deeds.*)

In place of Eisenstein's mass-hero, Capra gives us the mass "reactive character," the technical equivalent of a main tenet: individuals lead,

masses huddle. The shortest vignettes are staged with remarkable density: as a youthful protester is carried kicking and screaming from a meeting, the camera pans a row of oblivious spectators and catches on one the fatuous expression of all the yes-men of history. With flawless timing, as Smith announces his filibuster will continue with a reading of "The Constitution of the United States," already-exhausted Senators groan in unison; one spins in his chair and throws up his hands.

Some of the cutting is almost subliminal. Into Harry Carey's hesitation on "The chair recognizes . . . Senator Smith," Capra cuts in flashes of Stewart and Rains vying for attention. And after Grant Mitchell deftly deflates Stewart's "Either I'm dead right or I'm crazy" ("You wouldn't care to put that to a vote, would you, Senator?"), Capra undercuts *him* with a quick glimpse of Jean Arthur curling her lip—using a character of established sophistication and intelligence to reinforce the audience's pain.

Stewart's anguished expression and limp torso during his one-man filibuster suggest for a moment "Ecce Homo" as he faints and is buried in an avalanche of "Taylor-made" hostile telegrams. It would be hard to top that but Capra does, as Rains attempts suicide and rushes to the floor screaming "I'm not fit to be a Senator!" The film ends ambiguously, with the Senate in turmoil and the fate of the political machine unresolved.

Often hollow in its moralism and rhetoric, for example the disproportionate cheering by Legionnaires at some belligerent homily of Stewart's, *Mr. Smith* is probably a failure by the highest critical standards. But the whole thing is put across with such verve that it hardly matters.

If *Mr. Smith* is archetypal Capra, *Meet John Doe* (1941) is Capracorn Kabuki, with the earlier film's formal richness solidifying into formula and ritual. Despite Edward Arnold's strong performance as the evil newspaper magnate, his character has all the depth of a Herblock cartoon, with neither the inner conflicts of *You Can't Take It with You*'s Kirby nor a morally ambiguous Claude Rains to front for him. But the Arnold character does at least understand that reaction in America cannot present itself undisguised; it needs the trappings of populism. Thus the choice of ex-baseball-player Gary Cooper as the plain-talkin' mouthpiece for a fascistic Corporate State. And thus the mass scenes in *Doe,* which combine the Spirit of Woodstock with the Substance of Spiro.

At the "John Doe Rally," the camera tracks through row upon row of singing, rain-soaked conventioneers, and provides a "set piece" of political spectacle equalling *Potemkin* or *Triumph of the Will.* As the

convention turns into a riot, a wet newspaper thrown at Cooper streaks the headline "John Doe a Fake" across his face, so timed to climax his humiliation. One wonders if Capra isn't *too* perfect and deliberate for modern taste.

The basis of the *Deeds-Smith-Doe* trilogy is its modern recasting of the Gospels. (No wonder they have such strong plots.) It is implicit in *Deeds*—"People have been crucified before"—and quite explicit in *Doe*—"the first John Doe . . . two thousand years ago." But Barbara Stanwyck's hysterical histrionics intervene, in a last-minute Calvary cavalry charge; neither Capra nor his audience was prepared to carry this hypothetically plausible Second Coming *that* far. As Dwight Macdonald has observed, there is something very American in the idea of an uncrucified Christ.

Meet John Doe is self-defeating for reasons other than the publicized confusion over its ending; Capra is appealing when extolling vagabondage and eccentricity, less so when glorifying plebeian averageness in terms akin to a George Wallace rally—all the more ironically since his own film shows the ulterior exploitability of "typical" Americanism. Not until contemporary TV commercials has such concentrated technical virtuosity served such aggressively banal content.

In retrospect, Capra's slippage can be dated from *Doe,* his first film in years failing either to make the National Board of Review Ten Best or figure importantly in the Academy Award nominations. There were signs too that audiences were starting to rebel against "messages." The solitary dissent of Alistair Cooke on *Deeds*—that Capra had begun making films "about themes instead of people"—became a chorus. The "little people" in his films were sounding more and more like ventriloquist dummies speaking with one voice: the director's. Preston Sturges, unconstrained by having to fit his human "found objects" into a social theory, was stealing Capra's thunder in satirical Americana—*Sullivan's Travels* tweaking show-biz social-consciousness *à la* John Doe—while Orson Welles seemed to make Capra a stylistic anachronism.

It's a Wonderful Life (1946) is best described as *A Christmas Carol* from Bob Crachit's point of view. Capra's first post-World War II production—and the maiden effort of Capra's independent Liberty Films—is, surprisingly, not forward-looking but reflective. Perhaps lack of confidence accounts for Capra's taking refuge in a reprise of characteristic themes and situations and surrounding himself with familiar faces, both in the cast and behind the camera.

Whatever the reason, *Wonderful Life* thus became Capra's contribution to what Andrew Sarris has called the forties "cinema of memory." It is his *Ambersons,* his *How Green Was My Valley*—one man's life and the

collective autobiography of a small town (the archetypal American microcosm) in the era spanning the two world wars. Abandoning his customarily linear narrative, Capra makes the entire film an extended flashback. Instead of the usual time-span of weeks or months culminating in a decisive act, the film chronicles decades through the character George Bailey—a Deeds who never got rich, a Smith who never got appointed to the Senate, a Doe who remained obscure—who just got old. Bailey is less a character than a container into which James Stewart pours every nuance of his own being, exposing his whole emotional range in a two-hour *tour-de-force*. Surpassing even *Mr. Smith*, it remains Stewart's own favorite performance, as *Wonderful Life* is Capra's favorite of his films. It is also Capra's most Ford-like film, dealing with themes of community and continuity, and taking place in the generation just past.

Capra draws upon the common experiences of those years, including the shared movie experience of which his own films were a preëminent part. Consequently, as the decades pass, the style of the film is modulated to match the evolution of Capra's work. The high-school prom that writes *finis* to the twenties is done in the style of late silent slapstick comedy with an elaborate sight gag—pranksters part a dance floor to reveal a swimming pool as the dance becomes an aquacade. The coming of the Depression, with Stewart and bride Donna Reed sacrificing their honeymoon money to salvage the building-and-loan, is handled with the click-clack pacing of early thirties films, specifically *American Madness*. Stewart's collisions with tycoon Lionel Barrymore (erstwhile Grandpa Vanderhof, now in the Edward Arnold part) obviously recall *You Can't Take It with You, Mr. Smith,* and *John Doe,* while World War II is depicted with "Why We Fight"-style documentary clips and the actors ingeniously and unobtrusively integrated via a new blue-screen process.

George Bailey's adult life is picked up in 1928 when he assumes charge of the building-and-loan; 1928 was the year Capra joined Columbia and his career, after two false starts, began in earnest: Stewart weds Donna Reed in 1932, the year of Capra's marriage to his wife of forty years. Bailey has four children, as Capra would have but for the death of his little son. *Wonderful Life* is, then, a personal and professional autobiography, though usually less specific. One can find the wild oscillations of euphoria and despair of Capra's films in his own life: an over-achieving childhood and adolescence followed by a long drought of unemployability and emotional paralysis, a film career launched by accident leading to temporary success (with Harry Langdon) followed by despair again, success again. Violent shifts of mood give his films the sense of life being lived. In *Wonderful Life,* with the audience not yet recovered from

the swimming pool scene, Stewart's playfully erotic pursuit of Reed through the bushes is chilled by news of his father's death. (From the triumphant press preview of his biggest hit, *You Can't Take It with You,* Capra was called to the hospital where his son had just died.)

Stewart, facing ruin, snarls viciously at his family, exposing the streak of paranoia and self-pity always implicit in a Capra hero (Deeds punching a poet; Smith beating up reporters). Stewart here is remarkably like Capra's account of his own actions during the year of enforced inactivity because of a contract dispute with Harry Cohn. It is supposed that Capra's theme is that people are basically good; instead it seems to be that people are good under the right circumstances. Careless critics think Capra sentimentalizes poverty, but real need in his films appears as desperation close to madness (the crazed farmer who tries to shoot Deeds; Stewart's sadism). Perhaps Capra, whose book begins, "I hated being poor, hated the ghetto," has created a portrait of The Man I Might Have Been.

The crisis of values has shifted from the millionaire in *You Can't Take It with You* to the character who upholds the Capra ethos. The perpetually falling "Home Sweet Home" sign in the earlier film is replaced by a less convivial anthropomorphic prop—the loose bannister knob constantly reminding Stewart of his shabby surroundings. Amid the *Mildred Pierce*-ish acquisitiveness of the middle forties, Stewart's adherence to the *Our Town* virtues seems an anachronism. And his planned suicide is not an act of principle like Doe's, but an admission of defeat. When a folk-hero like Stewart contemplates suicide, it is indirectly as clear an indication of post-war confusion as *The Best Years of Our Lives*—and a mirror, perhaps, of Capra's own self-doubts.

If forties Hollywood was a cinema of memory, it was also a cinema of imagination abundant in fantasy and dream sequences. Sidney Buchman's *Here Comes Mr. Jordan* was just one of many films depicting Heaven as a super-efficient air-traffic control tower. Mercifully, Capra deleted a similar opening scene in the *Wonderful Life* script (Scene: Interior. Ben Franklin's Workshop in Heaven) in favor of Christmas-card views of small-town streets, a sound montage of praying voices à la Norman Corwin's radio plays, and animated stars twinkling in conversation.

Guardian angel Henry Travers—the original Grandpa Vanderhof on stage—lets Stewart see the world from the outside looking in, as if he had never been born. This harrowing film-within-the-film, a nocturnal parody of the sunlit main narrative, is enacted over a four-acre small-town set deep in highly realistic snow, and is punctuated with anguished close-ups of Stewart's baggy-eyed face.

One's ultimate critical estimate of *It's a Wonderful Life* depends on whether divine intervention is viewed as a *deus ex machina* cop-out or as a legitimate recourse to the classical tradition of metaphor. That other Italian, Dante, pioneered the didactic guided tour; and what is *Wonderful Life* but an inverted *Faust* in which life is taken, not given?

Instead of the editorial virtuosity and "set pieces" of earlier films, Capra gives individual scenes a new emotional density: a Bailey family dinner in which a whole meal is consumed in one take; an erotic telephone scene between Stewart and Reed in which a Capra hero actually evidences sexuality; Stewart's isolation in the frame when his brother's marriage insures that he (Stewart) will stay chained to the building-and-loan—anticipating the thematic-spatial unity of the last shot in *The Searchers.*

It's a Wonderful Life certainly has faults. Apart from his rescue by a guardian angel, Stewart's suicidal intentions aren't particularly consistent with his character as established; the scenes with Barrymore (imitating his annual Scrooge performance on radio) are too rhetorical and dully shot. Indeed, the whole Barrymore character is oddly 19th-century—and extraneous—as the real conflict is no longer between good and bad characters but has shifted to the affirmative and suicidal/nihilistic traits warring within the protagonist. Nevertheless, *Wonderful Life* is one of the most personal visions ever realized in commercial cinema. Rich in performance, unflinching in its confrontation of the "permanent things" of human existence, it is probably the film for which Capra will ultimately be remembered. Capra has said he tried for no less.

It is tempting to connect Spencer Tracy's fall from grace in *State of the Union* (1948) with Capra's sell-out of his figurative and literal Liberty to a major studio, giving an ironic dimension to what Andrew Sarris has called the obligatory scene in Capra: "the confession of folly in the most public manner possible." Tracy in *State:* "I lost faith in you, faith in myself . . . was afraid I wouldn't be elected. That's why I'm withdrawing . . . because I'm dishonest." Capra in his autobiography: "I fell never to rise to be the same man again either as a person or a talent . . . I lost my nerve . . . for fear of losing a few bucks."

To a remarkable extent, Capra's films caught the mood of America in the thirties and forties. When sufficiently little was happening in the world for the masses to be bemused for weeks by the deserved misfortunes of the rich, Capra rebuilt the Depression-bruised male ego with reassurance that, despite unemployment, he was still virile and the master of any situation: "Twenty million dollars and you don't know how to dunk." *Deeds* and *You Can't Take It with You* combined the folk experience of the Depression (bankruptcy, eviction), with an optimism

born equally of the renewed confidence inspired by the New Deal and the need to dispel the lingering malaise. *Mr. Smith* tempered the muckraking of the earlier thirties with the vindication of a flawed democracy that was threatened with extinction abroad. *Doe* (visually darker than earlier Capra, and not just because of a different cameraman) caught that moment when, in Roosevelt's phrase, Dr. New Deal gave way to Dr. Win-the-War. *State,* released by Louis B. Mayer's MGM, had Tracy advocating immediate world government and mass public housing—a poignant reminder of the hopes cherished for the "post-War world" before the Cold War and the long night of McCarthyism froze the New Deal-Fair Deal reform impulse at its root.

Internally, the Capra films became more pessimistic, though this was not immediately apparent. Only in *Deeds* does the hero win a clear victory by his own efforts. In *Smith,* the popular protests are all beaten down and the end is more absurdist than triumphal. (Even in these two films, the arbitrariness of the "happy" endings was underscored when the Russians circulated throughout Europe captured prints of *Deeds* and *Smith,* respectively retitled *Grip of the Dollar* and *The Senator.*) In *Doe* the people's movement is completely discredited, and it is unlikely that Cooper's few remaining adherents can rebuild it. In Capra's later films, the hero is often saved by a directorial decree as dictatorial as it is delirious.

The acquisition of awareness, simultaneously social and sexual, is the subject of *Mr. Deeds, Mr. Smith,* and *John Doe.* In *State of the Union,* awareness includes the hero's own culpability. After 1948, Capra made only four more features. Ironically—for a director who had accused his colleagues of learning about life from each other's movies—two of the four were remakes of his own films; auteurism had become autocannibalism. Various explanations, some plausible, have been advanced. Most probably, Capra put all he had and all he was into *It's a Wonderful Life.* And, after the confession of *State of the Union,* there was no place left to go.

AMERICAN MADNESS

WILLIAM S. PECHTER

I suppose that merely to bring oneself to see a film with a name like *Pocketful of Miracles,* no less like it, it is necessary simply to like the movies, and, at least in part, in a strictly noncerebral way. I saw it, and I liked it, and I can't say that the experience of it much involved the faculty of mind. Nor, even on the level of mindless diversion, can Frank Capra's new movie, his second following a retirement of eight years, be said to be impeccable. It is an expensive job, and gives occasionally onto those big, dull, vacant spaces which money seems infallibly to buy; it suffers from the Hollywood disease—elephantiasis ("A ninety-minute picture, Jules? You must be talking about the coming attractions!"). At its best—a bravura performance by Bette Davis as "Apple Annie," some wonderfully funny bits and pieces, a knockdown brawl which assails and exhilarates by its sheer kinetic energy—the insubstantiality of the whole is almost justified. At its bad moments—particularly those featuring an incredible ingenue and her Valentino-like Latin fiancé, in whom even Capra does not seem to believe—one has the sense not so much of talent lacking as of talent not engaged. Yet Capra is his own producer, wholly independent; he hops to no mogul's barked command. Among important

From *Twenty-Four Times a Second,* by William S. Pechter (New York: Harper & Row, 1971), 123–32. Copyright © 1962 by William S. Pechter. Reprinted by permission of Harper & Row, Publishers, Inc.

Hollywood directors, only George Stevens has recently had this kind of independence, and, with the financial collapse of his last film, he now has probably lost it. Indeed, with the exceptions of John Ford and De Mille,[1] Capra is perhaps the most conventionally successful director Hollywood has ever known: consistent maker of profit; winner of several Academy Awards.

And, despite these credentials, Capra *is* a director of considerable importance. Among Hollywood directors, perhaps only Preston Sturges has so consistently concerned himself with a comedy of the contemporary scene; yet, for all Sturges' cosmopolitan wit, he was essentially a *farceur,* and Capra, for all his occasional air of being merely topical and his apparent sentimentality, works in a much more Aristophanic tradition. Billy Wilder also comes to mind. But his films seem to me almost the inverse of Capra's; hard cynicism on the surface, soft sentimentality underneath; and, in a film like *The Apartment,* the surface becomes scarcely distinguishable from the core. What is sentimentality if not a deficiency of feeling expressed as an excess of response; and what is cynicism if not the reciprocal of this?

Capra has called his latest film a fairy tale, and this it is, a fable of innocence out of Damon Runyon. There are a number of things wrong with it, but never does it become sentimental; if anything, one is rather conscious of a sharp edge of cruelty running through the work, an edge which cuts. Capra has populated his film—and this is one of its pleasures—with the greatest array of character actors assembled since the thirties, but the familiarity of their faces serves a purpose beyond nostalgia. The faces, like the rest of the movie's artifice, seem there constantly to remind us we are in a theater, and, indeed, Capra seems always to be saying of his fairy tale, you'd better enjoy it while you can because it only happens in the movies.

But the faces—epitomized by the marvelous mask of cosmic incompetence which is the face of Edward Everett Horton—serve still another function: inescapably, they date the work. One of the film's shrewdest strokes was in Capra's decision not to modernize his material, as, for instance, Billy Wilder refurbishes Molnar. *Pocketful of Miracles* is a fable of the twenties set in the twenties; its innocence remains inviolate. In the pervasive ambience of the fairy tale, even a joke on implied homosexuality is redeemed for innocence. The audience with whom I saw it laughed at the comedy and cried at the pathos as at no other film of my recent experience; in fact, my impression was of seeing, in the audience as well, faces that had not been inside a movie theater since the thirties. How one aches for the simple innocence of the world on the screen; I found myself nostalgic for a time in which I had not yet been born: clue,

perhaps, that it was a time which never existed. Never, that is, but in our movies; and who would deny the reality of our experience of them? It is the movies themselves for which the film evokes nostalgia. But the pastness of *Pocketful of Miracles* exceeds mere nostalgia, both more profound and more complex; the film in its totality, has the aura of some earlier experience. And, in fact, the film is a remake of one of Capra's earliest successes, a remake in the sixties of a film made in the thirties and set in the twenties. The final effect left by Frank Capra's latest film is that of having seen a revival.

In an enterprise as vast and impersonal as the making of a film, it is rare enough that a director creates his own style; if, then, he also creates his own genre, it is indeed a signal accomplishment. That Frank Capra did both, and then abruptly climaxed his spectacularly successful career by a self-imposed premature retirement, would serve to make him an absolute conundrum. For Hollywood directors are notoriously like old soldiers in the way in which they just fade out and away.

The unique Capra genre has been defined by Richard Griffith, the film historian, as the "fantasy of goodwill," and he has also described its archetypical pattern. "In each film, a messianic innocent, not unlike the classic simpletons of literature ... pits himself against the forces of entrenched greed. His inexperience defeats him strategically, but his gallant integrity in the face of temptation calls forth the goodwill of the 'little people,' and through their combined protest, he triumphs." This ritual of innocence triumphant did little to ingratiate Capra to an intellectual audience to whom he represented only the triumph of the *Saturday Evening Post.* But though the apparent vein of cheery optimism which informs this ritual's re-enactment *is,* of course, precisely that quality which both endears Capra to his popular audience and alienates an intellectual one, yet, in seeing the films again, this quality seems strangely elusive, forever asserting itself on set occasions, but always dissipating itself finally in a kind of shrill excitement. There are even intimations of something like melancholy constantly lurking beneath the surface glare of happy affirmation.

The sense of this becomes particularly emphatic if one views the films—and I restrict myself to his most famous and characteristic comedies—in chronological sequence. From this perspective, although the pattern is already set in such early work as *The Strong Man,* a 1926 Harry Langdon seven-reeler, *Mr. Deeds Goes to Town* is its first major exposition, at once the prototype and the exception. Compared to Capra's subsequent films, it is the most unreservedly "positive" in tone. Longfellow Deeds does, indeed, win out, and innocence triumphs. The

rustic poet *cum* tuba confronts the powerful presence of metropolitan venality, and not only effects a personal victory, but manages to impress the cynical—a reminder of their own lost innocence—with his exemplary goodness as well. The memory of innocence lost is a crucially disturbing one in Capra's films, and central to any understanding of them. While the progress from small-town purity to big-city corruption may not, in fact, be part of the audience's personal history, it remains a fact of its acquired cultural legacy. That is, it is part of the inherited myth of an American past—of quiet, shady, tree-lined streets of white wood homes—which is so concretely a part of an American childhood that it persists into adulthood as a psychological fact, with the force of memory. And while the audience is asked to, and indeed must, identify with the innocent hero, it cannot fail to recognize itself, if not quite consciously, more nearly depicted in the images of his antagonists—the cynics, smart guys, hustlers, chiselers, opportunists, exploiters, hypocrites: all the corrupt; all our failed selves; what we have become. We respond finally to the classic Capra hero, whether Mr. Smith or John Doe, the uniquely American Everyman, with a kind of reluctant longing. He is our conscience *manqué*, the image of our childhood selves, reminding us, as we do not wish to be reminded, of the ways and degrees to which we have failed this image; all reaching some comic apotheosis in the figure of Jimmy Stewart, as Mr. Smith, in Washington, quite literally, a big Boy Scout.

What moderates the merely Sunday school piety of the Capra hero, what keeps his meaning just short of the moralizing "essay" on the page before the murder case in our Sunday supplements, is always some specifically foolish, specifically human trait which becomes the comic correlative of virtue: Mr. Deeds plays his tuba, John Doe plays his baseball, and Mr. Smith is not simply a patriot, but an absurdly fanatical one, who cannot pass the Washington Monument, however casually, without adopting some posture of ridiculously extravagant reverence. The virtue of the characters seems inseparable from their absurdity, and, bound up as it is with this absurdity, passes from the ideality of the Sunday moral to the reality of a concrete human embodiment. It becomes a human possibility; that is to say, the peculiar impact of the Capra hero is as an assertion that it is possible to be that good . . . and human, too.

It is the formularized happy ending which has always seemed the fatal weakness of Capra's films; the apparent belief that everything will turn out all right in the end serves, finally, only to nullify any serious moral concern. Yet this convention of the happy ending seems, on closer look, to be curiously quarantined in Capra's films, and the observance of

it has often been strangely perfunctory. Only *Mr. Deeds Goes to Town* appears comfortably to adopt a happy ending, and, while this film remains the prototype of the others, much of their interest derives from the variations they work on the original pattern. In *Mr. Smith Goes to Washington,* the dramatic climax is brought off with such astonishing abruptness as to be over before we can consciously comprehend it. The filibuster has dragged on interminably. Mr. Smith seems defeated, and with the arrival of the hostile letters he suddenly becomes aware of his defeat. More suddenly still, the corrupt Senator leaps to the railing— admits the truth of Smith's accusation—Smith collapses in exhaustion and disbelief—wild commotion—Jean Arthur smiles—The End. The entire dramatic reversal takes place in less than a minute. The finale of *Meet John Doe* is almost the reverse in quality. With John Doe's suicide an apparent inevitability, the film closes on an episode of almost dreamlike tranquillity. It is Christmas Eve; there is an all but unendurably slow elevator ride to the top of a deserted skyscraper; the snow is falling, thick and silent; John Doe appears and moves to the edge of the roof; Edward Arnold appears with his henchmen; the Girl appears with specimen types of little folk who have regained faith in the idea of John Doe, and Doe allows himself to be persuaded to return to life. Distant church bells. In both cases, the tone and tenor of the final sequence are seriously at odds with the rest of the work: in *Meet John Doe,* it seems to take place in a vacuum; in *Mr. Smith Goes to Washington,* on a roller coaster. I am not at all sure that Capra rejects the validity of the happy ending, but what one detects, in the abrupt changes of style, is some knowledge, if less than conscious, of the discrepancy between the complex nature of his film's recurring antitheses and the evasive facility of their reconciliation.

To understand this is to come to a film such as *It's a Wonderful Life* with a fresh eye. For it is in this film that Capra effects the perfect equipoise between the antitheses he poses and the apparatus by which he reconciles them; there being, in fact, no recourse in "real life," the end is served by the intervention of a literal *deus ex machina.* And, as George Bailey, the film's hero, jumps into the river to commit suicide as the culmination of his progress of disastrous failures, he is saved . . . by an angel! This is, of course, the perfect, and, in fact, only, alternative for Capra; and the *deus ex machina* serves its classic purpose, from *Iphigenia in Tauris* to *The Threepenny Opera;* namely, to satisfy an understanding of the work on every level. It creates, for those who wish it, the happy ending par excellence, since it had already become apparent, in the previous Capra movies, that the climaxes, by the very extremity of the situations which gave rise to them, were derived *de force majeure.* Yet, for those who can accept the realities of George Bailey's situation—the

continual frustration of his ambitions, his envy of those who have done what he has only wanted to do, the collapse of his business, a sense of utter isolation, final despair—and do not believe in angels (and Capra no more says *we* must believe in slightly absurd angels, although *he* possibly does, than Euripides says we may not believe in slightly absurd gods, although he surely doesn't), the film ends, in effect, with the hero's suicide.[2]

It's a Wonderful Life is the kind of work which defies criticism; almost, one might say, defies art. It is one of the funniest and one of the bleakest, as well as being one of the most technically adroit, films ever made; it is a masterpiece, yet rather of that kind peculiar to the film: unconscious masterpieces. Consciously, except in the matter of his certainly conscious concern with the mastery of his medium's technique, I don't imagine Capra conceives of himself as much different from Clarence Budington Kelland, from whose story *Mr. Deeds Goes to Town* was adapted. *It's a Wonderful Life* is a truly subversive work, the *Huckleberry Finn* which gives the lie to the *Tom Sawyers;* yet I am certain Capra would not think of it in this way, nor boast of pacts made with the devil. I mention Twain and allude to Melville not haphazardly; Capra's films seem to me related in a direct way to the mainstream of our literature; and the kind of case Leslie Fiedler makes with regard to the American novel, leaving aside questions of its truth or falsity, might equally have been derived from the American film. Just as *Pull My Daisy* is clearly out of *Huckleberry Finn,* so *A Place in the Sun* (once one forgets Dreiser, as the film itself was quite ready to do) is pure *Gatsby;* and Capra seems to me, in many ways, the analogue of Twain, always, but once, flawing his genius. I would not wish to press this analogy, for, as artists, Twain and Capra are vastly dissimilar; yet they seem to me comparable in their situation with respect to art and consciousness. And, like Twain also, Capra is a "natural"; a folk artist in the sense of drawing imaginatively for his substance on some of the most characteristic matter of our national folklore.

Capra (whose life, in actuality, was in imitation of that most classic American cliché: poor Italian immigrant makes good) has made our clichés the stuff of his art; compounding his most significant films of the ritual elements of the peculiarly American mythos of innocence. The image of metropolitan corruption, the hatred of the city slicker, the suspicion of sophistication, the distrust of politics and the fear of government, the virtue of the rural: what is this if not a compendium of the beliefs of Populism and of Progressivism, which, in turn, are Jeffersonianism, grown ossified and anachronistic. Even the agrarian quality of Jeffersonianism has been curiously preserved; Mr. Deeds wants to use his

twenty-million-dollar inheritance to aid homeless farmers with free land and seed, and Mr. Smith wants the disputed tract of land to be used as an outdoor camp for boys. And there is, in addition, in Capra's work, a preoccupation with still another aspect of our national subconscious. All of his heroes are made to undergo some extraordinarily harrowing ordeal before their final triumph: Mr. Deeds is placed on trial; Mr. Smith is forced to filibuster; John Doe is hissed, jeered, and ridiculed before an assemblage of his followers; George Bailey is humiliatingly bankrupt. There is, as Dwight Macdonald has observed, something very American in the idea of an uncrucified Christ.

But Capra's genius is a comic one, and there remains that quality of irreducible foolishness in the Capra heroes, a foolishness that is the emblem of their humanity: Mr. Deeds' tuba and awful poetry, Mr. Smith's patriotic mania, John Doe's hobo language and legends, George Bailey's consummate awkwardness. And their innocence, their virtue, their beauty is inextricable from this. In a world of cleverness and corruption, they have allowed themselves to be "fools for Christ's sake"; and it hardly seems a flaw in this scheme that George Bailey's antagonist in *It's a Wonderful Life* is made a Dickensian caricature of villainy, embodying his single trait; rather, he becomes an abstracted converse of the George Baileys, the incarnation of pure, natural malignity. He exists not so much as a human being as an operative force in this world; and, by the suicide of George Bailey, the triumphant one; in the end, the cross will not be cheated of its suffering.

I have mentioned the breaches of Capra's style, but it remains to mention the style as such. It is a style—although one might never guess it from the most part of his recent work—of almost classic purity; and it seems somehow appropriate to the American ethos of casual abundance that the director of quite probably the greatest technical genius in the Hollywood film, post-Griffith, pre-Hitchcock—a genius, as Richard Griffith has suggested, on the order of those of the silent Russian cinema at its zenith—should have placed his great gifts at the service of an apparently frivolous kind of comedy. It is a style, one is tempted to say, based solely on editing, since it depends for its effect on a sustained sequence of rhythmic motion. There is very little about Capra's style which may be ascertained from a still, as, say, each still from Eisenstein has the carefully composed quality of an Old Master. A Capra still is unbeautiful; if anything, a characteristic still from Capra will strike one as a little too busy, even chaotic. But whereas Eisenstein's complex and intricate editing seems, finally, the attempt to impose movement on material which is essentially static, Capra's has the effect of imposing order on images constantly in motion, imposing order on chaos. The end of all this is

indeed a kind of beauty, a beauty of controlled motion, more like dancing than like painting, but more like the movies than like anything else.

A comic genius is fundamentally a realistic one, and, in his films, his various conclusions notwithstanding, Capra has created for us an anthology of indelible images of predatory greed, political corruption, the cynical manipulation of public opinion, the murderous nature of private enterprise, and the frustration and aridity of small-town American life. There is always a gulf between what Capra wishes to say and what he actually succeeds in saying. He seems obsessed with certain American social myths, but he observes that society itself as a realist. The most succinct statement of this discrepancy between intention and accomplishment is put by Richard Griffith, in his monograph on Capra, simply by juxtaposing a commonplace phrase of Capra criticism—"engrossing affection for small American types"—against a still of the witnesses at the trial of Mr. Deeds. Their faces remain more expressive than any comment one could make upon them: mean, stupid, vain, petty, ridiculous; they form an imposing catalogue of human viciousness.

And Capra seems always to realize this. His films move at a breath-taking clip: dynamic, driving, taut, at their extreme even hysterical; the unrelenting, frantic acceleration of pace seems to spring from the release of some tremendous accumulation of pressure. The sheer speed and energy seem, finally, less calculated than desperate, as though Capra were aware, on some level, of the tension established between his material and what he attempts to make of it. Desperation—in this quality of Capra's films one sees again the fundamental nature of style as moral action: Capra's desperation is his final honesty. It ruthlessly exposes his own affirmation as pretense, and reveals, recklessly and without defense, dilemma.

Perhaps mention should be made, in passing, of what was, in effect—the rest being only a few remakes, a few frank time-killers, and eight years of silence—Capra's last film, *State of the Union;* despite its prodigal talent and virtuoso style, an acknowledgment of defeat. With *It's a Wonderful Life,* the ideal form for the Capra comedy had been established, but it was a form which could be employed only once. Despite the fact that, in *State of the Union,* such actual names as Vandenberg and Stassen (*O tempora! O mores!*) are mentioned with considerable irreverence, these ostensible signs of daring only serve to emphasize a more fundamental lack of it. Unlike any of Capra's other films, *State of the Union* seems anxious to retreat into its subplot, one of romantic misalliance. And all the hoopla of its finale, as frenetic and noisy as anything Capra has put on the screen, cannot disguise the fact

that the hero resigns from politics with the implication being that he is, in fact, *too good* to be involved. In one sense, this is Capra at his most realistic, but also at his least engaged. For the artist, withdrawal from the world—the world as he perceives it—is never achieved without some radical diminution of his art.

Perhaps, having made *It's a Wonderful Life,* there was nothing more Capra had to say. His only fruitful alternative, having achieved a kind of perfection within his own terms, had to be to question the very nature of those terms themselves. Without a realization that the dilemma existed inherently in the terms in which he articulated it, he could, in effect, go no further. It remains only to note that he went no further.

Notes

1. In this, as with the question of independence, I exclude Hitchcock as a special case.
2. I don't mean to give the impression here that Capra employs his *deus ex machina* with any Euripidean irony (all the film's irony is contained in its title). The agonizing pathos of the film's climax derives precisely from the tension one senses between Capra's deeply felt desire to save his protagonist and his terrible knowledge that he cannot.

Contributors

James Agee is the author of *Let Us Now Praise Famous Men,* and was a
 film critic for the *Nation* from 1942 to 1948.
Richard Barsam is professor of English at Richmond College of the City
 University of New York.
Andrew Bergman is a free-lance writer and author of *We're in the Money.*
Otis Ferguson was movie reviewer for the *New Republic* from 1934 to
 1941.
Graham Greene, the novelist, was a film critic whose criticisms have re-
 cently been published in a volume entitled *Graham Greene on Film:
 Collected Film Criticism, 1935–1940,* edited by John R. Taylor.
Richard Griffith is the author of *The Movies* and co-author of *The Film
 Till Now.*
Richard Glatzer is a graduate student in English at the University of
 Virginia.
Stephen Handzo is professor of film in School of the Arts at Columbia
 University.
Geoffrey T. Hellman is a staff member of the *New Yorker.*
Lewis Jacobs is the author of *The Rise of the American Film,* among
 other books on film.
Malcolm Lowry is the author of *Under the Volcano.*
William S. Pechter is the reviewer of movies for *Commentary.*
John Raeburn is professor of American literature and American culture
 at the University of Iowa.
Robert Sklar is professor of history at the University of Michigan, and
 author of *F. Scott Fitzgerald: The Last Laocoon.*
Robert Stebbins (Sidney Meyers) was a contributor to *New Theater,* and
 director of *The Quiet One.*
William Troy was a reviewer of fiction and movies for the *Nation* during
 the 1930s.
Robert Willson is professor of English at the University of Missouri–
 Kansas City.

Filmography

Fultah Fisher's Boarding House (1923)
Tramp, Tramp, Tramp (1926)
The Strong Man (1926)
Long Pants (1927)
For the Love of Mike (1927)
That Certain Thing (1928)
So This is Love (1928)
The Matinee Idol (1928)
The Way of the Strong (1928)
Say It with Sables (1928)
Submarine (1928)
The Power of the Press (1928)
The Donovan Affair (1929)
The Younger Generation (1929)
Flight (1929)
Ladies of Leisure (1930)
Rain or Shine (1930)
Dirigible (1931)
The Miracle Woman (1931)
Platinum Blond (1931)
Forbidden (1931)
American Madness (1932)
The Bitter Tea of General Yen (1933)
Lady For a Day (1933)
It Happened One Night (1934)
Broadway Bill (1934)
Mr. Deeds Goes to Town (1936)
Lost Horizon (1937)
You Can't Take It with You (1938)
Mr. Smith Goes to Washington (1939)
Meet John Doe (1941)

Arsenic and Old Lace (1941)
Prelude to War (1942)
Nazis Strike (1942)
Divide and Conquer (1943)
The Battle of Britain (1943)
The Battle of Russia (1943)
Know Your Ally: Britain (1943)
The Battle of China (1944)
War Comes to America (1945)
The Negro Soldier (1944)
Know Your Enemy: Japan (1945)
Know Your Enemy: Germany (1945)
Tunisian Victory (1945)
Two Down—One to Go (1945)
It's a Wonderful Life (1946)
State of the Union (1948)
Riding High (1949)
Here Comes the Groom (1951)
A Hole in the Head (1959)
A Pocketful of Miracles (1961)

Selected Bibliography

Published Screenplays

It Happened One Night. In *Four Star Scripts,* edited by Lorraine Noble. Garden City, N.Y.: Doubleday, 1936.
Lady for a Day. In *Four Star Scripts,* edited by Lorraine Noble. Garden City, N.Y.: Doubleday, 1936.
Mr. Smith Goes to Washington. In *The Best Pictures: 1939–1940,* edited by Jerry Wald and Richard Macauley. New York: Dodd Mead & Co., 1940.

Works by Frank Capra

"The Gag Man." In *Breaking into the Movies,* edited by Charles Reed Jones. New York: Unicorn Press, 1927, pp. 164–71.
"The Cinematographer's Place in the Motion Picture Industry." *Cinematographic Annual* 2 (1932).
"Sacred Cows to the Slaughter." *Stage* (July, 1936): 40–41.
"Breaking Hollywood's Pattern of Sameness." *New York Times Magazine* (May 5, 1946): 18, 57.
The Name Above the Title. New York: Macmillan, 1971.
Introduction to *The Man Who Invented Hollywood: The Autobiography of D. W. Griffith.* Louisville, Ky.: Touchstone Press, 1972.
Introduction to *Light Your Torches and Pull Up Your Socks,* by Tay Garnett. New Rochelle, N.Y.: Arlington House, 1973.
Introduction to *Directors in Action,* edited by Bob Thomas. Indianapolis and New York: Bobbs-Merrill, 1973.

Works about Frank Capra

Childs, James. "Capra Today." *Film Comment* 8 (November–December, 1972): 22–23.

Corliss, Richard. "Capra and Riskin." *Film Comment* 8 (November–December, 1972): 18–21.

Durgnat, Raymond. *The Crazy Mirror: Hollywood Comedy and the American Image.* New York: Horizon Press, 1970, pp. 123–26, 129–30.

Farber, Manny. *Negative Space.* New York: Praeger, 1971, pp. 105–7.

Houston, Penelope. "Mr. Deeds and Willie Stark." *Sight and Sound* 19 (1950): 276.

Hovland, Carl I., Arthur A. Lumsdaire, and Fred D. Sheffield. *Experiments on Mass Communication,* vol. 3. Princeton: Princeton University Press, 1949. Part of the *Studies in Social Psychology in World War II Series;* volume 3 is largely on the effects of the "Why We Fight" series.

Leary, Richard. "Capra and Langdon." *Film Comment* 8 (November–December, 1972): 15–17.

MacCann, Richard Dyer. *The People's Films.* New York: Hastings House, 1973, pp. 153–59.

Mast, Gerald. *The Comic Mind.* Indianapolis and New York: Bobbs-Merrill, 1973, pp. 168–74, 259–65.

Queval, Jean. "Capra ou l'idealisme Americain." *Mercure de France* 314 (February, 1952): 328–31.

Richards, Jeffrey. "Frank Capra and the Cinema of Populism." *Film Society Review* 6 (February, 1972): 38–47; 7–9 (March–April–May, 1972): 61–71.

Rivkin, Allen. "Frank Capra Sticks by the Little Man." *U.N. World* 1 (March, 1947): 64.

Samelson, Harold J. "Mr. Capra's Short Cuts to Utopia." *Penguin Film Review* 7 (September, 1948): 25–35.

Shales, Tom. "Frank Capra." In *American Film Heritage.* Washington, D.C.: Acropolis Books, 1972, pp. 115–23.

Stein, Elliott. "Capra Counts His Oscars." *Sight and Sound* 41 (Summer, 1972): 162–64.

Selected Ann Arbor Paperbacks
Works of enduring merit

AA 8 **THE DESERT FATHERS** Helen Waddell
AA 17 **SIX THEOSOPHIC POINTS** Jacob Boehme
AA 18 **THOMAS MORE** R. W. Chambers
AA 19 **PHYSICS AND PHILOSOPHY** Sir James Jeans
AA 20 **THE PHILOSOPHY OF PHYSICAL SCIENCE** Sir Arthur Eddington
AA 21 **THE PURITAN MIND** Herbert W. Schneider
AA 22 **THE GREEK VIEW OF LIFE** G. Lowes Dickinson
AA 23 **THE PRAISE OF FOLLY** Erasmus
AA 30 **DEVOTIONS** John Donne
AA 35 **THE LIFE OF CHARLEMAGNE** Einhard
AA 37 **THE NATURE OF TRUE VIRTUE** Jonathan Edwards
AA 38 **HELOISE AND ABELARD** Etienne Gilson
AA 41 **THE MIND OF PLATO** A. E. Taylor
AA 42 **METAPHYSICS** Aristotle Translated by Richard Hope
AA 49 **THE GATEWAY TO THE MIDDLE AGES: ITALY** Eleanor Shipley Duckett
AA 50 **THE GATEWAY TO THE MIDDLE AGES: FRANCE AND BRITAIN** Eleanor Shipley Duckett
AA 51 **THE GATEWAY TO THE MIDDLE AGES: MONASTICISM** Eleanor Shipley Duckett
AA 52 **AUGUSTE COMTE AND POSITIVISM** John Stuart Mill
AA 54 **HOBBES** Sir Leslie Stephen
AA 59 **THE FATE OF MAN IN THE MODERN WORLD** Nicolas Berdyaev
AA 62 **A HISTORY OF BUSINESS: From Babylon to the Monopolists Vol. I** Miriam Beard
AA 71 **CAROLINGIAN ART** Roger Hinks
AA 75 **JEAN-PAUL SARTRE: The Existentialist Ethic** Norman N. Greene
AA 76 **A HISTORY OF BUSINESS: From the Monopolists to the Organization Man Vol. II** M. Beard
AA 97 **LANGUAGE, THOUGHT, AND CULTURE** Paul Henle, ed.
AA 106 **EDMUND BURKE AND THE NATURAL LAW** Peter J. Stanlis
AA 108 **WRITING FOR BUSINESS** Mary C. Bromage
AA 121 **THE PHILOSOPHY OF EDMUND BURKE: A Selection from His Speeches and Writings** Louis I. Bredvold and Ralph G. Ross, ed.
AA 123 **SOLILOQUIES IN ENGLAND And Later Soliloquies** George Santayana
AA 129 **BUDDHIST THOUGHT IN INDIA** Edward Conze
AA 130 **ASPECTS OF ISLAMIC CIVILIZATION** A. J. Arberry
AA 151 **SOVIET ETHICS AND MORALITY** Richard T. De George
AA 157 **CAROLINGIAN PORTRAITS: A Study in the Ninth Century** Eleanor Duckett
AA 158 **UNIVERSAL NATURAL HISTORY AND THEORY OF THE HEAVENS** Immanuel Kant
AA 162 **THE MEANING OF TRUTH** William James
AA 166 **POETICS** Aristotle Translated, with an Introduction, by Gerald Else
AA 167 **BEYOND ECONOMICS** Kenneth E. Boulding
AA 173 **GALILEO, SCIENCE AND THE CHURCH** Jerome J. Langford
AA 182 **MANIFESTOES OF SURREALISM** André Breton
AA 184 **THERAVADA BUDDHISM IN SOUTHEAST ASIA** Robert C. Lester
AA 185 **IMAGINATION** Jean-Paul Sartre
AA 188 **THE SURREALIST REVOLUTION IN FRANCE** Herbert S. Gershman
AA 189 **RICHARD WRIGHT: Impressions and Perspectives** David Ray and Robert M. Farnsworth, eds.
AA 190 **SCIENCE AND RELIGION IN SEVENTEENTH-CENTURY ENGLAND** Richard S. Westfall
AA 191 **FROM AFFLUENCE TO PRAXIS: Philosophy and Social Criticism** Mihailo Marković
AA 192 **CRISIS IN WATERTOWN: The Polarization of an American Community** Lynn Eden
AA 193 **HENRY FORD AND GRASS-ROOTS AMERICA** Reynold M. Wik

For a complete list of Ann Arbor Paperback titles write:
THE UNIVERSITY OF MICHIGAN PRESS ANN ARBOR